KEEPING WARM

Also by Max Schott

Up Where I Used to Live
Murphy's Romance
Ben

Keeping Warm

Selected Essays and Stories

MAX SCHOTT

2004 | John Daniel & Company
McKinleyville, California

ACKNOWLEDGMENTS
Short pieces published in the Santa Barbara *Independent:* "No Luck," "My Chinese Life," "Readers," "Parents' Orientation," "The Violin Gods," "To Be Included," "Chico," an earlier version of "Jill," "Ory Summers," "Paying Attention," "Old Hopes and New," "Turpitude and Rectitude," "The Fashion Plate," "Chekhov's Colleague," "Liberated Dogs," "To the Blivits!"

"No Paradise": *Santa Barbara Magazine*

"Cecil": *Helix* (an Australian literary magazine)

"Shannon": *Los Angeles Times Magazine*

"The Act of Reading and the Prospect of Loss": Part of a talk given at the Literature Symposium of UCSB's College of Creative Studies.

"First Class": Part of a College of Creative Studies symposium. Afterward published in a little magazine, *You Stamp Little Feet*

Essays and diaries published in *Spectrum:* "The Outsider," "On Reading William Carlos Williams' Story 'The Knife of Times," "The Leveler," "Chaucer's Moral Judgments," "A Short Happy Marriage," "The Scene in the White Hart Inn," "From a Diary," "Diary About My Father."

The *News-Press* obituary of my father was published in the *Santa Barbara News-Press*.

"Boswell, Johnson, Hume—Their Attitudes Towards Death" was read at the College of Creative Studies Literature Symposium. An earlier version was published in *Spectrum*.

Book design and typography:
Eric Larson, Studio E Books, Santa Barbara

Cover illustration:
M. Proenza, "Max and Elaine's House"

Published by John Daniel & Company
A division of Daniel and Daniel, Publishers, Inc.
Post Office Box 2790
McKinleyville, CA 95519
www.danielpublishing.com

LIBRARY OF CONGRESS CATALOGING-IN-PUBLICATION DATA
Schott, Max, (date)
 Keeping warm : selected essays and stories / by Max Schott.
 p. cm.
 ISBN 1-880284-64-2 (pbk. : alk. paper)
 I. Title.
 PS3569.C5263K44 2004
 818'.54—dc22
 2003017907

for Elaine

Contents

KEEPING WARM

No Luck

Not long ago my father pointed out to me that people, if something bad happens to them unexpectedly, will almost always start talking afterward about how lucky they were—lucky that it wasn't worse.

It's so, isn't it? If your brakes fail and you end up in your car in somebody's living room—still alive—you consider yourself lucky. While on the other hand, if your brakes simply fail and you have to get your car fixed, you may very likely consider yourself unlucky. It doesn't make logical sense.

If a brick falls out of the sky and "only" mashes my foot, my mind will very quickly and not very rationally divide the event into two parts. That a brick should enter my life I accept after the fact, as a given. But instead of accepting the fact that it missed my head as another given (or as part of the same one), I see it as good luck. Why so? My father didn't say why. But he at least managed to make our ordinary way of behaving look pretty foolish.

Anyhow, afterward, with that much light thrown on the subject, I figured I would no longer be quite as foolish as I used to be or as other people are. The next time I, or as it turned out, we, escaped with minor wounds from some random catastrophe, I meant to very reasonably curse my luck. Or if I couldn't manage that, at least I'd have enough sense to keep quiet.

It didn't work, of course.

What happened was this: A resilient young friend of ours, and of our daughter, was walking with our daughter. As they were

crossing a relatively quiet street, at the corner, on a green light, a car, turning left, hit Lori. She was bounced up into the air, landed hard on the pavement, got up, found herself to be, roughly speaking, all right—just bruised.

Lori's parents happened not to be home. Our daughter called us. My wife and I went down. A couple of witnesses, young men, very kindly waited around for more than an hour, until the police had come and an accident report had been filed. After that, we went to the Emergency Room, just to make sure. Yes, she was okay—just the few visible bruises. Through it all Lori remained alert and composed. But her face was pale, and her blood pressure, she told us, after the nurse had checked it, was higher than normal for her.

The whole experience couldn't have been much fun. As for me, I kept telling myself that the whole event was (1) a bad event, and (2) an unlikely event; therefore, the whole event was certainly unlucky. But, I kept feeling against my will, that we—the driver of the car, our daughter, Lori's parents—we were all lucky; and that the person who'd got hit by the car of course was the luckiest of all. Lucky Lori. Gee, she could have been badly hurt!

Apparently my father's lesson had not sunk in. Unable to drive these contradictory thoughts and feelings out of my mind, I tried to explain them to my wife. It's hard, though, to explain what you don't understand very well yourself. I made a long statement, about what my father had said. I said that he seemed to be right— people are always, when something bad happens, saying how lucky it was that it wasn't worse. I said that I understood that this was foolish, that I had determined not to do it anymore myself, but that at that very moment, as we were walking along, I still felt that same forbidden thing…. It was a long, incoherent statement that ended somehow with the word fate: "It must have something to do with our feelings about fate."

My wife understood me, and she answered me. I remember exactly where we were, walking along under the trees that border the northwest side of Alameda Park, but her exact words I can't remember. I think she put it so beautifully that I couldn't stand it, and they faded from my mind like a dream. But fate was the key, and I take pride in that.

MAX SCHOTT

She said that we are superstitious, egocentric, justice-loving creatures, and as a result, in regards to our own lives, we can hardly be brought to believe in accident or luck. When a blow falls we secretly believe that it was foreseen or somehow preordained. When it turns out to have been a glancing blow, we're grateful, or feel as if we'd better be. And to propitiate fate, who has shown her strength but has only given us a tap, maybe even saved us, given us at the last moment a reprieve, and might or might not give us another...we bless our good fortune, cross ourselves, knock on wood, promise to be good, and hope, modestly, to live forever.

My Chinese Life

One night about twenty years ago my wife and I and a couple of our kids went to dinner, as we often did, at El Charro, a restaurant at the corner of Santa Barbara and Canon Perdido. Across the street, kitty corner from El Charro, was a small Chinese market, where you could buy almond cookies out of a jar for a nickel a cookie. Our custom was: towards the end of dinner, I'd get up, walk across to the market, and come back with cookies for us all.

It was a ritual. The old Chinese man who ran the place kept the cookie jar—which was huge, you could stick your whole arm into it—on the counter. You'd tell him how many you wanted, he'd take the lid off the jar, you'd reach in and carefully lift out a cookie—while he repeated over and over: "One at a time! One at a time!"

This time when I walked in, the place was even quieter than usual. No one else was in the store. The proprietor was sitting behind the counter, head bent forward, his cheek flat on the wood surface, asleep. That was what I thought at first, but then I saw that he'd actually slumped over not onto the counter but onto his supper plate.

I said something. He raised his head, struggled to his feet and almost fell. I put his arm around my shoulder and we staggered towards the back of the store and through a passageway that led into a sort of kitchen. His wife was sitting at the table. She looked up at the pair of us and said something like "huh!"—Expressing what? —Contempt? Anger? Certainly not surprise. I began to realize that the man was probably only drunk or drugged and that we'd all have

been better off if I'd kept my mouth shut and sneaked away at the very beginning.

Anyway, that's all that happened. The only reason I bring it up is that the experience became dream-like for me almost while it was happening. I remember recrossing the street and telling my family what had happened and why I had no cookies. But the explanation already seemed remote from how it felt to be alone in the quiet of that store, with the man's arm around my shoulder.

Dream-like, I say, and a few nights later I had a dream.

An old Chinese man, blind and sinister, is climbing down some steps into a well, with my daughter Kate under his arm. My little daughter Kate! I can see the surface of the water, into which she will soon disappear. The old man also has—as important to me as my daughter, and nearly as tangible—a secret. To have the secret, and my daughter, it is only necessary that I touch him. He pauses on the lowest step, his feet in the water, waiting. Kate, suspended under his arm like a sack of grain, looks up at me pathetically. If I don't touch him, he and she and the knowledge that he has will all disappear forever. And who will be to blame? I will. And yet, I can't bring myself to move. I'm afraid.

That's all I remember of the dream; maybe it's all there was.

A few weeks ago, I was sitting at a table, outside, in a small shopping mall near U.S.C. I was writing. An old Chinese man with a white beard, odd-looking dark glasses (rather like the celluloid ones they give you to wear for an hour or two while your eyes are dilated), hobbling along with a partly white cane, smiling (I had noticed him earlier and had seen him stop to talk to some other old men), came up close to me, grinned and said, "Mister, you are studious! You are writing a story?"

A good guess. I admitted I was. He began talking very animatedly. I couldn't understand everything he said, but I heard him say "Tolstoy! Hugo!" He had read them. They were great teachers. He twisted his hands, dug an imaginary hole with his cane, and talked, nodding. "Base," he said. "Idea." "Teach."

"Yes," I said, nodding. "I love Tolstoy."

"Base..." by which he meant a base to build from, because he

went on to say, "...idea of a human being. From there...extend that idea to..."

"Yes, yes," I said, feeling we were both terribly profound. And I still believe that he was.

"Thank!" he said, lifting his cane, waving it, grinning, and walked off (not painfully I hope, but it looked like it.)

And he too, within hours, became like a dream dreamed over in my mind.

Why should the mysteries of my very unChinese life be Chinese? When I was a child I was told, like other children, that if you dig a hole deep enough you will come out on the other side of the earth and that the people you see there walking upside down, will be Chinese. Maybe the image took hold.

Readers

It's hard to tell at a glance who are the real readers, or maybe I should say the ideal readers, the ones who just read to be reading—because they like it. That good looking boy over there is reading. In fact he has three books, all open, and is writing too. But I'd guess he probably has ulterior motives, and not very interesting ones—an exam to pass, a paper to write.

But that girl at the table over by the window, she has a book in her hand, and no other paraphernalia—a good sign, and she seems absorbed. When she was little, I'll bet her relatives would say, "She's a reader. Always has a book in her hand." It starts early. And later on, at twelve, fourteen, sixteen, she remained just as book hungry, if she really is a reader. She not only out-read her teachers (which might not be saying much), but out-read her fellow students too. Omnivorous, she read any and everything, read like the wind blows—in every direction. As a result, maybe she didn't do too well in school.

And then, to continue the story, maybe people even began to tell her that reading like that, for no purpose, would never get her anywhere. And she, looking sulky, would say nothing, but just go on reading. I like to think of her as being intractable. But on the other hand, it's true, they were right, it won't get you anywhere; it may even make you wonder if there's anywhere to get. Anyhow, look how intent she is, I hope she'll stay that way, all her life. But the fact that it's even necessary to hope, casts a shadow of a doubt.

Reading—a reader's reading—is either a love affair or nothing. And love affairs don't always last.

Especially not if something better comes along. I remember a threesome—two brothers and the wife of one of them. The ranch they lived on was 70 miles from a paved road, and their own road was impassable when it was wet. From late fall till early spring they were ranch bound. So to pass the evenings they kept on hand a big pile of pulp magazines, mostly *True West* and *Ranch Romances*, and these they read—for their own pleasure and no other reason—night after night, winter after winter. Readers, surely!

Then around 1955 a television broadcasting station came to the nearest fair sized town. You know the rest of the story. When choices proliferate, new tastes emerge, and the old ones drop away or alter. They bought a TV set, stuck an antenna up on the house roof, started up the generator, plugged the thing in, and were instant and happy converts.

One night they were punished, though, for their apostasy. It was during a thunderstorm. The three of them had gathered around the new shrine, pleased to be getting, in such weather, a fair kind of a picture on the screen, when a burst of lightning and thunder (simultaneous—it was right on them) rattled the house, and afterward an odd smell—too bitter for ozone—filled the room. The innards of the TV had melted. So it was back to the magazines for the rest of the winter. But it wasn't the same anymore, as they were quick enough to admit.

I admit, I have a bias in favor of reading. But it's just a bias. Why be fussy? Avoid books if you prefer to, and if you happen to get stuck with one, enjoy it any way you can.

I had a student, for example, who got pleasure out of setting one of his assigned texts (Gertrude Stein's autobiography) on fire, and then got pleasure again out of telling the class about it. His only remaining complaint was that it was hard to get it to burn.

And at the Victoria Street Theater one night, a whole audience, including myself, enjoyed a book together, without even dreaming of reading it. These were nearly all young, healthy, lively looking

MAX SCHOTT

people—high spirited too—there to watch a ski movie. Before the movie started, there was a drawing for some door prizes. A young man jumped up on the stage, drew a name out of a hat. "The first winner is…(a girl's name)." "Hooray," people shouted, nearly the whole audience, and clapped. "And the prize is…a book!" He held it up, a nice little thin book. Boos, hisses, catcalls. You couldn't even hear the title.

It was fun. But if you're reading this, you probably weren't there.

No Paradise

Santa Barbara a peaceful, tranquil place? If you ask me, no place is. Ever since I read a bit of Darwin, thirty years ago, I've believed that a close look at any spot of earth will reveal a busy, chancy, hard-living, sometimes lovely, often surprising universe. (One of Darwin's attractively modest experiments was to take a tiny piece of bare earth, just three-feet-by-two, where he allowed the weeds to come up freely. "I marked all the seedlings of our native weeds as they came up," he writes, and then goes on: "And out of 357 no less than 295 were destroyed.") There are no peaceful, tranquil places, and people who think there are, are kidding themselves. Though I suppose it could be argued that Santa Barbara at least is an easy place to kid yourself about.

But I'm against being lulled into believing that the world is different from how it is. A few days ago when I was starting to walk past the pond near our house, I noticed seven or eight turtles out on the bank sunning themselves. As I came closer, all but one stayed where they were. But he plopped off into the water at my approach and swam as fast as he could go, right to the bottom of the pond, where I saw him disappear into the green muck. He figured I was his enemy. He may have been mistaken, but I think he had, generally speaking, the right idea. At any rate, he's my kind of turtle and lives in a place that doesn't seem peaceful and tranquil to him, however it may seem to his neighbors.

But people do kid themselves, and many have been eager enough to kid themselves about Santa Barbara. Santa Barbara,

they say, is lotusland—a benign and dream inducing pla[...] does this particular myth come from?

I think it originally came from the East Coast and that the [...] ple who first peddled it were good—or at least handy—with word[...] spreaders of culture. Such people, when they arrive in Santa Barbara, or Southern California, discover a place where there is great social mobility, an absence of formality, a relatively non-violent climate, an attractive landscape, an ocean that is not too cold to dip your foot in. Life looks soft, free, and easy to them here, and they begin to furnish the place with their own fantasies: universal love, instant friendship, easy inspiration, effortless accomplishment, riskless adventure....

I suggest that any new Santa Barbaran who happens to be in danger of succumbing to those kinds of illusions be given a job working outdoors up in our not-so-gentle hills. If this were done, then I think the myth of lotusland would die the many happy deaths it deserves. The reason I come up with this particular form of education is because I remember what it was like for the cowboys who came here to work from other parts of the country.

These were experienced men, used to riding hard after cattle over difficult ground in nearly every kind of weather. But our terrain and climate were alien to them. They were used to rocky or sandy desert, to juniper flats, mountain meadow, open prairie. Here they had to ride up and down steep clay hillsides where the ground was hard and rough as cobblestones (or in wet weather, slick as glass), and riddled with squirrel- and gopher- and even badger-holes, and broken by steep-sided ravines and canyons full of thick brush that was higher than your head. If the cowboy had brought with him his own horse, raised somewhere else, the horse stumbled, sometimes nearly at every step. If he was lucky enough to get on a good locally raised horse, then he was likely to have more of a ride than he was ready for, when that horse took off after a half-wild cow. I've seen these men's faces turn white as a frightened child's, and they weren't ashamed to admit it afterwards.

And the thick fogs, too, which cling to the hills and make it impossible to see past your horse's head, are strange and awesome to the newcomer. The oaks, or even the single branch of an oak, will

seem to be in motion, and if the fog thins a
trees take on queer shapes, like maimed
here you are going, and stop, and have a
the new man's face, you're likely to see re-

later, when the hills have got terribly dry
while the cows are still inexplicably fat, the
...... is mystified, till someone shows him that the clover burrs
which disappeared from the visible landscape weeks ago, are lying
in the ravines like grain in a trough, and that it's these the cattle
have been feeding on. The man is interested and surprised, and
gradually he has come to know the place. When the earth quakes
or the hills burn, these are yet more aspects for him to take in. And
he says to himself, though probably not in these words: "Yes, this
place is different. It has its own ways of being harsh, troublesome,
eerie, benevolent, dangerous, beautiful."

So I don't live in Paradise or want to, but I do live *here*, and I
ask myself: Why? Why here out of all the world? It's the kind of
question nobody cares about the answer to, except me. But it's also
the kind we're all always asking ourselves: How did I come to be
where I am?

In my case, a perfectly mundane answer would go like this: In
1963 I started working on a ranch in the Santa Ynez Valley. In 1965
I went from there to the nearest university. Someone at the univer-
sity eventually offered me a job, teaching. And since nobody any-
where else ever offered me a better one, or even another one, I
never left.

But it's hard not to feel that our lives are more fateful than that,
less ruled by accident. We long to believe—and sometimes do be-
lieve—that we are wherever we are because we belong there:
some guiding hand has moved us, or some design or fate has got us
into its web. And it's the same way with places that mean a lot to us
as it is with people—one or two people maybe. I met the woman in
my life by accident, it seems. And yet, how can it be an accident?
How could I *not* have met her? Could she be anyone but who she
is?

In the same way, I can't help believing or feeling that this place,

this town or bit of countryside, got its hold on me long before I was aware of it, and that I'm here as the result of a choice—a choice made partly for me, partly by me, made, maybe, as long ago as the first time I ever came here, as a child.

I hadn't read Darwin, but one thing I discover when I think back is that it was not a peaceful place for me then, either.

This isn't because anything traumatic happened. I was born and grew up in Los Angeles. My father's father and stepmother had a beach house just south of Santa Barbara, on Padaro Lane. I don't remember how old I was when I was first taken there—maybe seven—but I remember the experience. In memory at least, it is uncluttered by nuance, utterly simple—and I believe it was that way at the time. Everything about the place seemed to me huge, loud, relentless, full of power.

Before you even got to the house, there were the railroad tracks, which I remember as going right through my grandmother's garden (which was a sharp prickly affair, and half-covered with gravel—not a place to play in). I had a vague fear that a train would rush up and crush us. Then, at the door, there was the dog, a big Russian wolfhound, who my father told us had once taken a whole turkey from the platter; then there were my grandparents, my grandfather, a self-made millionaire whom everybody seemed to worship and be afraid of, and my grandmother who was queenly and austere and sat me down in front of her and questioned me—intending no doubt to be friendly.

From the inside of the house you could hear the waves crashing and see the foam flying. When you went out you saw and heard that they were crashing—and crashing and crashing—against the huge boulders that—as I came to understand—had somehow—by the combined power of my grandfather's money and my grandmother's will—been deposited there between the house and the sea. I was overawed and fascinated by the place—but not frightened. The people frightened me, and the dog, but not the place.

And what astonished me most of all was the train. When I was left in a square, immaculate little room near the garden, to take my afternoon nap, I forgot entirely about the railroad tracks and what they might signify. I fell asleep, and in my sleep the whole world

began to roar and shake—I didn't know whether I was dead or alive or who or what or where I was. But it went on for a long while, and I finally figured out or realized—a train!—shaking me and my bed and the whole house! I was delighted. And a bit of that feeling has stayed with me, as it does with us all. The world is a place that can astonish you, and the parts of it that have astonished you, you might well wish to come back to.

MAX SCHOTT

Jill

I was looking for a subject. I knew, in a vague sort of way, that that wasn't a good sign. When you're in a condition to really write, subjects, ideas, images, characters, buzz around your head like mosquitoes: you have to fend them off.

Still, that was how it was. I had obligated myself, for better or worse, to write a newspaper column, and I was wandering around, this particular Saturday, looking for a subject.

As I walked past an outdoor cafe I heard a woman's voice. "It's my third day here," she said, "—and my third day *here!*" I turned to look. Middle-aged, evidently from out of town, brightly dressed, she was speaking to a waitress, who smiled now and said, "Yes, it's a lovely restaurant, I'm glad to be working here."

The waitress was articulate and polite, but the woman was almost effervescent, her spirits were so high. I felt my own spirits lift and asked myself why. Because I was tickled by her delight? But then, walking away, I thought, "No, that's not right. It's her way of *expressing* her delight that pleases me. What was it she said? "…my third day here, and my third day *here!*"—simple enough, anybody could've said it. "But that's the point!" I said to myself. "That's the point: The feeling, the delight she takes, is her own but the mode of expression, the words that come out of her mouth, even the order of the words—belongs to us all."

The unoriginal thought struck me as a revelation, no doubt because I needed one. Anyhow, suddenly I was…on the verge of having a subject to write about.

But, when I settled down a little and asked myself, please, to be more explicit, I found I was still in a bit of a fog. I didn't *quite* have a subject, if I couldn't say what it was. But at least I could begin to see (I thought) what the column would look like, feel like. It would be crammed with snippets, that was certain, filled with little bits of talk that I would bring in safely out of the air. Nothing longer than a sentence: that would be the rule. The connections, the idea, the analysis, would come. All I had to do now was sit down in a coffee shop, write down what the woman said before I forgot, then go wander around again listening.

On the way to the coffee shop I walked by the patio of another café. A bunch of tables had been shoved together to make one long table, at the head of which sat a teacherly looking man who was facing a double row of adolescent boys. The boys looked so self-conscious and glum sitting there that I stopped. "Biodiversity," the man said, "spaceship-earth," "a key concept." The bits of jargon hung in the air; two or three of the boys nodded.

"Well, I will use that too," I thought. "Dead snippets have their part to play, too."

It seemed to me that I knew now what my subject was: I would write about the bits of speech, living and dead, that define us, in spite of ourselves, to anyone who will listen. I thought, "Stick to that, and the thing will write itself!"

The coffee shop was nearly empty. There was a girl sitting at a table by herself, and a little farther away, a couple of girls sitting together. I started writing.

The girl sitting by herself was facing away from me. She wasn't eating or drinking or doing anything. She sat sort of slouched, with her head bent forward. There was nothing on the table but a set of keys, which she pushed around a little. She had a lot of hair, and some of it was hanging over her face.

The other two girls were talking to each other. I couldn't hear what they were saying, and didn't really want to. But after a few minutes one of them called over to the first girl, called her by name: "Jill, why are you just sitting there looking weird?"

Jill explained, in a voice that sounded as unenergetic as she looked, that there were two delivery trucks parked behind her car,

MAX SCHOTT

so she couldn't leave. There was nothing interesting in this to me, even as a snippet.

"Tell them to move," one of the girls said.

"Should I tell them to move?" Jill asked.

"Sure, tell them to move!"

This didn't inspire any radical activity, though, on Jill's part. She just went on sitting there, pushing her keys around. But after a while she called over to one of the two girls, saying she'd heard some guys talking favorably about her. The girl laughed. But Jill seemed to subside again, maybe into thought, because after a long moment she said, to the same girl, "If I was a guy I'd want to fuck you."

The girl receiving the compliment didn't reply, and after another little silence Jill went on philosophically: "If I was a guy I'd want to fuck every girl I saw. If I was a guy I wouldn't want to have a girlfriend. Why would I want the hassle?"

The other of the two girls asked her rather dryly why she didn't just adopt the same attitude, as a girl.

"Nah. I'm a girl. So there's a little thing called love, and all that shit. I'm sentimental."

By this time I'd begun trying to write down everything she said.

Just then a boy came into the place from the back, walked over, said "Hi, Jill," and bent down as if to kiss her.

"Hi, I'm sick," she said, and turned a little away.

"That's all right," he said, kissing her.

She didn't resist, and didn't respond, either. "Lots of guys say that" she said to him. "I say I'm sick, they say it's all right, and then they're in bed for three days."

"That's all right," he said.

When he'd gone away, she turned again to the two girls. "That happens all the time," she said.

"What?"

"You know. When you say, 'I'm sick,' and then they get near you and they get sick."

Afterwards I asked myself why she'd been so distracting. Why she was, in fact, still distracting—even when she was no longer there and I was trying to go "back to the subject." She had either

ruined my column or taken it over. What made her so interesting to me? I found it hard to say. She was…unlike anybody else, but you can say that about anyone. She was unconscious, but lots of people are. She was lackadaisical—at least when she was sick. Outspoken? Forthright? That was better. Forthright was at least a part of what she was. But all these little definitions and ideas coming into my mind reduced her and made me feel dull. It was the girl herself who ought to be the subject, not anyone's ideas about her. But how do you catch her in the act of being herself and get it down on the page? That would be a subject too.

MAX SCHOTT

Parents' Orientation

It used to be that every fall out at UCSB I'd watch parents wandering around campus with their freshman children, and I'd look at the parents and think something like "Well, your children will be well rid of you, and the sooner the better!"

That's how it was in the past. But from now on, at least till I stop feeling sorry for myself, I'm going to have a little more sympathy for the older generation. My wife and I have just sent our youngest child off to college, way off, all the way to Ohio, or to be more exact we went with her, then came home to a too-quiet house.

We'd planned just to put her on the plane and let her fly away by herself, but we chickened out. As my wife put it: To have our daughter gone would be in itself hard enough—but to have her gone and not to even be able to imagine the place where she was?

So we went, and suffered, and saw others suffering. It's an odd kind of suffering. We send them off willingly after all; we are even willing to pay for it. And it's the kind of suffering that has many pleasures associated with it. But the sense of loss is real. And the loss is in some ways permanent. The person who comes back on vacations and breaks will never have—should never have—the same relations with us as the person who went away.

There at the college, at a large parents' orientation meeting, we were all—some 500 or so of us—addressed by a woman from the Department of Psychological Services. She told us that many of us were feeling now, and nearly all of us would feel later, a sort of bereavement. But this boat that we were all in together, though it

might list and leak, would not ultimately sink, and the shore that it would finally reach would be the shore of a good land, where we could start afresh, unencumbered.

And she told us a joke. Three wise men gather together to answer the question: When does life begin?

The first wise man, a priest, says, "At conception."

The second, a minister, says something more wishy-washy and profound. (Which helps delay the punch line.)

The third, a rabbi, says: "You're both wrong. Life begins when the last kid moves out of the house and the dog dies."

Ha ha. We laughed ruefully. How did she figure out that we all had dogs at home so old they were barely still alive? We were all in this together for sure. It was better than church.

But, then, we were on our own again.

The next evening I was sitting at a sidewalk table. Just across the street was a grass-covered square, dotted with trees. A few people, most of them students, were walking on the grass. I just sat and looked, feeling...I was going to say, content, but that's not quite right. When I'm by myself I lose track of my own state of mind, or don't have one. Anyhow, I was sitting there, rather peaceful and carrot-like, when I recognized—it was twilight and so humid that everything looked oddly granular—I recognized my daughter and her friend, walking at an angle across the grass, moving away from me.

They walked a little ways and then sat down under a tree. I could tell, from the attitudes of their bodies, that they were talking. "I wonder what they're talking about?" I thought. And then I wondered, in a dreamy way, how could they possibly have anything to talk about at all, when they were so far away from me. If I could neither hear them nor imagine what they were saying, it seemed improbable that they could continue on so easily. But they did. I could see them. But even that was changing. They were becoming dimmer, and it occurred to me, that if I had not seen them walking earlier, but only saw them now, I wouldn't know who they were. At about this point I realized that my feelings were running away with my thoughts, that I was experiencing a rather morbid symbolic vision of separation, though the objects in it were real. My daughter's

MAX SCHOTT

friend lay down flat on her back in the grass. My daughter tossed a piece of paper toward her friend. It fluttered, white and bright and square, and broke up the vague obscurity of the day, almost like a sharp sound. They got up together and walked off.

From that moment on, I don't quite know why, I think I felt better.

Also visible from where I was sitting—it was imbedded in the grass at the edge of the square, so that everyone walking along the main street of the little town could see it—was a rock about the size of an armchair. I noticed that there were some words painted on it, but I must have been too befuddled to take in what they were.

It was only on the plane coming home that a friend, who, with his wife had been on the same errand to the same place, and who had heard the same jokes and experienced the same feelings, asked me, "Did you notice what was painted on the rock at the edge of the square?"

"No, I saw the rock, but—what did it say?"

"*Pay* and *leave*," he said, and we both laughed.

The Violin Gods

There's a kind of mystery in the sacrifices people make, and in the transformation they undergo, in order to be or to try to be performing artists—dancers say, or musicians.

In the old days if there was a mystery, you got to postulate a god, or better yet, several. The ballet god, the violin god... If we characterize them by the behavior of their followers, these gods are insatiable and also terribly fussy. Most of what is brought to them they try out and then send back. "Not good enough! Good, but not good enough. Go back. Try harder. Bring us more. Bring us others."

And the young aspirants, how devoted they are (though in their spare time they complain and grumble), how devoted and persistent they are—and how unlike themselves they become in the gods' service!

Unlike themselves? It sounds irritatingly mystical. But I swear there is a transformation—at moments there is. Jacqueline Du Pre's mother tries to describe it. There was the little girl who behaved like an ordinary little girl, and the other one, who sat behind the too-large cello. They were different from each other. We will have to take her word for it.

In Suzanne Farrell we can almost see it for ourselves. The woman we see dance seems to be inside what she does. The woman who talks and writes about what it's like to dance seems to be almost as far outside the activity as we are. There is an absolute separation, or it appears so.

These are extreme cases. They make the gods happy.

I imagine there are lots of more modest examples of the same kind of homage. I know that in my own life I've been witness to one of them.

My daughter takes violin lessons. She's eighteen, and her teacher, a woman, is only twenty-one. My daughter, like most of the human race, doesn't take well to being bossed around. Her teacher, in ordinary life, is not in the least bossy. She is unassuming, pleasantly deferent, willing to gossip, quick to laugh, never calls any attention to herself.

But in lessons, these people are not themselves.

Sometimes, at these lessons, I write down what's happening. For example this is from a letter. "…Just now I'm sitting in a soundproof practice room near USC. Anna is having a violin lesson—playing away pretty violently while her teacher shouts corrections and objections over the noise. 'You put too much weight on the E! It's very flat! You put too much weight on the E! Flat! Don't lose your tempo! This is *crescendo*. It says *crescendo*. No dips! Keep going. Are you reaching for this? Don't give up! Go! Flat, flat, flat. You can't lose your tempo. Do you know what the rhythm is?'"

The work is hard, the intensity of the instruction is amazing; the responses by the student are immediate; and this goes on for a quarter of an hour at a time without even a pause, and often for two hours without a break.

"Make it simple, it's too busy. Don't give up, I don't see any diminuendos in there. You can't let up your intensity anywhere. No—*crescendo*, *crescendo*.

"Don't rush them. That sounds like a diminuendo to me. Good. That's good. Sounds good. Don't give up. Good. Good. Same place one more time…Nobody's going to hear you. It says forte. It doesn't have to be an aggressive forte but…Then it says softer. How are you going to get softer? Nobody's going to hear you…That means do something. It's *full*, it's calm but it's full. Watch your vibrato now, it's too wobbly, it's too wo-ob-obly."

Then to my surprise, Anna's teacher turns to me and says (when Anna can't hear): "This is hard, this is very hard, she's doing a very

good job," then back to Anna: "It's flat, flat, flat," then a moment later: "It sounds good." A good lesson! Everybody is pleased. Sometimes it doesn't go so well. "That's gotta be…" (demonstrating), and then Anna tries it. "But they don't have intensity. They're lazy sounding." (Anna plays.) "I don't know what you're doing. I don't hear the G-sharp."(Anna plays.) "Again. Really bring out the G-sharp." (Anna plays.) "Okay, and you've gotta save, here, and then…" (Anna plays.) "Right…okay, but the pianissimo is here, not here." (Anna plays.) "Better. Why's it messy? That fourth finger…" (Anna plays.) "No, it's lazy." And a little later. "*Don't* kill the harmonic. *Please* don't kill the harmonic…. You gotta stop it around here and then you gotta start doing this again. It's a trick, okay? It's an illusion. This is not an interesting part all by itself, okay? But you've gotta make it something that people are going to want to listen to." (Anna plays.) "That's a backwards bowing." (Anna plays.) "No. One! Two one two. This second beat has gotta be in relation to what you just did." (Anna plays.) "Vibrato! Don't slow down! Flat! I lost the tempo already. Start again."

And so, she starts again.

MAX SCHOTT

Shannon

Culver City, in those days—forty-five years ago—was nearly as urban in spirit as it is now. But there were still bits of unoccupied land, including especially the riverbed, where the young people who hung around Jute Smith's Sunset Stables could ride.

But I didn't know much about it. I was a boy of twelve then, and my home and Ben's stables were in Brentwood. The Sunset Stables kids I knew about mostly by hearsay. They were wilder and braver than me—I believed that before I saw them and was sure of it afterward. The girls in particular lived on in my imagination like dream people, though I actually only saw them perform once.

It was at a Junior Rodeo, put on by the kids themselves, in a little ramshackle arena that they themselves had built. Ben and his girlfriend Toni had taken me there, and I was sitting with them in the small, not very full grandstand. Everything from the fences to the horses, had an air of makeshift. The kids around there weren't rich. No one sent them to have riding lessons or rented or bought horses for them to ride. Everything they knew, they'd taught each other. And the horses that Nicky and Shannon rode as often as not were borrowed and sometimes were just taken out of a stall and used when the owner wasn't around. But Nicky and Shannon were only names to me, which I heard again from the grandstand, electrified, out in the air, called out by the announcer, a boy of fifteen or sixteen: "Nicky and Shannon, come to the track, you're up! Nicky and Shannon!"

The two girls came out on the track, each standing with her feet

spread on the moving backs of two unmatched, half-trained horses, holding a whole fistful of reins in one hand and a whip in the other. "Why, they're no more than children!" Ben said, and it was true. Then they raced, all the way round the track, laughing and calling out to one another. But before they got to the stretch in front of the grandstand, we saw one pair of horses spread apart, gradually, spreading the girl's legs wider and wider, till she dropped between, disappeared, then reappeared rolling in the dust, scrambled to her feet and wiped away a tear with the back of a dirty arm. The other girl finished, jockeyed her horses to a stop, circled them around, and went back toward her friend. Two boys ran out to intercept the pair of loose horses, and within minutes I saw the fallen one— Nicky or Shannon, I couldn't tell one from the other—laughing again, ruefully; and within a few more minutes, they were racing again, back up on the same horses.

And later in the afternoon, they came out with a smaller, gentler horse that would lope in a straight line without urging and that didn't mind things or people flapping around near its feet, and one of the girls lay suspended back over the horse's rump as it ran, with her feet hooked in straps high on the skirts of the saddle, and her hair almost brushing the ground behind the clicking hoofs—while her friend shouted encouragement or advice from the other side of the track.

And those were the kinds of things they would practice along the dry, sandy bed of the river on weekday afternoons, till Nicky was dragged to death there one day, with Shannon watching—just the two girls alone. I sat on a bench out in front of the office at Ben's stables and heard him and his brother talk about it. Ben used words like "fate" and phrases like "a crying shame," and his brother said, "They were told, weren't they?"

"Told what?" Ben said, already irritated.

"Told what to do and not to do. Jute told me they were told a hundred times not to go down on that riverbed by themselves and pull off stunts like that on horses that weren't trained for it."

Ben turned his face away from his brother and said to me, or toward me: "That other child, poor thing, I feel almost sorrier for her than for the one that's gone."

MAX SCHOTT

"Crocodile tears," Clyde said. "You don't know either one of them."

When I got home from the stables, I looked in the past few days' newspapers till I found a paragraph on an inside page, "Fatal Accident," which I read and cut out to take to junior high next day as a current event for my social studies class. But nobody paid much attention to it when the teacher read it out loud with the others, and she told me quietly afterward that she preferred national, or better yet international, current events.

Still, all told it was a grand thing to think about, and I liked to imagine the suffering of the "other" girl too, so I could pity her, like Ben.

With the thrill still not worn off—it must have been the same week—I heard Frosty Straight, a friend of Ben's, say that the other girl had "cried like a waterfall" for two days at home then gone back to the stables, jumped up on somebody's horse and started doing handstands. But Jute's attorney had heard about that and told Jute he'd better put a stop to it.

A week or so more passed. Then one afternoon, it turned out Clyde was right: We didn't know her, didn't even know who she was when she came walking around the corner of the barn, a small, trim-looking girl, neat as a pin in her beltless jeans and moccasins and tucked-in white shirt, dark hair pulled back and braided in a single braid. In spite of the adolescent breasts and hips, she was no bigger than I was; I doubt if she weighed ninety pounds, and, catlike, she didn't seem to take up any more space than the space she actually filled, which was so little it made it easy not to take her much into account. And Ben didn't at first. But he had a policy of being civil to children, partly because Clyde usually wasn't.

It was a weekday afternoon, a sunny spring day after school. There was nobody out in front of the office but Ben and me, Ben sitting on one bench with the daybook in his hand, about to look and see what reservations there were, and I on the other bench, just basking in his presence.

Ben got to his feet. "Can I help you, sweetheart?"

"How much does it cost to ride here?" She didn't come up very

close but stood over by the hitch rail, where there were a couple of saddled horses tied.

"A dollar-fifty an hour. There's the sign, you see." Ben was tall and all made up of angles. He tilted his head toward the sign on the wall and then again toward her. She walked over in front of us and looked up at the sign.

"Would you like to rent a horse?" he said.

"Not today. I was just curious, if that's all right."

"That's fine," he said. "Do you live around here close? I didn't hear a car pull up."

She shook her head and her brow creased.

He smiled down at her. "Then you must have walked all the way up that hill. Not many people would do that, just to see what the price is."

I looked at her brown eyes, which looked back at me once, as if I were part of the furniture. They were luminous and clear but not bright and not inviting—you couldn't see your way into them. She started to turn as if she would walk away, but turned again and said, "Is it all right if I sit on the fence, then, and look at the horses—"

Ben started to answer, and she went on "or do you charge for that too around here?"

Ben straightened up—she came only to his chest—then lowered his chin. "Honey, what we don't do is talk like that here. I don't to you, and you don't to me. Yes, you may look at the horses."

"Thank you," she said, walked over to the fence of the big rent-horse corral, climbed up and sat on the top two–by–six with her back to us, and looked out at the horses. They were mostly standing idle, with their heads low and their hips cocked, only their tails occasionally slashing the air.

Ben was or tried to be amused. "What kind of manners do people raise their children to have nowadays? I don't know, son, do you?" He said this all in a pretty loud voice.

"No," I said, looking at her back and hoping she wouldn't hear me.

He lowered his voice then and said, "What made her take against me that way?"

"I don't know," I said.

"Do you suppose she wanted me to let her ride for free?"

"I don't know," I said.

"I'll bet she lives right around the corner there, and her folks could buy and sell me twice a day—little slip of a smart aleck thing! Cute as a bug's ear, too, isn't she, son? We should have told her 'Yes, there's a parking fee, hourly, on the fence.'" And he laughed. Yet she'd got under his hide a little.

She sat without moving, and he turned again to his daybook, found he'd left his glasses up at the house, handed the book to me and listened as I began to read out what the reservations were for the next day: "Captain and Lady at nine in the morning for Mr. Gregorius and his daughter. Strick and Sonny at four for a riding lesson for the—"

The office door opened. Clyde stood in the doorway, stretching and yawning. Ben looked up at him, grinned, stretched his right leg out, fished in his watch pocket and held the watch up in front of Clyde, who wouldn't look at it. "You just woke up in time for your nap," Ben said.

Clyde moved his head. "Do you see that little girl, standing on the fence?"

We turned. She was walking along the two–inch wide edge of the top board. "I've seen her one time too many," Ben said then hollered in his loudest voice, "You want to *break your neck*? Get down off of there!"

She walked six or seven feet to the next post, hopped up on the flat top of that and jumped off, hardly stirring the dust when she landed. Without looking back, she started walking down the road.

"She's seen all she wants of you, too—seems to be leaving."

"My heart's broken."

"Do you know who she is?"

"Who does she *think* she is, that's what I want to know."

"She's the one you've been feeling so sorry for."

"I'll give her something to feel sorry for, across my knee, if she—you said what?"

We watched her head bob away out of sight down the hill.

"I say, she's the one who you said's worse off than her buddy who's dead."

"No? Damn you, I'll bet you're right for once."

"And that's one bet you'll win, if you can find anybody to bet with."

Ben got to his feet, looking off after her and still talking: "I understand now.... They ran her off from the other stables, so she came here, and we.... Damn me, anyway!" He took off in long strides down the hill.

"If she breaks and runs, I'd like to see him chase her. Oh, well, shall we start doing some of these chores while he's off playing?"

Clyde and I were up farther on the hill, forking hay into the long manger for the rent–horses that lined up to eat amid much kicking and biting, when we saw Ben coming back and stopped to watch. He wasn't breathing hard. "Did you catch her?" I said.

He laughed, "I couldn't have if she didn't want to be caught, the little vixen."

"What did you tell her?"

"I didn't tell her anything, I asked her. We patched it up, though, I believe. She said she might come up tomorrow and ride, if we're nice to her."

"Paid for by—?" Clyde said.

"Why, you, brother, and me. After tomorrow, we'll have to figure something out. Would you like to have her for a helper, son?"

I blushed and said, "What horse will she ride?"

"Well...what's the best horse in the rent–string for somebody who likes to ride upside down? Dusty? He'd tolerate that, maybe."

It wasn't so simple, though. She came up the next day and rode, but she didn't stay out very long, and she didn't seem to enjoy it. Favors–done wasn't the air she liked to breathe, evidently. She called Ben "Mr. Webber," me nothing at all and would hardly even raise her eyes to look at Clyde.

When she was putting the horse back into the corral, Ben slipped through the gate behind her. It was a heavy wooden gate with baling–wire hinges; he dragged it shut and must have thought he had her more or less cornered, inside the corral, and she did stop and talk—or listen. I could see his head tilted, chin raised, and

MAX SCHOTT

every now and then she shook her head; the end of her braid would shake too, as if it could say no by itself.

A car pulled up into the lot. A short, solid–looking man got out and stood looking up toward the barn. "Goodbye, Mr. Webber. I have to go. There's my father. Thanks." She climbed between two boards of the fence that were about eight inches apart, and ran, leaving Ben holding the bridle.

He still managed to laugh. "Well, son," he said, "I asked her if she'd like to help us in exchange for having a horse to ride sometimes, and she said no. So then I said, 'Like that boy there does. He works for rides, and he seems to enjoy the work almost as much as he does the riding.' And she took one look at you and said double no." Ben saw the look on my face. "I'm just joshing you, son. But she did say no. That message came through pretty clear."

"Why?"

"I don't know why she doesn't want to work to ride. Maybe it's because she and her friend never had to. They just took a horse and rode. Or maybe it smells like charity to her. She didn't seem to enjoy her free ride, did she? But chances are she won't be back, so we won't have to worry about it."

She was back the next day. She walked around here and there, looked inside the office, which was mostly full of saddles, looked inside the tack room, poked her head into the grain bin, then spent half an hour chatting up two or three of the privately owned horses that were kept in stalls, rubbing their necks. Then she went over to the rent-horse corral again, but further up the hill this time, away from the barnyard, up by where the water barrels were, to sit on the fence. And nobody bothered her.

Even when Ben went up to fill the water barrels (me trailing along, to help), he wasn't going to do any more than nod to her. But this time she jumped down right away and started a conversation.

"Mr. Webber?"

"Yes, ma'am?" He sank the end of the hose into the water so he could hear.

"Do you know Mr. Watkins?"

"Watkins? I don't know. I might. Who is he?"

"Have you heard of Watkins Chevrolet?"

"On the radio, I have."

"Do you know Mr. Watkins, though?"

"That Watkins? No."

"I do. He's my uncle on my mother's side."

That was the beginning, and I think he already didn't believe her. "Well, that's good, sweetheart. Everybody'd like to have a rich uncle. I know I would, if he'd give me anything."

"He wants to buy me a horse."

"Well…good," Ben said.

"He wants me to pick one out."

"Well…that's good too. I'm glad to hear it. But you don't want to depend too much just on what you *hope* will happen."

"I know," she said. "But he does."

Afterward, Ben shook his head. And later, when she'd gone home, I heard him say—not to me, but to Toni—that it was a ticklish business, because he thought the little girl was lying, but he wasn't sure, and then he said that if he was sure, it would still be a ticklish business.

Toni laughed and said, "The world better watch out for *that* girl. In fact, *I'd* better watch out for her."

"Afraid not," Ben said.

"He says, wistfully," Toni said.

Even though she always came straight from school (carrying her school clothes in a paper bag), and I always went home first, still she would get to the stables later than me, because she had farther to come on the bus and farther to walk. Ben and I were cleaning stalls, a couple of days after she'd talked to him the first time about her uncle. Ben was sweating, bent double over a short handled, wide barreled shovel. She appeared at the stall door, looking as if she'd just stepped out of a bandbox—as if nothing in this world had ever touched her. He stopped and straightened up and wiped his brow, while I stood back in the deep shade, as if I wasn't there, which I wasn't, to her.

"Mr. Webber, my uncle wants me to have a horse *for sure*," she said.

"Oh? Did you see him, then?"

"He wrote it in a letter."

MAX SCHOTT

"And when is this horse-buying going to take place?"

"He's on a trip, a business trip. When he comes back he's going to pay you."

"Me? When he comes back from...buying Chevrolets, I imagine."

"I know," she said. "But he wants me to have the horse first—because he won't be back for a while."

Ben paused. He didn't ask any of the obvious things, that even I thought of, to trick or trap her, but whether he was right or wrong not to, who knows.

"He wants me to have the horse now," she said. "I can show you the letter."

"No, you just hang on to the letter, honey. You say he wants you to have the horse—what does he mean, exactly?"

"To keep here in a stall, for me to ride."

"I see. For you and nobody else to ride."

"If it's my horse, nobody else could ride him if I didn't let them—and I wouldn't."

"I don't blame you. I wouldn't either," Ben said. "Especially if I could do tricks on him."

"No," she said.

"So then when he comes back, this uncle of yours, he'll pay the board bill plus the purchase price—is that right?"

She nodded.

"But doesn't he want to know how much the horse will cost, before he agrees to buy it?"

"He wants me to find that out," she said.

"And which horse did you have in mind?"

"Dusty," she said.

"Well, he'd run your uncle about two hundred dollars, and the board bill is either fifteen or twenty dollars a month. Do you want him fed grain or only hay?"

"We want him fed grain," she said.

"All right. And it'll take a letter a little while to get to your uncle, and another while for him to write back. Would you like to move the horse into a stall before that—this evening, say—and we'll put it on the books for tomorrow?"

She said, "Yes," but didn't move.

"Was there something more?" Ben said.

No, it was the shock of accomplishment, and disbelief. "Take a halter," he said. "You go with her, son. Bring Dusty down and put him in a stall. You show her which ones there are to choose from."

So I showed her, and she was friendlier to me then, and from then on, than she ever had been before. It was as if she'd risen so high above me now (in her own mind—she had always been high above me in mine), that she could talk with me without risking being dragged down. And she would let me look over the half-door of the stall while she was inside with the horse. The first three or four afternoons, she spent hours petting the horse on all the ticklish parts of his body, where he wasn't used to being touched—the flanks, and between the hind legs, up under the tail, all the while saying things like, "It's all right, stand still, that doesn't hurt, it only tickles, don't kick, please don't kick, I'll kick you, don't kick, thank you, no, put your leg down, put it down—that's right..." until she could touch him anywhere without his flinching.

After she'd done that, she started climbing all over him—sliding over his rump, swinging on his neck, and after that, she crawled all under him—straight through under his belly, then squeezed herself between his front legs and even his hind ones.

Spring was becoming summer. We were still in school, but the afternoons were long, and her father didn't come for her now. She would stay till evening, then take a lift to the bus, if anyone offered her one. At first she hardly rode. But she'd bring the horse out and tie him to the hitch rail—though within two weeks she'd taught him to ground-tie, so whenever the halter rope or the reins touched the ground, he'd stand. She'd brush every inch of him, scrape the fly eggs off his leg hairs with the blade of a pocketknife, put Vaseline inside his ears where flies had nibbled away at the skin.

One day she came up with a leather headpiece that she'd made at home; it had little tassels on it that jiggled when he moved his head and frightened the flies away from his face and eyes. She double-bedded him in straw and cleaned the stall every day herself, though two cleanings a week would have come gratis with the price of the board.

Then she began to ride in the evenings, always alone. She liked to use the ring, but only if no one else was in it. We'd watch her from a distance. She had a canvas surcingle that made it easy for her bare feet to get a grip, and she'd ride standing up, doing no tricks but that, which didn't look like a trick, even at a lope, when she did it.

We were sitting on the porch of Ben's house. It was dusk. She was moving in a slow lope, round and round the ring. The curve of her back would shift-and-flex, shift-and-flex, in a rhythm that was really the horse's rhythm, which she just absorbed.

"Isn't that a lovely thing to watch," Ben said.

"It or she?" Toni said.

"Take a good look," Clyde said. "You're paying for it."

"It is beautiful," Toni said. "So peaceful looking."

"She never does any wild stunts," Ben said.

"Remember how wild the two of them were when we saw them?" Toni said. "I guess it's hard to be wild by yourself, though."

"I think it's balm to her soul," Ben said. "Do you remember the old fellow whose wife died? Time went by, and he got a little over it, and he said: 'Well, I lost my drinking partner.' Expressed a little of what he felt. I wonder if she's doing something like that, but without words."

"But, what will happen? With her uncle?" Toni said.

"I don't know. Something. It always does."

"I wonder what her parents think."

"She won't bring her father near here anymore. Afraid I'll talk to him about her uncle, I suppose."

"He doesn't drive a Hal Watkins Chevrolet, does he," Clyde said. "Just an old Ford."

"I wonder what kind of man he is," Ben said. "He looks pretty solid."

"That's not half of it," Clyde said. "I found out from Jute, he's fierce as a little bobcat."

"To her?" Ben said.

"I didn't say that."

"What's he do for a living?"

"Works. But they say he trains dogs on the side, and raises every

kind of animal you can keep in a back yard—does well at it. But you'd better watch out. Jute told me, one day some fellow tried to run this little bobcat's Ford off the road, nobody knows why, and he caught up to him somewhere afterward and got out, and that other fellow saw his face and locked all the doors of his car and rolled his windows up tight and wouldn't answer when he was spoken to—and this bobcat-man we're talking about, he just smashed his fist right through the glass, opened the door and lifted this fellow out like he was picking up a rabbit. He'd tear you into more pieces than we could find, probably."

"Well, I'd protest that," Ben said. "Anyhow, I'm not going to run him off the road. You're just sorry I didn't ask you to share the board bill, I mean in case she doesn't have an uncle."

"Everybody has an uncle," Clyde said. "But you can bet her uncle doesn't know he has a horse."

About eleven o'clock on a June morning I was walking from my house along the unpaved road, when she came riding up behind me on Dusty.

"Going to the stables?"

"Sure."

"Want a ride?"

The surcingle had no stirrups. "I can't get on," I said.

"Oh, yes you can. Here, put your foot on my foot—and I'll lean the other way and you swing. Now, swing!"

And out of shame and desire I swung my chubby self up behind her—then sat there afraid to touch her.

"You'd better hold on," she said, and started off.

So I took hold of her sides. She struck out into a lope, and started to laugh, and the laugh vibrated up through my arms and turned into some emotion of my own—longing, love—the most intense experience in my young life.

Just as we crested the stables hill, we saw her father's car down below. She stopped the horse. Her father got out on one side, and another, bigger man on the other. "Uh oh. Off," she said. "Goodbye." She pressed her bare heels into Dusty's ribs and away she went.

MAX SCHOTT

"Come back!" the big man shouted.

Ben came out of his house, took one look around, and started walking slowly down the hill to the office, where Clyde was already, and the other two men converged there, too.

I dawdled, out of fear.

Ben put out his hand; her father shook it.

The big man was seedy-looking, as if he over-ate and -drank. His face was red, anyway, right now, and he was opening and closing his hands in a kind of fury. While her father stood looking about as excited as a fire hydrant, but watchful. "And this is my wife's brother, Mr. Watkins," he said.

Ben put out his hand again, but the man would hardly touch it.

"Are you one of the...Chevrolet Watkins, sir?"

"Ha-ha. And now I'm going to ask you a question. Whose horse is that that she's riding?"

"She?"

"My niece."

"My horse," Ben said.

"And who pays for her to ride him? Who's expected to pay?"

"There's been no pay on either side. He's kept in a stall and fed grain, so he's lively and needs exercise. She takes him out and rides him—at my request and corresponding to her wish—and she trains him a little too. She's good at that, he's a better horse for it, and I'm not looking for any pay."

"That's right," Clyde said.

"I have a letter in my pocket," the uncle said. He reached into a back pocket and pulled out a sheet of paper. "It's got my name signed to it, and I don't like that. She told you a whopping lie, which you were foolish enough to believe. That's why she's out riding that horse. And now you're telling me another, which I'm not foolish enough to believe. How many horses do you let these kids ride for free?"

"Not many," Ben said.

Meanwhile, the father stood quiet, watching. It was a funny thing. You began to feel, there was so much potential motion in that stillness. He reminded us all of her, when we had time to think about it.

Ben turned away from the big man and said to the father, "I lied. I didn't know whether you'd seen the letter or not. I'd never seen it myself, but I'd heard of it. Could I look at it, please?"

"Give him the letter, John," the father said.

"Why for? He'll—"

But the father just nodded, and the uncle gave Ben the letter, but he didn't stop talking. "I'd like to have her here for about five minutes, I'd—"

"Well, you won't though, will you," the father said. "She's like a treed cat, she won't come down, not while she thinks you're here, or probably even while I'm here. That's how she is. But I'm going to take you back to your car now, and you're going to go home."

Ben looked at the letter and handed it back.

"I can wait," the uncle said.

"I'll take you down to your car." He put his hand on the uncle's shoulder. "You come on over next week, and we'll make a stew out of some rabbits and talk it all over when you've got your temper back. You haven't lost anything. And I don't believe that this gentleman meant any harm. He may even have meant the opposite of harm. You come with me. And if my girl comes back," he said to Ben, "you tell her I'll be here after dark to pick her up, and tell her there won't be anybody at our house but her mother and me."

All afternoon we watched for her, but she didn't come back.

"He'll wait a long time after dark, for her," Clyde said. "We'll have to put a warrant out on our horse."

"She'll bring the horse back. He'll be in his stall in the morning," Ben said.

"Well, you're an optimist."

"But I'm afraid we'll never see her again afterwards."

"Well, you're *really* an optimist."

Ben didn't smile.

It got dark. I had to go home. Ben tacked a note to the stall door—saying what her father'd asked him to—and went up to the house to supper.

This time Ben was nearly right. Except she didn't put the horse in a stall, she turned him back into the big corral with the other rent-horses. They found him there in the morning. The bridle,

MAX SCHOTT

which belonged to Ben, was hanging on the gatepost. Her surcingle she'd taken with her. They hadn't heard her father's car. Maybe she'd met him, though, on the road. She hadn't seen the note. We found it still on the stall door.

Two years after that, Ben was in the market, Mashburn Brothers, where he always shopped. Someone tapped him on the shoulder. He turned, and of course it was Shannon. He hardly knew her at first, she'd grown so.

"Mr. Webber," she said, smiled at him, big as life, and shook his hand. She was back at Sunset Stables, had a horse of her own, and a boyfriend. Ben told her to drop in up at our stables. She said she'd like to. And afterward, when she hadn't, he didn't know whether to be sorry or glad.

To Be Included

Like other kids who hung around Ben's stables, I worked for rides. But unlike the others I didn't care as much about riding as working. Why would I rather work? I think the way I reasoned was something like this: I was crazy about Ben and knew he was not—had no reason to be—crazy about me. Work, I believed, was the way to attach myself to him. If I worked hard enough, made myself useful enough, if I could do the work of a man without receiving a man's pay, then I would be worth having around.

For a short chubby boy of ten, this was an impractical ambition. Foolish, really. In the attempt to be more than I was, I began to make ludicrous substitutions of form for content. I wore a hat like Ben's, spoke with a drawl, and became, while I was cleaning up around the barnyard for example ("rolling turds" as Ben put it), pedantic and officious. Once I overheard a woman say—after she'd been watching me for a while: "Why, he's just like a little man!" I'd turned myself—in her eyes and for the space of a moment even in my own—into a sort of freak.

Anyhow, I worked. And Ben, maybe touched by the efforts I made, became rather fond of me. He would take me out to eat with him sometimes, and to the horse and mule auction, and he took to calling me "The Foreman." All was well, for me.

Joe, the man who owned the property the stables occupied, also owned a roadhouse just a few hundred yards down the hill. Ben was in there one day with his girlfriend. They were standing at the bar when Joe, who may have had an old score to settle,

came up to Ben and told him he should take off his hat. Ben said no he wouldn't. Nearly every man at the bar had a hat on. Joe said something else, Ben's girl said something back, Joe slapped her face, and Ben hit Joe on the chin, knocking him down and nearly out.

That, according to Ben, was how it came about, not long afterwards, that he lost his lease. While, according to Joe, the stables had to be closed down because the neighbors had complained without effect about the smell, the flies, and especially the dust. (Joe never leased the stables out again. After Ben left, the place never reopened.)

Ben left. All I knew beyond that was that he had gone to Oregon, which may as well have been another planet. I grieved, and then was terribly bored. How useless I felt, and how slowly the time passed! Play was nothing to me anymore, or at least it could not replace work. I had had a glimpse of the world, had formed a connection with it, and now it was gone.

Fully a year went by. I was eleven, had a horse of my own now, and a barn in our own yard, but I hadn't, during all that time, found a way to fill the gap. Then I heard it rumored casually, maybe at the saddlery in Santa Monica, that Ben was at another stables, just a few miles away.

I told my father what I had heard, and he said he'd take me there and we would see. I was giddy with anticipation and something resembling dread. Either Ben was not there, or if he was there, he'd have no time or space or use for me.

The new stables was in the elegant, high-domed, dark and cool old barn that Will Rogers had built for his roping horses and polo ponies. We walked in through the entrance-way, and there immediately was Ben. He shook hands with my father, seemed glad enough to see me, and within no more than a minute or two said it'd be swell if I could come help him out again. The feelings of relief and anxious pleasure were nearly too much for me. I would not like to live through even the best parts of childhood again.

But if working life had been good before, it was better now. The new stables was too far from my house to go there after school, but this distance turned out to be to my advantage. I would ride over

on Friday afternoons and not come home till Sunday evening or sometimes early Monday morning. And I spent my vacations and the whole following summer there. A kitchen, toilet, shower, bedroom, and a sort of workroom were built right into the barn. Ben lived there, and so did Carl, a young man just out of the Navy who worked for Ben now.

It seemed to me there was no part of their lives that I was excluded from. Some of this feeling of being included just came from the circumstances. The three of us slept in one room. (I remember Ben kidding me when I'd get undressed for bed and forget to take my hat off.) And I was almost necessarily included in things that were kept secret—for example, when Ben took his rifle up to the big horse corral early one morning and killed a doe that had come through the fence there. We brought her into the kitchen, closed the doors, and butchered her. After dark that night we buried the hide and guts, and took a quarter of the dressed meat down to where the chief park ranger's frozen food locker was and slipped it in. He and Ben had an understanding.

But sometimes it was clear that Ben went out of his way to include me. The instance I remember best is this: One afternoon he went out riding with a woman—a married woman—who'd just bought a horse from him. He hardly knew her, but they went out riding together. I saw them leave, and I saw them when they came back, moving single file along the trail, her horse behind his.

She rode with her head lowered, as if she were ashamed, and the expression on her face was soft and open. Ben looked solemn. They rode slowly to the barn, then got down off their horses and stood close to each other and talked. But not for long—he was in a hurry: soon as he'd unsaddled her horse for her, Ben got me and Carl into his car, and we took off down the hill toward town, leaving our evening chores undone and leaving her there alone to wait for her husband.

There were two roads that led from Sunset Boulevard to the stables. The rangers had made them both one-way. On our way down we wouldn't meet the husband on his way up, or know when he'd arrived. That made it worse for Ben. He began imagining first

MAX SCHOTT

that *possibly*, then that *probably*, and then that it was *nearly certain* that the man had pulled up to the barn only a moment after we'd pulled away from it, that his wife would instantly confess, and that he was even now roaring down the hill behind us. Ben drove fast around the curves, glancing into the rear-view mirror every second, and talking about the husband to Carl.

But Carl still hadn't heard exactly what had taken place with the wife. He wanted to ask. But I, a child, was there in the back seat listening to everything. Carl turned his head slightly and gave me one of those quick sidelong glances that children know so well: I wish you weren't here, or would close your ears, so we grown-ups could talk.

I was hurt. Didn't I know better than Carl did, what Ben and the woman had done? I had seen their faces!

Carl quietly put a question to Ben. And Ben, without looking at me or acknowledging me at all, said to Carl: "I tested her oil."

The words took me away from my injured feelings for a moment. In my mind I saw their faces, tried to imagine their bodies, heard Ben's phrase repeated, and pictured a dipstick. The things were incompatible, and yet they weren't. There was beauty in their faces, ugliness in "tested her oil," and the beauty and the ugliness were so strangely, thrillingly mixed together.

But all the thrill and mystery in the world couldn't distract me very long from my own sense of injury or grievance. Did Ben think I didn't know what the words meant? Was he trying to hide from me what he was talking about?

We were coming to the bottom of the hill, the end of the curves, the safety of the boulevard with all its traffic and side roads. Ben, as he slowed to a stop at the stop sign, looked again in the mirror and this time caught a glimpse of my sulky, self-pitying face. Amidst his own anxieties he thought to turn to me and say: "I know you know what we're talking about, son."

I've remembered that with gratitude all my life.

As it turned out, the wife hadn't instantly confessed, and later, when she did confess, the husband didn't come after Ben, or after anyone. He kept bringing his wife up to the stables when she'd ask him to. He was a big gorilla-like man (with hair all over his body—

not a good man for a woman, it seemed to me), who wrote books and wrote movies. Once, when he'd gone to the races and got lucky, he even brought a case of whiskey up to the stables as a gift for Ben. I don't know why. Probably Ben had picked the horse.

Chico

Why did I become a horse trainer? After I get rich doing what I'm doing now (teaching school), I'm going to hire a professional to answer questions like that for me. Meanwhile I'll have to struggle along by myself.

My first horse, Chico, must have been a big influence, a "formative" influence as they say. For about the first three years of our relationship, he was definitely in charge, and I give him credit for having taught me a lot. Though to give myself my due I did end up, like Aristotle, wiser than my master.

The philosophy we lived by when we were together was based on the single principle of fear. Chico wasn't afraid of me, but of nearly everything else, while I was afraid both of him and of everything he was afraid of.

Like any good student, I learned to anticipate his reactions to things. But I went further even than that, and often would alert him to the presence of objects he might otherwise never have noticed. For example, a little piece of paper lying near the trail would be enough, if I spotted it, to make quivers run down my legs and cause my hands to tighten or tense on the reins—causing Chico in turn to become exquisitely alert. Operating together we were a sort of fear machine. And in truth the glitter of something white, were it no larger than a cigarette butt, was enough to make him snort and jump sideways.

But I shouldn't exaggerate. It would be possible to make a long list of things Chico wasn't afraid of: trees, hay, etc. It would be

more accurate to say that wherever we were, there was nearly always something that he *was* or might be afraid of. His stupid imagination found dangers everywhere, and mine grew wonderfully attuned to it. The sight of a puddle, the mild sound of a bird moving around in the bushes, the dull glint of someone's mailbox, a person on a bicycle, a piece of cardboard—such things and a thousand others spooked us; not to speak of such obvious terror producers as flags, bright white square signboards, a trickling stream, motorcycles.

Still I used to go everywhere with him. To get to Ben's stables at Will Rogers State Park we had to ride through several residential neighborhoods and along a number of paved roads. He wasn't afraid of cars, and I remember now that the music of the ice cream truck and even the truck itself didn't frighten him.

I remember this because once I found the truck stopped on a quiet street and rode up and asked for an ice cream. I was riding bareback, as I usually did, and as usual I was afraid to get off because I couldn't get on by myself unless I could manage to move Chico up against a fence or bank that I could mount from, and that was hard to do, because after I'd get him positioned and would begin to reach out for his withers, he would step away. So the Good-Humor man agreed to hand me the ice cream. But Chico was afraid either of him or his white apron or of the out-held ice cream bar itself. Every time the man would step toward us, Chico would step quickly sideways and backwards and snort and prick his ears forward and roll his eyes.

After a few attempts the man became impatient. He asked me to throw him his dime. Then he took hold of the reins close to the horse's mouth. This frightened Chico, he tried to jump away backwards, but the pull on the bridle brought him forward again, and one of his heavy hooves, rimmed in steel, came down on the lightly shod toes of the Good-Humor man.

Selfish and frightened, I was less aware of the man's pain than of his anger. Bless him, though, he didn't give up. He tossed the ice cream bar toward me—Chico did not even see it—and to my surprise I caught it, and rode away eating it, though I doubt if I enjoyed it.

MAX SCHOTT

As I say, though, I wonder, if I was so frightened all the time, what was the attraction? Why doesn't one give up or become interested in something sensible? Is it relevant that Chico was in all other ways a likable beast? He didn't have a mean impulse in him—never bucked, kicked, bit, sulked, or tried to run away. He was smooth-gaited, soft-mouthed, willing, easy to handle. He was just fearful, like me.

Sometime during those years, I had a nightmare, which is noteworthy only for being exactly like daily life and at the same time scarier. I was hanging onto the tail of a white horse racing along the edge of a precipice. I was being flung back and forth over the void.

I suppose that as I grew older—more experienced, bigger, stronger—it became easier for me to ride my horse. It must have been gradual. But I don't remember it that way. When I was, I think, fifteen, I went away for the summer to work on a ranch. I rode all kinds of horses there. Probably I came home feeling rather cocky. I rode Chico, and wasn't afraid anymore. He could jump from things if he liked. I didn't mind. In fact I liked it! As a result of course he jumped from many fewer things. The fear machine had broken down. It's a lovely feeling when that happens. But it was an ending, too. I hardly ever rode Chico after that.

Keeping Warm

1

One day when I was eight or nine my father was going to give me a ride somewhere. He was sitting in his chair near the bed, reading. My mother lay on her back awake, her head raised by the pillows. I came in and said: "It's time to go."

"To go? Oh, yes." He turned to Mom. "I'm going to give Max a ride over to the stables. Rose will come in and sit with you."

She nodded and smiled. "Don't forget to take your jacket," she said.

"I don't need one," I said. "It's not cold. Let's go, it's late."

"It's not cold *now*," he said, raising his eyebrows and looking again at Mom, trying to make her laugh or smile. But her eyes had closed.

I went up closer to the bed. "Goodbye, Mom."

She opened her eyes. "Goodbye, dear."

We went out of the room, and Rose came in.

Before we left the house, my father, absent-minded though he was, remembered to remind me to take a jacket.

Out of love for her, he wanted me to be warm: that was how I saw it.

I longed, in those days, for an earlier condition. If she were only well again, then he would be like he used to be. A year later, when it became apparent even to me that she was not going to get well, I

began to imagine her death, to wish for it, believing that it would have the effect of returning my father's love to me.

When she did die nothing of the sort happened: she was nearly as present to his mind dead as she had been alive.

I don't know how many jackets—during my later childhood—I lost or mislaid or left behind, always hoping, I think, to attract my father's attention. I often did attract it, in which case he was kind, good-humored, not impatient. But since it wasn't in him to give me what I wanted—since what I wanted wasn't in him to give—the same small drama kept repeating itself, till the sullenness of adolescence interfered.

2

Ever since I was a child—ever since my mother's illness—my father, in one way or another, has occupied my mind. For most of my life, I didn't like his presence there and did everything I could to drive it out or to somehow leave him behind.

It's different now, and the change is puzzling. I catch myself speaking in his voice, laughing his awkward explosive little laugh, making silly puns. I recognize his presence, sometimes probably even invent or imagine it. I tell myself, "You are, you're like him," and take pleasure in it! As I say, there's nothing very strange about this—except the pleasure.

The dead are easy to manipulate. We do what we want with them. I sit at my desk, writing, and feel, almost, that he is sitting at my desk, writing. Sometimes reason takes over, and I have to admit that there is no real likeness. Thousands of people sit at desks and write, and the thoughts I write down don't at all resemble the thoughts he wrote down—which were full of numbers and strict reasoning. But the illusion, if it goes away for a moment, comes back quickly enough. If I ask myself what causes it, where it comes from, why I take pleasure, now, in what I used to dislike, the answer is, the pleasure, the illusion, comes from love: an unremarkable idea but for me still a kind of novelty.

He has not been dead long—he died in 1996 at the age of ninety-two—and it was only during the last three years of his life that I began to take in, to feel some of the affection he bore towards

me—and at the same time to recognize in myself some of the affection I bore towards him. (It's a stiff and clumsy way to put it, but that's probably as it should be.)

Love was always there, no doubt. I remember how it was when I was a child. I remember my own feelings, I remember being aware of his. But even this awareness is new. Those feelings seemed to disappear, something went wrong with them, I had trouble even remembering them. But if they were there at the beginning and if they are here again now at the end, then during all the intervening years, they must have been there too. Love is nearly as hard to kill off as it is to create.

Because I believe that love was always there, I sometimes these days want to register a complaint against the universe. I want to say first that I am grateful, but as soon as that's said, I want to protest: "Why so long? Why so many years?" To think this way is dangerous. I seem to want to evade the question of my own culpability— or of his. But there are other questions that for me are more dangerous: "What are the causes?" "Who is to blame?" In my life, looking for causes and laying blame have done a great deal of damage.

<p style="text-align:center">3</p>

As a boy what I wanted more than anything else was to free myself from the world I'd been born into. I worked at it with a vengeance, beginning when I was about nine or ten, and as I got older I came to believe, or tried harder and harder to believe, till I convinced myself, that I really could make myself into what I wanted to be.

In the spring of 1957, when I was twenty-two, my then-wife and I and our two-year-old daughter moved to a small ranch in the high desert country of southern Oregon, and I set up as a horse trainer. It was a new country to us, we liked the looks and feel of it, and we didn't know anybody. We were on our own. Our hope was that when people saw how good a job I'd done training the three or four horses we'd brought with us, they'd bring their own young horses to us to have them trained. If we could get ten outside horses at the going rate of one hundred dollars a month per horse, we could

make a living. Why not? To me now this sounds like a reasonable plan. To me then it seemed reasonable but audacious. I'd been training horses more or less professionally since I was sixteen, but I'd always been among people I knew, and usually worked as a kind of apprentice.

Anyway, I began competing on weekends in all the nearby fairs, horseshows, rodeos, jackpot ropings, cutting-horse contests. And during the week—more and more often as word got round—I'd ride out and help the neighboring ranchers with their cattle. Sometimes they'd pay me wages, sometimes not. But it was good for the horses, and anywhere I could show my wares I'd go.

For me the thrill, as we began to get customers, ran very deep. My life was my own. As I saw it, I had put it together out of materials no one had provided.

What did my father think of the life I'd decided to lead? Was he disappointed? He didn't say he was, and I didn't say even to myself that he was, but I felt it.

Years earlier, when I was seven or eight, he'd written a letter about me to his own father, saying that, given the books I was reading (*The Earth for Sam* I remember was one of them), and my obvious interest in animals, he believed I might turn out to be a paleontologist or zoologist—a scientist like himself. The letter, which I came across recently, is full of pride and fatherly delight and hopefulness....

But that was not the heart of the issue between us. What was at the heart of it? I don't know. Whenever we were in the same place together, the same room for example, I always wished that one of us was someplace else. And I believe he felt the same way.

Not long after Marie and I settled in to our new place, my father came up from Los Angeles to visit us. He asked intelligent questions, fixed things around the house and barn, and spent time with a couple of our farmer neighbors, who liked him. He was fond of Marie (she liked him), and delighted by his granddaughter.

Towards me he expressed all the good will that he could. You might say he came armed with good will. He brought along a riddle that he'd learned, I think, expressly for me. A farmer has three

sons. He gives them a feedlot—a place where cattle are to be fattened for beef. The only thing he asks of them is that they call the new place *Focus*. Why does he choose that name? "Because," my father said, "it's where the *sons raise meat!* You see? The *sun's rays meet*. It's a pun on all three words, which is unusual."

Why were we so "stiff with each other"? Marie asked me that, and I asked myself the same question. In my heart of hearts I believed that the person to blame was my father, that he had done something he shouldn't have done, or left undone something he should have done. He'd ignored me when my mother was ill. He had loved her too much and everyone else too little. I was glib with reasons. He was my father, in any case, and he was to blame. What a blessing it would be, I thought, when we could take him to the airport and he would fly away home again—and of course he did soon go away.

<div align="center">4</div>

One of our neighbors—actually he lived a few miles away— became a friend of mine. This was Bill Hill, young Bill as people called him sometimes. Before we met Bill or knew of his existence, even before we moved into our house, we heard about his father, who was a big name in those parts.

I remember how that came about. The real estate agent was driving us around. He'd just shown us the place we ended up taking, and since things were going well, he decided to give us a short tour of the neighborhood. Things hadn't always gone so well between him and me. In the beginning, when we'd gone to him and told him what we were looking for—fifty or sixty acres of irrigated land with a house and barn—he'd asked a question that I'd taken offense at. If we found a place we liked, was it going to be ours, really, or were we maybe shopping for somebody older. He said it was good to have these things understood in advance, and that he'd had people out shopping with their parents' money, and their parents it turned out had different feelings about it.

"It's our money," I said.

Marie, who had more sense that I did, jumped in and explained that my grandfather, my father's father, had died two

MAX SCHOTT

years before and had left me a small inheritance, most of which was now on deposit in a local bank. Our parents had nothing to do with it.

"I don't need to know any more," the man said. "I apologize for bringing it up."

"That's perfectly all right," Marie said, while I pulled down the bill of my cap, sank down in the seat of the car and sulked.

Anyhow, things were going well. We were just about sold, and he took us for a drive around what was going to be our neighborhood. Just east of our place he slowed down to cross the railroad tracks. About fifty feet up the tracks I could see a siding with a sign by it. Still a little touchy and wanting to prove how grown up I was, I asked him, "How come that railroad siding has a sign by it that says 'Hill' when all the ground around here's flat?"

The real estate man laughed and said back in the same tone, "The same reason this road you're going to be living on is named Hill Road." Then he went on to tell us about "old Bill Hill," who'd come to this part of the country as a young man "with nothing but a young wife and the head on his shoulders and a willingness to put himself to work. You could homestead a hundred and sixty acres then, which they did. There's the old homestead-house. Doesn't look like much, does it? But it's where they got a start. It's rented out, now. He built himself a better one." He went on. It was the kind of story people like to tell. Gradually old Bill Hill had made his way, leasing land, raising barley, alfalfa, potatoes ("That's what those dirt roofs are, sticking up out of the ground—potato cellars"), and more than anything else, cattle. And now, "forty years down the road," the man was land-rich, cow-rich, and money-rich—"though money I don't believe is his first preference. He just keeps buying more land, more cattle, and he works as hard today as he ever did. He's that kind of old-timer, you know. He could buy and sell me a hundred times over, but you'd never know it to talk to him. There—that's their new house, just there along the river. Fit to live in, compared to what they used to have, but nothing out of the way—modest, you know. He owns all this land, on both sides of the river, between here and Merrill…some people say he owns most of the town too. But I happen to know that's not so. And right

here, that's where one of his sons lives. The other one's off at college." The son's house—young Bill's house as it turned out—looked like it'd been dragged in from somewhere with a tractor: no foundation, no trees or grass around it.

I had trouble separating old Bill Hill from the man who was telling his story. So he was rich, powerful, ubiquitous, hard working, tight-fisted, a regular patriarch—and this man, this money-grubbing sycophant, who'd had the nerve to think I was still in my father's pocket—this man was ready to love him for it. Marie heard the silence coming from the backseat and without turning around to look, she tried to carry on a conversation. What college had the younger son gone off to? Why did the older son live in such a shabby house?

5

One afternoon a few weeks after we'd moved in, I was out in front of the barn fooling with a horse, when a red pickup, fairly new, pulled in. On the sidepanel of the door somebody'd painted, in neat bright letters:

William F. Hill II
Quarter Horses and Cattle
Merrill, Oregon

He got out, extended a hand and said, "Bill Hill."

"Max Schott."

"I know," he said, and began to talk. "That's a good looking horse. Colorful, too. I like a little color in a horse. A lot of people don't, but I do. Attracts attention. You take a brown horse to a show, I don't care how good a horse he is—the judge might overlook him. You mind telling me who he belongs to?"

"Johnny Weston."

"Johnny, I know him, I never knew he had an animal like this. I wouldn't hide him away if he was mine, would you?" He walked all around the horse, appraising him, running his hands over him. I'd been teaching the horse to stand without moving, using a home-made hobble that I'd fashioned out of an empty burlap sack with a

pocketknife, the way somebody'd shown me. "What kind of a thing is that you've got his legs tied together with?"

"Just a hobble."

"It's not like any hobble I know about. Burlap, is it? What's it made out of?"

"Just an old sack."

"I see that. I like that, that's all right. What would it cost to get you to show me how to make one of them—sometime when there's time?"

I laughed. "I don't know…a thousand dollars? Do you have a pocketknife on you? We'll make two right now."

I got some empty feedsacks out of the barn. We sat on the cement lip of the water trough, each working on a sack, and he went on talking. He asked me how much I charged to train a horse, how long at a time I rode them, whether I rode them all every day, how many I had now in training, how many I wanted to have, how long it usually took to teach one this or that. At one point he paused, then said that if I had ten horses and rode them an hour each, every day, and fed and cleaned up after them and doctored and brushed and washed them—then I wouldn't have any time left over to sit out in front of the barn like this and make hobbles.

"I guess not," I said. "But we'll be able to keep eating."

"And if a person doesn't have any money and wants to have a horse trained, do you ever trade?"

"I never have, but sure, I would—if there was something to trade for, that I needed."

"You need hay, don't you?"

"Sure."

So he began telling me about his hay—alfalfa, which if I didn't want he could trade for oat hay or whatever kind of hay I did want, then he told me about his horses, then about the particular horse he was "thinking about having somebody who knows something about it train."

Voice pitched a little high, he talked on, and the blood rose in his cheeks. In the end, I suppose I would've agreed to almost any trade he wanted to make. He seemed to take a kind of pride in

being sly, though to the small extent that he actually was sly it was the least likeable thing about him.

Later, when I went back up to the house, Marie asked who the visitor was. She'd seen the pickup drive out to the barn.

"Bill Hill," I said.

She laughed. "Bill Hill, himself?"

"No-no, just one of his sons."

"He was out there a long time. Did you like him?"

"He might want to have a horse trained."

"That's good. Did you like him?"

"So far."

"Is he the one who lives in the house?"

"What house?"

"Is he married?"

"I don't know. We just talked about important things."

<center>6</center>

As the spring and summer went by, Bill and I spent a lot of time to-gether. But things that really were important, the things that were most on our minds—children, marriage, families, fathers—we hardly knew how to talk about at all, though once in a while we'd make an attempt. "What's your dad think of you being way up here, if you don't mind my asking?"

"Nothing. He likes it here."

"And how is it he makes his living, again?"

"He's a research chemist and a logician."

"A la-what?"

"Logician."

"I can't even *say* that."

"I can say it, but that's about all."

"But you're close? You're not...?"

"Estranged? No. Why should we be?"

"Shirley kind of thought you were. Must've got it from Marie."

"No, he has his life and I have mine. We get along, though."

He laughed.

"What's funny?"

"Nothing," he said. "My dad, he has to work with me every

MAX SCHOTT

day, damn near. I could've left, like my brother did. I still could."

"But you won't?"

He shrugged, and didn't answer.

He and Shirley had two kids. The older one was a girl, three. The younger one was a boy, Billy, about eight months old when Marie and I first saw him, early that summer. In serene moments he looked wiser and more sensible than his father. Our two families saw quite a bit of each other. Bill had built a roping arena across the road from his house, and I built one too. In the long evenings, we'd get together to rope, and then we'd eat—all seven of us. And on the weekends we'd go to rodeos or jackpot ropings together whenever we could. Shirley and Marie knew more about Bill and me than we knew about ourselves. The two women had in common, among other things, that they'd married husbands who were like overgrown children. And talk between them—even the most casual talk—came nearer to the heart of matters than talk between Bill and me ever did. I would like to go back in time and hear some of it—but maybe if that were possible I wouldn't like it so much after all.

Some things they would let us in on, though, and I remember it was common knowledge among us that Bill's father didn't treat him fairly—asked too much of him and gave too little in return. I was quick to believe this, disliking the man anyway, on principle. From the old man's point of view the wrong son had stayed home. We all thought it wasn't fair. Bill would be a wealthy man some day, probably, but now he made so little, working for his dad, that Shirley had to go to Merrill every day to work in the bank while Bill's mother looked after the kids. She was good about it, but it wasn't what either she or Shirley would have chosen to do—and the fault was all old Bill's.

But even though I thought Bill was in the right against his father, I still didn't take his feelings very seriously. This was partly because I didn't take anybody's feelings seriously but my own, but it was also because Bill was in the habit of clowning, and tried to make everybody believe that nothing went very deep with him.

There were times when he seemed silly.

Around his house, on both sides of the road, Bill had some irri-

gated pasture that he called his own. It wasn't his: it was land his father had given him the use of. Bill ran some cattle there—not many, maybe fifty or sixty cows and their calves. Bill felt cheated. If he'd been given the use of twice as much land, or ten times as much, probably he'd still have felt the same way—as long as the man giving him the use of it was his father.

One day early in the summer, he called me on the phone at noon and asked if I could help him get some cattle in off the road. "They've been out a couple of days," he said. "The neighbors are complaining."

We put the cows back into the field through the gate, and I helped him—I thought I was helping him—find the place where they'd got out through the fence. It was an old four-strand wire-fence with wood posts. At one point along the road, two posts had got snapped off at the base, and the fence, still intact but well trampled on, was lying flat on the ground. We braced it up again in kind of a half-assed way. "That's good enough," he said.

"They'll get out again, won't they?"

"Highly likely," he said.

I must have looked puzzled.

"If they need help I'll give it to them. You see this grass along the road, how lush it is? I call this the long pasture. It's the best field I have. Doesn't get overgrazed, gets a double dose of water when it rains. 'Course my dad, he doesn't like the cattle to be out along the road. He says the neighbors call *him*. I say, 'Tell them to call *me*, they're my cattle.' He says, even if they call me they blame him. And I say—I don't say it outright but he knows what I'm thinking— I say, let me have that other forty acres between here and the river, then I won't need to use this. He won't, though. The more you goad a man like him, the less you'll get out of him in the end."

"Then why goad him?"

"That's what Shirley says, too," he said, and laughed.

7

But there were other sides to Bill—for better and worse.

One Friday he called and said if we didn't have plans to do anything special on Sunday, maybe we'd like to go with him and Shir-

MAX SCHOTT

ley and the kids for a picnic down at the local park. "I have another friend, too, Lewis, who might come along."

"Is Lewis an old guy?" I said, when Bill and I were on our way to pick him up.

"Not exactly," Bill said. "About fifty, maybe. It's hard to tell by looking at him, but I know for a fact that's about what he is."

"Is he an old family friend?"

"Of my folks? Nope. He was a grown man already when I was a kid. But our family didn't have anything to do with him. Neither did anybody else. I just grew up knowing he was there."

"Where?"

"Oh, just the little house he lives in. I knew what had happened to him because everybody knows it. He doesn't need anything. He takes care of himself all right, but he won't go anywhere on his own, except to the store and back. So we take him places sometimes. You'll see what he's like."

"Is he not quite right?"

"I guess you could say that. I'll tell you his story if you want to know it."

Lewis's father had had a farm a few miles south of Merrill. When a neighbor farmer's son got orphaned, Lewis's parents took the boy in, mostly at first for the work they could get out of him. Lewis was nine years old at the time, and the other boy was a year younger.

Bill said he didn't know just how it came about—whether Lewis was already a tad slow, or whether the main cause lay somehow in the father, who everybody said was a hard man. Anyhow, the child they took in was quicker and more ambitious from the start, and when the father realized that, he took against his own son—and the boy just stopped. He got a reputation as a simple soul, dropped out of school, did a few chores around the place for his keep, and that was all. His folks treated him like a servant, and the other boy ignored him. The other boy turned into a man. He ran everything, and when the old people died he inherited nearly everything, sold the farm and moved away. Now Lewis lived on the edge of town, well enough off—he had some kind of pension or insurance. They'd provided for him—or maybe his foster brother had—provided everything except what he needed most.

He came out when we drove up: a small man in a too big pair of overalls, his body almost lost in them. He was scrubbed clean for Sunday, his hair wet and brushed back. The most striking thing about him was his eyes—blue eyes that looked as though they'd been taken out and washed and maybe bleached.

Bill said, "Lewis, this is Max." Lewis smiled and said "Pleased to meet you." We shook hands.

I think he liked being at the park, sitting on the grass with us, eating, even talking. Bill especially could carry on a conversation with him. He wasn't simple, in the usual sense, but emptied out. To me it seemed—and I may well have imagined it—that the judgment levied on him by his father was too heavy for him to carry, and yet he had to carry it.

<p style="text-align:center">8</p>

One day at the beginning of October Bill called to see if I wanted to help doctor some of his father's cattle that were up at a place called Swan Lake. His dad had a thousand cows up there, Bill said, grazing on the lakebed, with about nine hundred calves, and some of the calves, maybe one in ten, had pink-eye. His dad was putting together a crew of seven or eight men to catch the sick calves and treat them.

"So we'll be doing a lot of roping?"

"You bet. I'll pick you up in one of my dad's trucks. Better bring a lunch, too."

Bill said he'd come by at eight in the morning. I got up early, but it was so warm I didn't even build a fire in the stove. Marie and Sharon were still asleep. I went out to the barn, fed the horses, came back to the house—they were stirring by then, made some coffee, drank some, ate something, filled a thermos. Marie got up and packed me a sack-lunch. Sharon toddled around in her pajamas. I said goodbye and went back out to the barn to saddle a horse—a rope-horse in training—and wait for Bill. It was a beautiful clear still fall morning. By seven-thirty it was already so warm you could shed your jacket.

Bill pulled in and backed the truck up to the loading dock. I led my horse up onto the dock and into the truck, tied him next to

Bill's, swung the endgate shut and bolted it. Before I climbed into the cab I sort of mentally checked to see that I hadn't forgotten anything: bridle, saddlebags, ropes, thermos, lunch.

9

Swan Lake was about ten miles the other side of Klamath Falls. After we passed through town we got onto a gravel road, which ran straight and climbed maybe a thousand feet by the time we got to the top of it, where the landscape opened out so that you could see where you were. On the right, way off, there was a barren-looking rim. All the ground between us and it was flat. What I could see of it was sandy-looking—good roping-ground—and dotted with clumps of tall coarse grass. There were whitefaced cows poking around here and there with their calves. Off in the distance you could see a glimmer of water, looking like a ribbon or a road. A four-strand barbed wire fence ran along the side of the road.

Tumbleweeds by the hundreds had been blown up against the fence. It took me a minute to realize, the wind that had blown them there couldn't be what was making them quiver now. And they were quivering. "I forgot my jacket."

Bill looked at me and shook his head. "I'm glad I brought mine."

We drove a little way in silence. "That's a stiff-looking breeze," I said.

"Comes right off the ice water in that lake," he said.

We could see an old barn ahead, next to a set of corrals and a loading chute and, off to the side, the remains of a house—half a chimney and some rubble of wood. There was a stock truck already nestled up to the chute. As we got closer I saw a craggy looking man of about sixty lead a horse down out of the truck, and a few more men and horses moving around in the corral.

Bill pulled in and stuck his head out the window. "Move your truck!" he hollered. "Let's get to work!"

His father turned and looked at him. He tied his mare to a post and pulled the truck out of the way so we could unload.

It was not a very strong wind—maybe fifteen miles an hour. When I got out of the truck my back was turned to it, and it

pierced me right through to the heart. When I turned around, it did the same thing. I hugged myself and tried not to think about the day ahead.

There were seven of us all together, seven men and six horses. Bill introduced me to his father, and his father introduced me to the others. There was an old man, Clarence, evidently a pensioner who worked for Bill's father. There were a couple of young guys, Robert and Jim, who worked for other ranches and were on loan for the day. They liked to rope—I'd seen them before. And there was a dour looking man of about fifty, named Gordon. We shook hands all round.

"You better put your jacket on," Gordon said, and ran his eyes over me as if to say, "What kind of a fool is this?"

"I left it home."

"Anybody happen to have…anything?" Old Bill said. "Sweater? Vest? Slicker? Blanket?"

"No," Gordon said.

"Sorry," Clarence said.

"I don't think so, I'll look in the car," Robert said.

Except for Gordon, nobody was unkind. But nobody had anything extra.

"It's all smoke so far, but back up to this fire for a minute or two," Clarence said. "You know what we say about the weather here: Stranger says, 'How early in the year does it freeze in this country?' Old timer says, 'Any time after the fourth of July is an early frost. Before that we call it late.'"

We laughed. I backed up to the fire and tried to stop my teeth from chattering.

Old Bill told us what the plan was. The lake bottom was about ten miles across. "It looks like you can see all of it when you look across towards that bluff. But you can't. When you move across, the horizon will keep shifting and cattle'll keep coming into view that you didn't think were there." He said we'd ride together for less than a mile, then pair off. Bill and I would make one pair, the other two boys another, and Gordon would come with him. "Clarence is going to stick around here and drive a few more nails into this old barn—see if we can make it last another year or two. So,

MAX SCHOTT

let's unpack this medicine chest and see what we have. If a calf looks fairly healthy and just has runny eyes, use these drops. But if there's a white spot on the eyeball or if a calf looks unwell, there's some penicillin. Don't be afraid to use it. But if a calf's healthy and doesn't need doctoring and you feel like roping, don't. You'll have all the roping you want by the time we're done."

Bill's dad, when he asked us not to rope any healthy calves, seemed to make an effort not to look at anybody in particular. In fact all the time that he was talking he avoided looking at his son—and at the same time went out of his way to try to treat him the same way he treated everybody else.

Bill—old Bill—was riding a young dun-colored mare. I watched him get ready to get on her. He kept the reins tucked up close in his hand, the left rein a little shorter so she couldn't turn her head away from him. She stood still, and rolled an eye. When he settled into the saddle, she stood there, stiff as a board. He nudged her with his heels and she moved off kind of gingerly. I thought she'd be all right. After fifty or a hundred yards she relaxed a little, and so did he. Her left ear flicked forward and back—she was paying attention to everything: the ground, the man in the saddle, the other animals. That was all right. The right ear she kept cocked back stiff.

Gordon was on his left. They were riding just a little ahead of the rest of us. The reins in his left hand, old Bill raised his right arm and pointed off to the right. "Coyote," he said.

Before we could turn our heads to look, the mare, frightened by the unfamiliar motion of his arm, bogged her head and snatched the reins from his hand. She bawled, then, and went to it. He was a goner from the first jump, though he lasted three or four. The coyote, who'd probably been jogging along beside us out of curiosity, veered off and loped away through the grass.

Old Bill was lucky. The ground was soft, and he landed on his back and shoulders and sort of rolled. But for a long moment after he stopped rolling, he just lay there.

During that moment, Bill's face was a study.

Then his father rolled over, groaned, and got to his feet. Gordon and Robert and Jim had stepped down off their horses to help.

The mare, meanwhile, took off across the plain. But she kept

stepping on the reins and slowing herself down, and finally she stopped and stood where she was, a couple of hundreds yards away. "I'll go get her. Are you all right?" I said to Bill, who hadn't moved or said a word to anybody.

"Makes me about half sick, when he pulls a stunt like that."

When I brought the mare back, old Bill took the reins and thanked me. "I'm glad you're all right," I said.

"Just my feelings are hurt," he said. "This ground's more unforgiving than it used to be."

"Do you want to trade horses for a few minutes, till you've got your legs under you again?"

"No, no need. Let's ride back to the barn for a minute, though."

"What for?" Bill said.

His father didn't answer him.

"What for? Are you hurt? A man your age has got no business riding a young horse. I told you that."

"Let's ride back. I want to see if something's there."

He got back on the mare, and we rode in silence to the barn.

Clarence came out of the barn. "What's going on?"

"Nothing. Getting bucked off this mare jogged my memory. You remember those sore-footed bulls we fed here for a few weeks this summer?"

Clarence laughed. "You staked a claim, did you?"

"You remember what we fed them?"

"Fed what? The bulls? Yeh, I remember. Ground alfalfa with molasses. I forget what all else."

"Where're the sacks?"

"The sacks? The empty sacks? Why, they're in the barn chucked up in a corner."

"Let's make some vests."

Clarence blinked, then looked at me. "Why, sure. I didn't think of that."

"I didn't either. I got to thinking, when I was lying there: 'If my back's broken, we're going to need a stretcher, and what are we going to make it out of?' And I remembered those sacks."

"If it takes that to make a man think, I think I'll do without," Gordon said.

Clarence went into the barn to get the sacks. I got off my horse and moved up close to the fire. Bill still looked green around the gills, and you could almost see him keeping as far as he could from his father. But he managed to say to me, "That's good. Those sack vests will make you warmer than you think, if you put on enough of them."

Old Bill sat down on the running board of a truck with six or eight gunny sacks on his knee. He opened his pocket knife, cut two arm holes and a head hole at the bottom of each sack. It took him maybe five or six minutes. Then he got to his feet, groaning, and walked over to the fire. "All right, raise your arms." He slipped a vest down over my head.

That first one didn't make me feel much better—or the second, either. With the third one, though, I could feel the heat of my body coming back to warm me.

"That's swell," I said. "Keep going!"

"I mean to," he said. "Lift your arms up again."

"He'll temper the wind to the shorn lamb,'" Clarence said.

10

We were still in sight of Bill's father and Gordon when we came across a little weepy-eyed heifer calf lying not far from where her mother was standing. "Which end you want?" Bill said.

"Either one."

Bill urged his horse. Seeing the horse coming and the rope swinging, the calf scrambled to her feet and took off like a jackrabbit, tail in the air, dodging through the clumps of grass. When running crooked didn't seem to help, she started to run straight. Bill flung a loop around her neck, took a turn of the rope around the saddlehorn and slowed his horse. The calf swung round in a big circle on the end of the rope. I loped in and dropped a loop down over her hip, laying a sort of trap for the hind legs. Bill got off his horse, took the rope off her neck and put it on her front feet so she wouldn't strangle. We had her, then, stretched out between the two horses, Bill knelt down and rolled an eyelid back between his fingers, to make sure she really did have pink eye and not just a foxtail. Then he dropped some drops into her eye.

"That's it," Bill said. "Let's go get another one."

I moved my horse forward. The calf got up, shook herself, and trotted off to her mother, who'd been watching us from a distance.

Bill got back on his horse and coiled up his rope. His color had come back. "So far so good," I thought. "He's all right. Soon as he unwinds a little more, he'll start enjoying himself."

We rode on a little ways, well out of his dad's sight now and moving away from him more all the time. They were whitefaced cattle by breed, and the calves' faces were white, clean and bright—except when their eyes were infected. Then the fur below their eyes was stained. You couldn't miss it.

We rode slowly towards a little group of cows and calves. "There's one," Bill said, pointing to a big fat steer calf. "Rope him."

"That one? I don't see anything the matter with him."

"Just rope the son of a bitch!"

I roped the calf around the neck. Bill roped his hind legs, and kept the rope tight while I got off my horse and took the rope off the calf's neck. Then Bill slacked his rope and the calf jumped up and ran off.

We went on a little farther.

"There's one," Bill said. "I'll get him." He roped the calf— another healthy calf—around the neck, I roped the hind legs, he got off and pulled the rope loose from the calf's neck, and we let him go.

This went on, one calf after another, all of them healthy, till our horses were winded. "We'd better take a breather," I said.

"Fun, isn't it," he said. "Five minutes, we'll go at it again."

"Let's talk it over," I said.

"Talk what over?"

"If we don't save some horsepower for what we're supposed to be doing, we're going to end up having to let a lot of sick calves go. What'll happen then?"

"Nothing much. We'll lie. Or is that something you've never done?"

"What'll happen to the calves."

"They'll go blind. But that's not your business.... You do what you want, though. Everywhere I turn, people take his side, but I'm not going to whine about it. You do what you want."

MAX SCHOTT

"But there isn't any side, in this."

"You try walking in my shoes—then you tell me where they pinch," he said.

"I'm not telling you anything. We ought to doctor the sick calves. If you want to rope the healthy ones behind your dad's back some other time, why, that's fine with me. I'll come and help you. I'll come and help you lie about it, too. Maybe we'll get so good we'll win a potful of money."

We rode along at a walk. A couple of cows, with big healthy calves trailing them, ambled out of our way. Bill gave them a look and let them go.

"It's after noon," I said. "I think I want to stop and eat."

"So do I," he said.

"Well, shall we stop at the same place at the same time?"

"Let's head over toward the road. There's some trees there. We'll get out of the wind."

11

It was almost dark when we got back to the corrals. Clarence had built up his fire and the three of them—old Bill and Clarence and Gordon—were standing by it. The other two boys and the car were gone. "Been back long?" Bill said.

"Not long," his father said.

We watered our horses and fed them a bait of grain. While they were eating, Bill told his father how many calves we'd doctored. "Thirty-one," he said, which was more or less right, and old Bill tallied up the numbers in a little book he carried. "How'd the mare go?" Bill said, trying to be civil.

"She went along all right. Got the kinks out of her, I guess."

You could see they were both making an effort, but that it'd be better if they didn't have to make it for too long. I think they said about as many cordial words to each other as they could find.

I thanked him again for the vests. "I got so warm in the afternoon I had to shed a couple of them."

"Well, that's good, then. I thank you for the help."

Bill and I loaded our horses and headed for home. Neither of us said much, but I was full of the milk of human kindness. Bill had

shown feelings he hadn't meant to show. I'd cajoled him, brought him back to good sense. That, and other things, made me superior to him. The main thing was, he was entangled with his father, entangled in every way, while I'd freed myself of mine.

We unloaded my horse in the dark—there wasn't any moon. Then Bill and I said goodnight, and he drove away. Before I went to put the horse away, I felt around on a couple of fence posts, found my jacket and put it on. I left a couple of sack vests on underneath, to show Marie—and Sharon if she was awake.

12

Sharon was half awake in her bed. When I leaned over her she reached up to touch the burlap.

"Scratchy!" Marie said, to warn her.

She touched it, tentative at first, then grabbed hold and pulled. "Kiss!" she said.

"Kiss what?"

"Dad!"

"I told her you would kiss her goodnight. She's been waiting."

"I've been waiting too."

When it came to Sharon I was so far gone that even Marie teased me sometimes about it. During that summer she'd begun to talk. Her first approach to language had been to purr like our old black cat. Now she could call most things by their names, but in some cases she refused to conform and went on using words of her own invention. Milk she called *guy;* eggs, *gaggies.* Bill she called *Horse.* She had spent an hour one morning helping me move a pile of stovewood, toddling from the old pile to the new at her own rate, carrying a stick at a time. Although she could barely dress herself, she liked to put her pajamas on the cat, who'd let himself go limp for the occasion. To me these were the actions not of an ordinary human child but of someone sent to earth to perform miracles.

I recognized my condition as love. A wave of it came over me now as she kissed me. But I was hardly out of the room when I found myself beginning to think troubling thoughts. At first I hardly knew what they were about and said to myself that they weren't really thoughts at all: I was just spent.

MAX SCHOTT

I pulled the vests off, hung them up with my jacket and sat down at the kitchen table. Marie'd waited supper for me. We ate, talked a little. But the same thoughts or non-thoughts kept going through my mind. Could my daughter some day be as remote from me as I was from my father? Of course she could. That was the answer. Everybody knew that was the answer, but the thing itself was beyond imagining. But how could it be beyond imagining when it had happened to me and my father? When a thing has happened to you, you have to try to understand it.... Marie saw I was in a mood of some kind and went into our room to lie down and read. "I'll be in pretty soon," I said.

I went into the front room and turned on the light. The cat, Linus, came in and stretched himself out on the rug in front of the stove—his customary spot when there was a fire. But there was no fire. "Wishful thinking," I said. He raised his head and looked at me. I sat down in the easy-chair and stared at the stove and the cat and the dark front window. The coldness between my father and me had started...when? I'd always connected it with my mother's illness and then her death, but who knew whether that was right? To think it through I'd have to remember times when there hadn't been any coldness.

Certain memories I knew were there, if I could bring them back. I made an effort and remembered running into his arms, climbing on his back, riding on his shoulders—I must've been only a little older than Sharon was now. I dragged these pictures up and looked at them, but it was like looking at somebody else's snapshots. The absence of feeling, the coldness, as I called it, seemed to have spread even to times when it didn't exist.

The curtains were open. Through the window I could see, barely see, the big hedge in front of the house, like a shadow in the dark. It reminded me of something: my father nodding his head toward me. I couldn't make it out at first, then the whole thing came back to me. When he'd come up to see us in the spring, one day we'd been standing out by the road, next to the hedge, waiting for Marie and Sharon to come out of the house. We were going to walk across to the neighbors. We had to stand there for a while waiting, just him and me, and without being aware of it, nervous,

not knowing what to do with my hands, I'd started stripping green leaves off a twig of the hedge. My father had nodded his head, I didn't know towards what till I followed his gaze and saw my hand stripping the leaves. He shook his head and I stopped. We both smiled, but they were different kinds of smiles—mine resentful, his apologetic.

What disturbed me was not that this had happened, then, but that it was happening now in my mind. He was there, inclining his head, judging me. Why hadn't I forgotten it? Why couldn't I let it pass? The truth was—I realized it now—he'd been in my head all day, overlooking everything I did. I was a thousand miles from where he was, living a life he understood almost nothing about, and he was there, like a second conscience. Waste, cruelty, unreason—his quiet battle against these things touched everything I'd done or said or thought. Everything wrong or troubling that I'd done, every calf I'd roped, sick or healthy, every bit of subterfuge I'd practiced, anything good or useful that I'd said to Bill—it had all been, every split second of it, under the shadow of his judgment.

It was a strange thing to realize. To do what I'd been trying to do—to live a life different from the life he led—was of no avail. To say, to believe, that I could free myself from him was a gross lie. The man himself I might escape from, but his presence in my mind—that would always be with me. And no warmth came from that presence. Fairness, gentleness, patience, yes—but no warmth.

The cat bestirred himself and went off to find someplace warmer. I fell asleep there in the chair, thinking, or trying to think. At one point in the night, probably still before midnight, I opened my eyes. Marie was covering me with a blanket. "I'll be in soon," I said.

Towards morning I dreamt that the stove was hot. With a stick in my hand I opened the fire-doors, meaning to stir the fire. A cat, burned alive, made of gray ash, was running in agony, round and round in the fire pit of the stove. It was my father. To put him out of his misery I knew I had to touch him with the stick. If I could do that, then the ashes that made up the cat would collapse, and he'd be gone. To touch him would be murder, active murder. Not to

MAX SCHOTT

touch him would be cruel. I stood there watching him suffer, and woke up.

It was getting light out. The stove was cold. I shook my head to try to get the dream out of it, got up, threw the blanket on the chair, opened the doors of the stove—to prove to myself that there was nothing there. The cat heard me moving around and came in. "You better keep out of there," I said. I laid a fire and lit it, trying to make the day real and the dream unreal.

In the end, I think the dream did me a service. Since I couldn't shake it off, I had to try to think about it. The violence—the revealed violence of my own feelings—shocked me. As the morning passed a thought formed in my mind. I say "in my mind," but it seemed unattached to me at first, like the floaters I used to see as a child. I'd lie on my back, look up at the sky, and there one would be, a sort of silvery ribbon floating slowly down. Where did it come from and why? It took me a long time—years, I think—to realize that the ribbons were not actually in the heavens but in my eye.

This thought was like that: it seemed to come from the outside, while really it must have come from some unfamiliar part of my mind. It arrived not exactly in words. I had to find the words for it. In my dream I had taken revenge—revenge on my father for his coldness. But the revenge was so violent that I couldn't pretend it was just. If there was too little warmth between my father and me, that was a pity, not a crime. It was not something you burn someone alive for. Yet the feeling I had in the dream was identical to the feelings I had about him most of the time. I had burned him alive in the dream because he was to blame. And now, awake, I saw that that was wrong—wrong not just in degree but absolutely wrong. Could it be that the questions I was always asking—Who is to blame? Am I to blame? Was my mother to blame? Is he to blame? How much is he to blame?—were the wrong questions? I hardly dared say yes. Could it be that in my life assigning blame was hardly different from taking revenge? And if that were true, then didn't it also follow that blaming could only make any love that still existed between my father and me harder to find? For a moment, I saw that it might.

Ory Summers

When an image of Ory Summers comes into my mind it's always the same one. I wonder why that is.

He—short, portly, about 60—is sitting with his wife, Martha—short, portly, and about 60 also—on the edge of the big cement water trough in my barnyard. It's late afternoon. The trough is shaded by a row of poplar trees.

If I stop to think about it, I know that Ory was sitting there waiting for me to come back—he was there on business. But he and Martha do not look as if they're waiting. They are talking to each other, sitting in the shade, and don't seem to wish to be anywhere but where they are or to be doing anything but what they're doing.

They were Indians—either Klamaths or Modocs—and made their living raising cattle up on the Klamath Marsh. The Marsh is a huge meadow; some people say it's the biggest uninterrupted meadow in the world. And in those days it was surrounded by some of the last old-growth forest in Oregon. Lovely country, anyhow, and Ory and Martha owned some of it.

Besides the cattle, Ory kept, as a sort of sideline or hobby, two or three hundred horses, some of which he'd sell off occasionally. The names of several were known all over the Northwest as rodeo bucking horses.

The horses he used on the ranch were of the same stock, and the cowboys he hired were pretty much of the same stock, too, so that in his old age Ory found himself without a single horse gentle

enough for him to ride. Finally he decided to take one of his young horses to town and have a trainer train it.

The first one he brought me was a spooky little blue roan. He left Blue at my place for a month, then came by to see how I'd done. To try to show off the horse I began to lope him back and forth under the row of poplars. But something went wrong, and Blue, as was his way, nearly jumped out from under me, and then, when he felt me shaken off balance, tried to finish the job.

Ory saw that his money had been wasted. But his reaction was—to laugh. It was fun to see a horse buck. In this case it was expensive entertainment—a large part of the joke was on himself. But that didn't seem to make him any less tickled.

"The son of a bitch bucks," he said afterward. "I'll give him to one of those boys up on the Marsh to ride. They'll just suit that son of a bitch. Do you know that country? Ride him another week for me and I'll bring you another one when I come back down. We don't come down every week. Wish we could, though, in the summer. Like to come to town. Can't go anywhere in the winter. I'll bring you another horse when I come down and we'll try again. Take this son of a bitch back when I bring the other one. Okay?"

"Swell."

"I've got plenty more. I can't ride 'em. Too old. You come up and see that country, before it snows. Can't, then. How much I owe you?"

"A hundred dollars."

He slipped a rubber band off a roll of money and peeled away a hundred dollar bill—the first one that I ever held in my hand.

The next horse—Red was his name—we were lucky with. He was a goosey, alert beast, but gentle as a kitten.

Whenever Ory and Martha were in town they'd stop by to see how he was coming along. And since they were so easy to please, they were always pleased.

When they'd arrive I'd often be out riding one horse or another, and they'd sit on the edge of the water trough and wait. I'd be riding in, and see them there, sitting, talking. Martha usually had a pad and pencil in her hands. Someone told me that Martha was the

one who kept things straight for Ory, that he'd never begun to get rich until he'd married her. But she seemed as good natured as he was, though she talked less. I'd say they probably kept things straight for each other.

I rode Red for a few months. Ory always paid me with a hundred dollar bill. When he came to take the horse home, Martha wasn't with him. And later that evening he was driving up to his place on the Marsh by himself, when his truck broke down or bogged down several miles from his house. I believe he told me there was snow on the ground. Anyway, all alone out there in the dark he unloaded Red, got him up next to a log or stump—Ory couldn't clamber up onto a horse bareback from the ground anymore—and without saddle or bridle, with just a halter on his head, he rode him home. It was an ordinary thing. But the next time he was in town he came by just to tell me how pleased he was.

Those things and others I can remember well enough, but I have to sort of conjure them up, while the one image, of Ory and Martha sitting together talking, waiting, comes into my mind unbidden.

MAX SCHOTT

Paying Attention

Remember how the teacher used to ask for our undivided attention—and never got it? Even if we had wanted to give it to her, she was doomed to failure. We poor humans, try as we may, can only rarely pay strict attention to anything outside our own minds. Isn't that so? It's so for me.

And when we do manage, the conditions are usually tough. For example, in Dostoevsky's novel *The Idiot*, a character who thinks he's about to be executed looks at sunlight sparkling on a roof and sees it with "terrible intensity." Good! He was alive in the moment, completely focused, the scene had his full attention. But who would want to share his circumstances? (In fact, a real-life prisoner who shared a similar experience with Dostoevsky himself went mad on the spot.)

As for me, the only time in my own life that I've managed to give my full attention to a single object (I mean, the way a cat does when stalking a bird) also was under circumstances I would not want to have to repeat.

I was out in a field by myself, riding a good horse named Roany. We were blocking a steer from getting back into a herd of cattle. Roany was dodging, running, sliding, turning, when his feet went out from under him. It happened fast. He lay there, stretched out on his side, and I, still in the saddle, found myself horizontal. He was on his left side, and my left leg was underneath him. My left foot was still in the stirrup. I could raise my head from the ground, and right away I began to be very curious. I don't know any other

word for it, and I didn't have any other feeling. What I wanted to know was, had the stirrup been bent or mashed by the weight of the falling horse? That was what I wanted to know, with a "terrible intensity." And I would find it out, see it, see my boot and the stirrup when Roany got up, which I knew he would—there was no way I could keep him from it.

Horses are nervous and flighty animals. They have to be. Darwin points out that a goat, a cow, even a deer, can afford to be relatively placid. A deer crops grass rapidly in the half-light of early morning, then goes to a secluded place to masticate what it's lopped off. But a horse is not designed that way. He has to stand out in the open for hours at a stretch, in full view of his enemies. He grinds his food where he finds it. Panic, along with speed, is his salvation.

And Roany, even for a horse, was rather skittish. For example, one day I'd taken my six-year-old daughter up behind me on the saddle. He hadn't seemed to mind that. But when we came to a gate and I got off, reins in hand, to open it, and left Sharon sitting up behind the saddle by herself, Roany looked back, saw that things didn't look as they usually looked.... It must have triggered some old instinct—what did he think she was, a mountain lion? He cocked his head, rolled his eyes, and tried to lunge away. I held onto the reins and jerked and shouted. Sharon, too frightened to scream, held tight to the back of the saddle. Roany kept twisting and jumping. I kept jerking and yelling. Sharon after a while began to list my way and finally trickled down Roany's flank to the ground. If he had got away from me, with her on him, no barbed wire fence would have done more than slow him down or flip him over or maybe cut him to ribbons, and God knows what would have happened to Sharon. We were all three I think about equally scared.

But oddly enough, I wasn't afraid now, though I knew how it would be. If my foot was jammed in the stirrup, then when Roany reached his feet and began to step away, my live lumpy body would be pulled along. Every time he took a step, it would move toward him. That he would then panic and run, there was no doubt in the world. This was old familiar knowledge to me. I had lived with it

MAX SCHOTT

most of my life. It was in the back of my mind every day, and made me twitch in my sleep sometimes at night. It was, I suppose, in my mind in some way now. But for once I wasn't aware of it. I was only aware of what was happening at the moment, and of being curious.

Time seemed to pass very slowly. Roany, with a little groan of effort, lifted his head. He blinked the sand away from his eye, or tried to, and there were large grains of damp brown sand stuck to the reddish hairs of his face. He raised his neck, began to bend his knees and to draw up his front hooves. He heaved himself up onto his belly. His left shoulder was visible now. I could see my upper leg down nearly to the knee. My pant leg was sandy. Roany's neck was matted with sweat and sand. I lay there watching. A horse has a heavy barrel and chest and hindquarters, but long slender legs. He runs easily, but gets himself up off the ground only with an awkward sudden effort. When Roany got his hind hooves under him and *thrust* himself up, it took me by surprise. My leg was jerked up into the air, and the very thing I was intent on seeing happened before I knew it. My booted foot had fallen from the stirrup.

Roany, without even rolling an eye at me, stepped a step or two away and stood with his head down, resting quietly from so much exertion. I got up, found myself uninjured, and began, in retrospect, to be afraid.

But I had paid attention.

Cecil

We were up in the loft of the barn, just him and me, sweeping it. Two or three times I'd seen him look across at the midbeam, a rafter is all it was, with a pulley hanging by a chain from the middle of it twenty-five feet over the barn floor.

When we had the place clean he stopped and leaned forward on his broom. The top of the handle only came about to his chest. He was a head taller than me. They say that doesn't make a difference, between people, but to the one looking up it does. "That pulley," he said, "we don't need it in here anymore, do we?"

"Sure don't," I said. "Not these days. Want to use it somewhere? I'll take it down right now."

"We don't have a ladder long enough to reach it," he said. "You'd have to crawl out on the beam. Wait till we come in here with a load of hay, we can stand up on that and get it."

If he hadn't wanted it now he wouldn't have mentioned it though. "I'm part monkey," I said. "I don't mind—might as well get it down right now while we're thinking about it."

"There's something in that, all right," he said.

He was the boss. Long as you kept that in mind, he'd treat you right. All you had to know was the work and your place, and I'd spent eighteen years trying to learn mine. So I climbed down the loft ladder, took a crescent wrench and a claw hammer out of the toolbox in the truck; and with the wrench in my hip pocket and the hammer stuck through my belt, while he put the forks and brooms away in the granary I crawled out along the beam.

Scared me, when I looked down; but when I came to the middle where the pulley was and where there was a brace—a double upright running straight up to the ridgepole (I'd put it up there myself eight years back when I'd hung the pulley in the first place—working then from the top of a load of hay and with a short ladder)—when I got to the brace I had something to hold onto and was all right. I wrapped myself around it, arms and legs both, then leaned forward around the right hand side of it and reached down to where the chain was wrapped around the beam, and working past the brace I unbolted the chain, then with the two ends loose unwrapped the chain from around the beam and let the pulley fall. Funny—when I saw it go for a second I thought I was going myself, just from the feeling.

The chain hung there, one link hooked over the nail—a four inch nail with a head on it almost the size of a dime and driven maybe two inches into the beam; I'd put it there myself, to keep the whole works—the pulley and chain—from drifting sideways, and I thought now I could pull it out easy with just a hammer— else I'd have brought a bar. But that old cedar was hard, and it was hard to get a purchase on the nail. I twisted and pried and ended up right where I was when I started, almost, with the nail sticking straight out again except bent up near the head a little now like a coat hook—so if you were twenty or so feet tall you could have reached up and hung your hat on it.

Then I tried worrying the link out over the head of the nail and found I could. So I dropped the chain, and dropped the hammer down too—and left the nail. We could pull it out later from the top of a load if we thought of it; because a person shouldn't leave a nail sticking out if he can help it, not even way up under the roof of a barn in a rafter (I remember thinking that, even at the time).

"Richard going to help us with the hay now that school's out?" I asked him, after we were both back down on the ground. I had business of my own on my mind, and if you wanted to put him in a good mood (provided he was already in a fair one, which he usually was, to tell the truth), then all you had to do was mention Richard, in those days.

"I hope so. I've asked him to."

I laughed. "Well, I guess he will then—if he still does what you ask him."

"He does, just barely."

"That age," I said. "Who'd have believed it—bashful as he's always been. Well, they grow, don't they!"

"It hasn't hit him so hard—not the way it does some," Lou said.

"I saw him yesterday getting off the school bus," I said. "Taller every week. Say, what would you say to my taking a trip to town late this afternoon. I thought if I could I might just—"

I had a lie concocted but he didn't let me tell it. "Sure, go ahead," he told me, then asked if I'd mind taking the truck in and picking up two or three things while I was there—save him going ("Fine," I said)—and to meet him and Richard here in the barn at four-thirty in the morning so we could be in the hayfield a little before daylight to start loading. "Fine." And to myself I said: Take me for granted while you can. I'd like to see the look on your face though when—but there was no use thinking like that. Where did it get you? I was the same as any other man to him, that was all, no better no worse—just so I did the work. And since he saw it that way, wasn't that about the way it was?—long as he saw it that way—and he'd been seeing it that way a long time. When he could have been like a father to me, right from the start he could have, if he'd only seen it the way I saw it. But there was no use thinking like that, for sure, if you could help it.

"Mary's not feeling any worse, I hope."

"No better," he said.

"Damn tough business," I said. "Doesn't seem like there's an end to it."

The broker who had the farm listed was a crony of Lou's, and knew me a little as Lou's man. I wanted the farm, though, so I went to him. "I didn't know you were even looking for a place," he said to me.

"There isn't anyone that does know it," I said.

"Oh? No one?"

I didn't say anything.

"You and Lou haven't quarreled, have you?"

MAX SCHOTT

"I'm not in a position to quarrel."

"Most people don't let that stop them," he said, laughing a little. "Buy this farm, if that's how it is. Then you'll be in a position to quarrel with whoever you want to." I didn't laugh, though, and after a minute he looked over at me (we were driving at the time, on our way out to look at the farm), looked at me and said: "Besides, aren't you related to Lou?"

"Not to speak of," I said.

"Somebody told me once you were. Don't think it was Lou."

"I'll guarantee you it wasn't," I said. "My father was his wife's brother. Some people call that related and some people don't."

You're trying to say Lou doesn't?"

"That's all right," I said, "don't worry about it. I grew up there, that's all: I work and he pays me."

"Hard to find anybody who will work, these days," he said, to change the subject. "Lou'll be sorry to lose you."

"Could be," I said.

"Shame about his wife," he said.

"Is," I said.

"She's your aunt, then."

"She's never forgot it either."

"No hope at all, they say. A lot they don't know, though, that's what I always say."

And after he saw I wasn't going to say anything to that he said: "Mind hasn't gone, I hope."

"Same as ever," I said.

"Glad to hear it. Except, there's times, you know, times I think a person'd be better off without one."

"Why's that?" I said, wondering if maybe he knew more than I did about something I wasn't too sure I knew anything about.

"Pays not to know some things," he said.

"What things are those?" I said.

"Why, that you're dying," he said, opening his eyes wide.

"Oh, is that all," I said and laughed.

He looked at me puzzled and kept quiet then maybe ten seconds, looking at the road.

"He'll keep her home right to the end, you think?"

"Least he can do, isn't it?" I said. "Might even try staying home himself."

"I didn't know he didn't," he said, swinging his head all the way round till I was afraid he'd run off in the ditch.

He didn't know a thing. "He has to be out a lot, that's all," I said. "Farm work."

He talked, talked like a barber all the way out there and all the way back, till he had my money in his pocket.

I thought I knew what I wanted, and it didn't take long for the money to change hands. Nine thousand dollars: money I'd saved forty dollars a month for fifteen years—ever since I was fifteen years old, in fact. So when I left his office I had a receipt for the earnest money folded up in my shirt pocket. He came down the stairs with me and shook my hand. "It's none of my business," he said, "but Lou, he's always been good to you hasn't he?"

"Fair."

"If you'd told him you were looking for a place, he'd have wished you well."

"I don't know why he wouldn't." I said.

"And you've been with him how long?—since you were just a little boy?"

"Ever since I was big enough to work," I said.

I started on home. It was five now; he'd eat his supper around six; and then (if he did the way he'd been doing) he'd more than likely go out. So if I meant to tell him before somebody else did I'd better do it first off. As for owing him, though, what did I owe him? Thirty days' notice that was all. I touched the pocket with my thumb and made the paper move against the cloth so I could feel it. He'd miss me. You bet, one of these days he would. Time would pass, years maybe, but he'd come around and see what he'd lost. Have to. He'd come to see it, the way I could see it now. I'd be out in the field, one day, my field on my tractor, coming down a wind-row minding my own business, I'd look up and there he'd be, at the edge of the field standing waiting for me. I'd pull up by him and shut the motor down and lean over toward him from the seat and he'd raise his head. The last few years had about worn him out,

MAX SCHOTT

he'd say, (I could see it, too), and he needed somebody he could trust who knew the work. But what about Richard? I'd ask him, acting friendly, Richard your own son and heir?—he's big enough, now; if you're a little tired, let him take over and run the place for you, like you always hoped and expected. But he'd have nothing to say to that; seemed there was nothing left fit to be said about Richard; all those hopes gone now, now that he'd grown up, but Lou wouldn't say a word, just as if he'd died. Then I'd say, Lou, I'm sorry....I'm sorry Lou, but I'm pretty well situated here now. I'd turn him down and break his heart. Why not, if I had the chance....

I came around the high curve by the river and could see the crossroads at Olene and the café, and a quarter mile this side of that, the row of poplars running along our lane. Right to the last I didn't know whether I'd turn in at his house, or not, and at the last I passed it by, drove on and pulled in behind the café instead.

When I saw how many cars and trucks there were in the lot I thought to myself, Full house. Funny, they'll see me walk in, look at me and think they know me, but won't any one of them know me for the man I am, only for what I was.

I went in. The place was buzzing. Four or five of them looked up and stopped their mouths moving, the way they would any time the door opened. But it put a kind of half crazy thought in my head: "They'll talk out of the other side of their mouths tomorrow—" as if they'd been talking about me.

I nodded to three or four.

Bill was at the counter talking to the waitress, who was standing over by him, taking what weight she could off her feet. The poor old thing looked up at me—just for a second. When I sat down at the counter by Bill he turned his big good-natured half-asleep face toward me and smiled, like he did with everybody.

"How are you, Katy, Bill?" I said.

If she knew how she was she didn't say, not to me.

"How's the world treating you, Cecil?" Bill said.

"Not so bad," I said. I ordered some coffee.

"Old man working you hard?"

"I work myself hard."

"Doesn't do any good, does it?" he said, laughing.

"I'd say it's done me some good, yes," I said loud enough so half a dozen men in a row along the counter raised their heads. He means no harm, I said to myself. Never has, "Work's a tonic," I said. "Makes you sleep good at night."

"I know," he said nodding.

"Last time I saw you you were hauling cattle—wasn't long ago either."

"Hay now," he said and looked down.

"Trouble with hay is you have to lift it. A cow has feet."

"I've been sitting here thinking about that," he said, raising his eyes and laughing a little.

"Well, a person has to think about something." I saw he was ashamed to talk about why he wasn't still hauling cattle so I said to him: "A thinking man, he's better off to haul cattle than hay, as you say yourself. So how come you to give that up so quick?"

He looked down at his hands again and turned his cup round on his saucer.

"You have to go so far out in the country after them," he said.

"So—what's the harm in that?"

When he looked up his face was pink as a rose. "The people don't like you to be late."

"Damn them, they're like that aren't they!" I said. The waitress had gone on down the counter; I saw her turn and start back, but I kept right on. "You say you'll be there in the morning and then when you show up in the afternoon people don't like it. Hard to understand!"

Two or three of them looked and laughed, and he saw I was laughing at him and started to try to say something but she gave me a look and stopped him. "Bill—" He turned. "Here!" She ran two fingers along the side of the cake dish and scooped up a gob of frosting and cake bigger than the pieces they serve you most places. "Shut your mouth with some of this."

Laughing he licked it right off her fingers (almost had to when she put them in his mouth) and forgot all about however I'd tried to make him feel. "Cecil's the one that's talking," he said. And two or three of them laughed at that, too, I don't know why.

"Let him talk," she said without looking at me. And I thought to

MAX SCHOTT

myself: they give him everything and thank him for taking it. When nobody watches out for you, though, you have to watch out for yourself. But they can't appreciate that.

"I'll try a piece of that cake, Katy, please," I said. She put one in front of me and I ate it thinking. What if I was to put the bill of sale—which is what it almost was—right down in front of him? Maybe he wouldn't understand what it was or what it meant but he'd wish me luck, wouldn't he, simple soul that he was? And how many would do that? But before I made up my mind, "Hi, Sweetie Pie," Katy said and I turned and there was Richard. "I haven't seen you in weeks," she said.

"How could you?—I haven't been in," he said, trying to joke like a grownup man, and she laughed so loud and long that he blushed and looked away from her, even though she was pushing fifty; and nearly every man at the counter looked at him and smiled.

"My father sent me over to ask you something," he said to me.

"No law against that—ask it," I said.

"I can't remember what it was," he said, as if that was the most natural thing in the world. "I'll go back." And he left without turning a hair.

"Isn't that something," I said, before he was out the door, "and he's not even ashamed. Lucky if he can remember his own name."

"Damn, they grow don't they?" somebody down the counter said.

"I remember when you could hardly get a straight look at him," somebody else said, "always behind something—Lou usually."

"Wasn't long ago either."

"I wouldn't mind being in his shoes, would you?"

"You bet. That old man of mine, he thought about money all his life but he never made any."

"Can't have everything," Bill said.

"No, but I'd settle for something."

"Some people get it on a platter and some people have to work for it," I said.

Katy said: "That's me—but what do you boys do?"

I stood up and put a dollar down on the counter.

"Leaving?" Bill said.

"Not till I make you look at this," I told him, and unfolded the paper and laid it in front of him.

He pressed it down flat on the counter with his two hands and bent his head over it till the tip of his cap-visor almost touched the wood.

"Earnest..." he said, and squeezed his eyebrows together so hard it must have hurt.

"Earnest money," I said.

"Who?"

I put my finger where I'd signed it. "Down payment on a place. Nine thousand dollars." Every man inside hearing distance sat still.

"You?"

"Two hundred and fifty acres," I said.

The words stood out in the air. Even Gordon, sitting with his wife over at a table on the far side with his back to us and who had about as much use for me as I did for him—even he turned his head.

"Hey Katy," Bill said, tapping the paper, "take a look at this. Here's how it's done."

Katy turned it around on the counter. "And where's the farm located?" she said, looking up at me.

"Way out by Keno," I said.

"Good."

Then Gordon came over—to pay his bill, or had it in his hand.

"How are you, Gordon?" I said.

"Not bad," he said. "What's new?"

"Not much," I said.

"Look at this," Bill said.

"What's that?" he said, without looking at it.

"I bought a farm," I said.

"I guess that calls for congratulations, then."

"Not necessary," I said. "Thanks."

"Well, I envy you, I don't deny it. Lou glad to see you go, is he?"

"If he is he didn't say so," I said, trying to stay halfway civil.

"He's sorry to lose you, I bet," Bill said.

"A good man like me, I imagine he is," I said.

"Lou's done more for you than most people would, to tell the truth," Gordon said.

His wife stepped up beside him and touched his arm with her hand.

"You follow me around from daylight to dark sometime, Gordon, and see if I earn my wages or not."

"Just a minute," he told her, without taking his eyes off me. "It must be something to have somebody like that behind you," he said.

"Nobody backed me," I said. "I saved my money same as you could if you knew how."

"A man who took you in and all but brought you up—for what gratitude he ever got out of it."

"Lou's a generous man, whenever he wants to be," I said. (He glanced up past me—toward the door, I saw him do it, but it didn't register till later.) "Lou's a generous man," I said, "I don't deny it—not even when you're the one who says so, Gordon."

"I wouldn't," he said, looking behind me.

Before I could turn I felt a hand on my shoulder.

"What are you up to, Lou?" I heard Bill saying.

"Looking for Cecil."

My heart sank, but when I turned and saw his face I saw he still didn't know.

"You knew where to look," Bill said. "Came at a good time, too."

"How so?" Lou said, looking from me to Gordon and back again.

"That's all right," Gordon said. "Cecil was just telling us how he's going to have to start killing his own time in here instead of yours," and he nodded toward the counter where the paper lay, but Bill was sitting in front of it.

Lou glanced that way and back again, trying to figure out what was up and, if I knew him, not much caring either—and Gordon figuring Lou already knew all about it, or else he'd have put me to shame in front of him. It dawned on me all of a sudden what that meant: if even a man who thought as little of me as Gordon did took it for granted that I must at least have told Lou I was leaving him—then I'd done a bigger wrong than I'd thought I was capable

of, and done it on purpose. For a second it made me feel light-headed.

Lou had his own business on his mind and wanted to get on with it. "I found a nut for that baler arm," he said to me, "but now I can't find a socket to fit it. I thought you might know where one is."

"There's one in the toolbox in the truck," I said. "Whenever you're ready we'll go get it. I'm done here."

We were halfway to the door when Bill said my name. I turned and walked back.

"You don't want to forget your document," he said.

"No," I said. I took it from him, Lou standing just inside the door watching.

"Truck's in back," I said. "Let me see the nut."

He fished it up out of his pocket and gave it to me.

I carried the paper open in my hand. He kept glancing at it, he was curious, and I halfway hoped he'd ask, it would have made it easier. But he wasn't one to mess around in the life of a man who worked for him—I knew that if anybody did. I climbed up on the bed of the truck, opened the tool box and found a socket. I put the nut in and turned it till it settled. "Fits," I said and handed it down to him. Then I sat myself down on the edge of the flatbed and let my legs swing back and forth.

He put the socket in his shirt pocket and stood there thinking about something, the hay probably, with one foot on the nub of the wheel and his hip resting against the edge of the bed. I watched him. His cheekbones stuck out farther than they used to, his jaw was heavier and the crease between his chin and his mouth had got deeper. Yet he was a better looking man than he used to be. People liked him. If he had anything to say to you he'd say it and you knew where it came from and what it meant, the same way you knew who he was when you looked at his face.

"Here, I want to show you something," I said, and held the paper out to him.

He took it and held it out at arms' length in both hands and cocked his head. His eyes moved down over it, then back to the top once and to the bottom again where I'd signed it. His jaw shifted and set. His lips flattened out into a line and got thin. He handed it

MAX SCHOTT

back to me. He was mad, but he still looked at me, waiting to see what I had to say.

"I put off telling you," I said, "because of all you've done for me."

He flushed red, but that passed fast.

"If I've done you a wrong I regret it," I said, looking at the ground. "I owe you thirty days' notice."

"You waited too long," he said. "I don't need any notice. You're a free man."

"—hay in the field, too," I said, trying not to hear him. "Isn't right to leave a man shorthanded. I'd like to help finish it up."

"You made your choice," he said. "Don't try to unmake it."

"I'm not," I said. "I—"

"This what you're waiting for?" He pulled out his billfold.

I shook my head. "No," I said. "No hurry about that."

He turned his back to me, slipped a check out, unfolded it and wrote it out on the rim of the truck bed.

I folded it in half without looking at it and put it in my shirt pocket.

"I shouldn't have gone about it the way I did," I said, looking him straight in the face. "I've been here eighteen years. I'd like to help get the hay in, wages or no."

"I'd rather you didn't," he said, and turned and walked off.

He was home before me. When I drove down the lane past his house I saw he'd parked his car by the back steps instead of in the garage, which meant he was going out after supper again. A man over sixty, and with hay to get up in the morning and haul—not to speak of a wife in a wheelchair—he must be chasing more than just a passing fancy. I passed my house, pulled around behind the hay barn and backed the truck in through the big double doors, into the dark, then walked back along the graveled lane toward home. The sun was going down. What was it he'd said? "You made your choice." Then he'd kept cutting me off. Couldn't stand even to hear me apologize, seemed like. By the time I got to the house it had started to rankle pretty fair. What right did he think he had to try to make me feel small? Who'd he think he was? "You made your choice," he said. "You bet I did."

Out through my kitchen window and across through the orchard I could see his kitchen window, but not into it, not yet, not while it was still light. "I'd rather you didn't," he said. That suited me. If he thought I was going to put his hay in his barn for him gratis just because I'd left him shorthanded, then he'd better think some more.

I fixed myself something to eat and sat down. Short-short-long the phone rang—his ring—and stopped after the first set. Had he been standing right by it waiting? I got up—too slow—and lifted the receiver off the hook. Nothing but a dial tone: they were that quick, before Mary could get it, either. I'm ready, come and get me: was that how it was? Or had I made it all up?

His screen door banged—only a tap from where I was but I heard it, looked up and saw him—flat-looking in the half-dark—coming down the steps, pulling down his hat. Then he drove off, and for a while I got him to stop occupying my mind.

Just before I was going to go to bed I came back in the kitchen and looked out. Without his father home to follow around after him and turn them off Richard had left half the lights in that big two-story house on.

I set the alarm for three. Somebody knocked. "Funny," I thought, "I didn't hear a car." I went to the door and opened it. Richard, standing there. "What?" I said.

"My mother wants you," he said, and turned and took off.

I pulled my boots on and crossed the orchard, went up the steps, tapped on the kitchen door that he'd left ajar, and went in. He was sitting at the kitchen table with some papers in front of him, looking at a book—almanac it looked like. "School's over," I said. "Where's your mother?"

She was in the front room, parked by the lamp. Her head was hanging forward, the light shining down on top of it so I could see her scalp through her hair. She had her eyes closed.

"Mary?"

Her shoulders jerked and she raised her head.

"Lou tell you?" I said.

"He told me. Sit down."

MAX SCHOTT

I pulled a straight chair up close to her and sat.

"He's gone out."

"Oh," I said. "Meeting?"

She looked straight at me. "Special meeting," she said.

"She knows," I thought, "but she doesn't know if I do."

She started pushing little dabs on the left-hand wheel: the chair would roll an inch and then back, an inch and then back. "Here, where you trying to get to?" I said.

"I'm sorry now we ever got this rug," she said, "it's too soft. But you never know, do you. There, that's right, turn me this way; it's hard to hold my head up straight. That's fine, I can see you better." She looked at me sort of half cocked and smiled on one side of her mouth. "Poor woman," I thought. "I'm glad you've bought yourself a place, Cecil. I hope you didn't think I wouldn't be."

"I've been wanting to say how grateful I am to you," I said.

"No-no, no speeches."

"I got to thinking yesterday. I was out checking the cattle and passed a little cow of mine—brindle—granddaughter to that brindle heifer—first thing you ever gave me—first thing anybody ever gave me, seems like. Made me stop and think. Been a lot since then too, you gave me. Bet you never thought I'd hang onto things the way I have. Anyhow I want you to know I never forgot it."

"Hush now, I'm going to give you something but you've got to promise me not to spend all night thanking me for it: I'll go to sleep."

"No need to, Mary. I—"

"Richard knows about it," she said. "I thought he should."

"Land," I said to myself.

"I wanted him to know, since it might have been his."

"It'll cause you trouble with Lou," I said.

"I have a right to forty acres—after twenty-seven years," she said.

"Only forty," I thought, "forty out of eight hundred." I felt the corners of my mouth turn down, though a minute ago I hadn't expected one. "Sure you do," I said, "but right or no right, it'll cause you trouble."

"Not this time," she said. "I hope it doesn't cause trouble for any-body, but I know it won't for me. Richard," she called, or tried to.

"I'll get him," I said.

"Ask him to bring it, please."

I went to the door of the kitchen and said "bring it."

He came in, walking with his head down and his shoulders hunched like a man a hundred years old, carrying a piece of paper; he handed it to her; she took it and glanced at it and held it out to me, and I took and read it.

> I, Mary Hill, being of sound mind do hereby declare it my wish and intention that my nephew Cecil Rhodes (my own dear late brother's only son) receive upon my decease for-ty acres (the back forty, below the embankment) of the property known as the home place, Hill Farm, on Hill Road, Midland, Klamath County, Oregon, said property held presently in joint tenancy by Louis Hill and me, Mary Hill.
>
> Executed in the presence of and with the knowledge and approval of my beloved son, Richard, this ninth day of June, 19—.
>
> Mary Hill
> Witnessed: Richard Hill

I handed it back to her.

"Thank you," she said, "now no more talk. That's Richard's handwriting. We got some of it out of the almanac. Well, Cecil, you never led the life here we could have hoped, but—Cecil, would you feel better if you had a copy, I see you can't take your eyes off it."

"Me? No. Doesn't matter. What for?" I said.

"Richard, can you bring Cecil a piece of paper. He'll copy it out himself and we'll sign it."

So I sat down at the table and wrote it out one word after anoth-er, straining to make the letters till I had to blink sweat out of my eyes.

"Let me see," she said.

MAX SCHOTT

I handed it to her. She'd hardly started reading it over when she stopped and gave me a look. "What?" I said. But when she saw I didn't know what, "no, nothing," she said and went on.

They signed it, then, and gave it back to me.

I sat down at the table soon as I got home. "I Mary Hill, being of sound mind do hereby declare it my wish and intention that my own dear nephew Cecil Rhodes (my late brother's only son) receive…"

I read it through. "Looks the same to me," I thought.

I went to bed and couldn't fall asleep for thinking. "That's two hundred and fifty sure," I thought, and forty that depend. They say she'll die. I wouldn't hurry her, even as a wish. Poor woman. Could have been eighty easy as forty—just as the whim took her. Has to die, which I don't much wish, or doubt either. Sure thing, if you think about it long enough. "You made your choice," he says. "You bet I made my choice—and I'll make another choice too one of these days if I happen to feel like it, and set up camp in your backyard again just like now, and I won't ask anybody for permission either, because forty acres you think's yours is mine—so now how's that taste to you?" He can make a lot of choices but I can only make one—he thinks. She put a kink in that, though. Things going my way for once. Odd I don't feel any better than I do. Head hurts."

Then after I did fall asleep I had a dream that woke me. I was in a place I'd never been, waiting I didn't know for what, when the door opened and a big woman naked as I was came in. Without knowing I was going to or why I should I said to her: "Where's Lou?" "Not here," she said, laughing at me. She must have wanted me, though, because she walked right toward me. But when I laid a hand on her I came and woke up. Then I fell asleep and dreamt I was in a café asking somebody if there was a place anywhere he knew of for sale, and he said he'd heard I'd already bought one. And I woke myself all the way up again, finally, just trying to make true sense out of it. I'd bought a place all right, that part was so, but I hadn't gone into any café looking for one.

And when I got back to sleep the next time I dreamt I was in a hot room where there was a red-hot stove—too hot to touch. I

pried the firebox door open with a stick, intending to spread the fire, but inside there was no fire, only a cat—ribs on it like a table fork—running round and round in that close space. Burnt alive. And when I bent down to look closer I saw it was no live cat anymore, but ash in the shape of one—suffering agonies, though, for all that. "It's all right, Lou," I said and when the stick clanged against the cast-iron wall of the stove I woke up, kicked off the covers and walked into the kitchen almost still in my sleep, or the dream still in me, and looked out the window. His house was dark too, so he was home. Then I slept, slept fine, till I woke up in the dark half-knowing it was late, waiting for the clock to ring. It didn't. I turned it on its back under the window where it caught a little starlight. Quarter to five. Had I shut it off? I swung around and put my feet on the floor. I wasn't one to be late. If I was late, he'd think I wasn't coming. But would I hurry? No, not anymore, not for him or any man. For years they'd kept me down—in their minds, where they wouldn't let me live—but not anymore, now that I—

I stood in the dark in the kitchen looking at his lighted window, a blank square of light at first, then, there, he crossed the room, already wearing a hat. One without a hat crossed: Richard. Then the two together crossed and recrossed and crossed again—filling their thermoses, probably, and gathering up their lunches and gloves and coats and leggings. From where I was, though, it was like watching shadows on a wall—hard to quite understand what made them move even if you knew. Then the light flashed out quicker than you could think and I heard the tap of the door. They'd take the truck and go to the field without me. But I was a farmer now myself, or as good as one. Funny how hard it was to feel it. But that was because of the face the world looked at me with—even now, even yesterday there in the café with the truth about me right in front of their faces—big as a road sign—still they—I put the bill of sale down on the table next to me while I ate. Hard to feel, and when I went into the bathroom and looked at myself in the glass I saw there wasn't anything there I hadn't seen before either.

I'd got what I wanted: what was the matter with me?

I grabbed my leggings, stuck a pair of gloves in my hip pocket and went out without even stopping to make a lunch. I'd catch

MAX SCHOTT

them in the barn after all if I could and ride with them to the field. If he thought I had a reason to be afraid or shamed to face him he'd find out different.

Dark out, and inside the barn it was darker. They were gone. I stood in the nave where the truck had been. Chaff hanging in the air (I could feel and smell it), stirred up by the tires. I listened. I might have run across the calf pasture and tried to catch them at the second gate, if I could have heard the truck, but water was falling over a head gate, somewhere, splashing. That was all I could hear, so I started walking.

From the top of the canal bank, when I got there, I saw the headlights already way off in the field, bobbing up and down small as penlights. I walked along the track on the sandy bank in the dark, with the loudest sound the legs of my leggings brushing one against the other, as if there was no them in the world but only me. When I came to where between me and them there was only a forty acre pasture—like a black lake below me, but I knew what it was—I felt my way down the side of the bank to take straight off across through it.

The grass when I stepped into the field was so long and thick and wet it made a sucking noise and pulled my feet half from under me the first step I took. I went on slow, and by the time I came to the field-fence there was an edge of light on the mountain. The lights on the truck came bouncing slow toward me. To make myself hard to see I stood by a post.

They came to the field edge five or six posts down, Lou driving (soon as I saw it was him it seemed as if it would have had to be). He backed the truck around, turning, and headed up the next row of bales. On the back, two men (he'd got someone to take my place, had he—that quick?), one standing on the bed pulling bales off the elevator as they came up, the other forward from him and up high: Richard, long and thin, flat against the half-dark sky, with no hat.

I crawled between the fence wires and started walking up the next row of bales. Wherever a bale lay crossways to the row I'd take hold of it by the wires and turn it long ways so it wouldn't catch and jam in the mouth of the elevator.

The truck moved away from me going about twice the speed I

was, until if I hadn't already seen the two men and kept my eye on them I wouldn't have known what they were; then it turned at the far side and started back toward me, coming down the same row of bales I was walking up: the headlights so dim in the new light that over them I could see the shape of the hood and cab and pretty soon his shape, first his elbow resting on the window ledge, sticking out, then the shape of the man himself behind the glass. What would he say when he saw me? If he tried to take me to task he'd see who he had to deal with, or what it was like to deal with an independent man. Not fifty feet from me the door opened (in the pale light until he actually hit the ground I thought even after the door opened that the truck was still moving and he was just leaning out to look at something), and Lou stepped out and came walking fast toward me, coming for me I thought and was afraid and stood turned to clay—until he stopped and took hold of a crossways bale by the wires not even knowing I was there.

"I'd've got it," I said.

He looked up. "Morning. Didn't see you."

I walked up to him. "Overslept," I said.

"Day's young," he said, which was just what he would say—what he would have always said. Did he think he could treat me just like he always had? "If I did you a wrong I regret it," I said, half hoping he'd chastise me again for it. But this time he only pushed his hat back and scratched his head.

"Want to take a pair of hooks out of the cab and climb up on the back?—Or drive if you want and I'll go up."

"I'll go up," I said, wanting to do what he wanted and kicking myself for it right afterward.

"That will make you a good farm," he said. "I always thought more could be done there than ever has."

I thanked him and for the space of a second I felt it. But then he turned away—sooner than he might have, and I cursed myself for a softheaded fool. He'd wish me well. Sure he would: to keep me at arms' length, why wouldn't he? And if I'd got under his skin there for a minute yesterday, well he probably said to himself that that was a minute he didn't want to repeat—a big man like him who had better things to exercise his mind on.

MAX SCHOTT

He handed me down the hooks and started the motor. I climbed up on the tail end of the moving truck, got my feet under me and stood there pulling my gloves on and looking at the back of the man who'd taken my place; bent over lifting a bale, he raised it up slow past his knees, a slow man with a big strong back, fat through the hips, used against the better judgment of the man himself—you could tell that. I knew him, I knew I did, but I had to wait to place him till he turned toward me: Bill. So I could be replaced by him—was that how it was? "Morning," I said.

"I didn't know you were coming, good to see you," he said.

"You bet. Make it easier," I said. "Who's that up there on top? Richard? Watch out he doesn't let a bale fall back down on you."

"Oh, he wouldn't do that," Bill said—after he looked up to see if one was coming.

"Not if he thought about it. Send a boy to do a man's work and you know what you get, don't you?"

"Gee, he seems like a good enough boy to me. What does he do wrong?"

"Does damn little wrong, or right either," I said. "Lou dotes on him but I never did see why I had to."

"Lou does?" he said and stopped and stood there trying to think. "Well maybe he does but I don't know how to fit that in with what I heard here a little while ago."

"What was it?" I said, moving close to him.

He drove the hooks in the ends of a bale that had come up the belt and lifted and pushed it on up through the air—groaning the while—to drop it on a ledge they'd set in the side of the stack. Richard saw it coming from up on top and stepped down with one foot onto the ledge, put a hook in the bale and pulled it on up.

"What?" I said.

"What?" he said (he'd already forgot what he'd even been talking about). "Oh. I don't know. Wasn't much. But I don't know if I could call it uh—"

"Doting," I said.

"I wouldn't call it that," he said, talking so slow you wanted to turn him upside down and shake him. "Right after we started, he must have stopped for something—Lou I mean, stopped the

truck—and Richard got down, and first thing I knew I heard Lou—if it wasn't for his voice I wouldn't have known who it was."

"You what?"

"Wasn't like him, I mean to say. I haven't ever heard him raise his voice, or I have now but before that I mean I—"

"What'd he say?"

" 'Now you listen to me! I asked you to help and you said you would.' Something like that. And Richard must have tried to answer him back."

"Why must he have?"

"Because after a minute I heard Lou start up again."

"What was he saying?"

" 'I don't care!' " Bill said (get him started and he was almost as good as a parrot). " 'No! I don't care about that. When you say you'll do something you do it. You don't try to back out of it.' I was sitting down and I stood up and looked over the side and they were standing right below me, Richard with his head hanging pretty low. So I sat back down here out of sight where if they looked up they wouldn't see me—not to bother them."

"And that was it?"

"No. Then Richard piped up loud enough so I could hear: 'I said I'd do it, so just leave me alone.' But that didn't set too well either. 'I'll leave you alone when you show me you're ready to be left alone. And if you can't work without sulking go back to the house and we'll do it without you.' "

"A love spat, that's what that was. He dotes on him, don't think for a minute he doesn't." A bale was coming. "Step back out of the way," I said, "I'll get it," and he backed up a step and rubbed his chin.

I told him to go on up, then, and help Richard. He found a toehold and went. Five minutes later he came back to the edge and called down: "Cecil, how many bales high do we go?"

"How many? Did you ask Richard? Call him over."

Richard came to the edge and stood looking down at me. "How many bales high do we load this truck so we can still get under the crossbeam of that barn?" I asked him (I figured if he'd ever known, he'd forgotten).

MAX SCHOTT

"Eleven, I think."

"Nobody's paying you to think," I said.

"Eleven," he said smiling. "Nobody's paying me at all."

"I could tell you why that is, too," I said to myself—and might have said it to him—last year I might have, if he'd been worth bothering with then—and I might have now, but I thought I'd better feel my way. He was a different boy from what he'd been last summer or the one before.

"And how many high are you now?" I asked him.

"Nine, I think." He stood there looking down at me calm as a judge. Was he trying to sass me?—more likely he thought he was funny." All that thinking's going to get you in trouble," I said. "Save it for school."

He stopped his smiling.

"Seven-sixty, that's enough for one man."

"What?" he said.

"'What?' You know what," I said. "Forty from eight hundred: subtraction, that's called. Little old chunk. Doesn't matter to you."

"No," he said, "it doesn't. I—"

"That's right," I said, "don't even dirty your mind with it."

A bale came up the belt, jammed against one already waiting on the platform (I'd let myself get behind), bumped it four or five times and finally rode up over the top of it. I sank a hook into the bottom bale and pulled it out from under. When I looked up Richard was gone, which suited me. I was lightheaded again, and there was a little rush and catch in my chest when I drew a breath. But when I put myself to work it helped. Bales kept coming, one then another; sweat ran off me, and I managed to get myself about half hypnotized, till after a while when I looked up and saw the bottoms of Richard's two big overshoes swinging.

"We're eleven high now," he said, sitting there on the edge of the stack just dangling his legs. Is that what he thought was right? To sit idle while another man works and watch him? "Where's your new farm going to be?"

"Keno," I said. "Go tell your father to stop the truck so we can move the elevator."

"Sure," he said and lifted his knees and rolled back out of sight.

So he was going to try to be friendly too. Did they all think it was as easy as that? Just whenever it took their fancy?

The truck stopped. Bill jumped down on the bed beside me and wiped his forehead with his sleeve.

"Steady job just to keep that boy on his feet," I said.

"Richard? I can hardly keep up with him."

"Well—then I guess the two of you are a pair."

He laughed, then, but a minute later, after we'd dropped down off the truck he came up close and nodded over toward the elevator where Lou and Richard were kneeling facing one another— nose to nose, almost—on either end of a nut and bolt. "No," Bill said, "if you're looking for a pair, now there's one, I'd say,"—as if I hadn't seen it a thousand times to his one. But I kept quiet.

Lou was holding his wrench on the bolthead while Richard on the nut-end was turning his. All of a sudden Lou looked up and raised his hand with his fingers spread. We hushed without knowing what for, listening.

Sure enough, a car somewhere on the other side of the canal, hid from sight by the raised bank.

"I had somebody coming to look at some hay," he said. "Sounds like she's got into the wrong field." He put the wrench in my hand and took off, stepping along through the cloddy stubble. I knelt down and found the bolt. The first time I looked up he'd already ducked through the fence wires and was starting across the pasture. The next time, he'd stopped halfway to the canal, stone still. Had she gone?—given up looking and gone back wherever she came from? But no, he must have heard her tires hit the planks on the bridge: there he went again, faster than before walking bent forward from the waist like a man trying to catch up with himself. And after a minute, here she came in an old green Plymouth the size of a fist, rolling along the top of the sandy bank, throwing off a little hoop of sand behind her. Richard, he was looking too, but when he saw me looking at him he looked away. "Be nice to have it made, wouldn't it," I said.

"This one's off, Cecil," he said and moved his wrench to the next nut.

I pulled the bolt out and looked at my hand shaking holding it.

MAX SCHOTT

They were standing by the door of her car when I looked up. A little on the thick side, and short; she didn't come to his shoulder. But if that was how he liked it let him have at it. She got in the car and he did too, on the same side, and drove off with her.

"Look there," I said. "Dad, he can go, can't he, go and come just as he pleases—but you, you can't, even if you ask."

He glanced at me. He knows too, I said to myself.

"That's all right, though," I said. "We don't mind, do we. He wants to talk to her a little in private—shouldn't take but an hour. We can do the work."

"This one's off, could you put your wrench on the next one?"

"Sure, why not? Where's she from, I wonder. Not from this neighbourhood, or somebody'd know who she is. Sort of intercepted her out there on the bank, didn't he. Nice looking woman, from a distance. How's she look up close?"

"I—don't know."

"What's her name?"

"I—don't know. *Bill*, this is ready to move, could you help us?"

"Never mind then," I said. "I don't like to push in where I'm not wanted. I wouldn't want to get on your shit list, I've been on a lot of people's but I wouldn't want to be on yours—big as you're getting, I'd hate to offend you."

"Don't be silly," he said, and blushed, looking at me to try to tell if I was ribbing him, but I wasn't, exactly.

"You'll be a farmer too one of these days. Give us something in common. I worked for it, but you can't help that. How's Mary this morning?"

"Not well."

"Been a long time since she's been well," I said.

He nodded and smiled and got away from me quick as he could afterward and tried to avoid me. We moved the elevator, put on the back half of the load, threw the ropes over the works and tied it down. I sat down behind the wheel to drive to the barn. When he saw that, "I'll ride in on the load," he said and took off up over the cab. So I said to Bill: "You drive, be good practice for you. I'll go up and keep him company."

I came up behind him on the hay. He had a shoe off and was

holding his stocking foot with one hand and picking at it with the other: off in a world of his own. When I touched his shoulder his whole body jerked. "Took you by surprise," I said, and sat down on the hay beside him. "Well, I won't be here much longer, we may as well try to get along, I'm willing if you are."

He hung his head and gave it a little shake no: hard to say what he meant by it.

"Burrs in your sock? You're growing up so fast—they say you're big enough to carry on a conversation with, almost—so I figured it was about time we sat down together and had one. Doesn't have to be about anything special."

"If you've anything to say about my father say it to him," he said, sitting up straight.

"Now who wants to talk about that?" I said. "Look. You know what this is?" I took the paper out of my pocket. "Bet you never seen one." I started to try to unfold it but my hand was shaking so hard I was afraid to and gave it to him the way it was.

"Take it, it won't bite you." I said. "I wouldn't show it to everybody."

He unfolded it. "The deed to your new place?" he said.

"Close enough."

He looked at me and tried to smile.

"How do you think it feels, carrying 250 acres around right in your pocket?"

"Good, I hope."

"It should, shouldn't it, it should feel good. Give it here." I took it out of his hand and held it out in front of me not a foot from his face.

He looked at my hand shaking and turned away. "What?" he said.

"You know what. That's not the wind blowing."

"What—what's it from?"

"Staying too long in one place."

"Are—are you afraid?—you don't seem like it."

"Nah—me?—not me. I remember something you don't," I said, talking fast and laughing, folding the paper up. "I remember the day you were born. Bet you don't, do you?" I laughed again but he just looked at me. "How old was your father then?"

MAX SCHOTT

"Fifty."

"That's right, fifty, and you're what?—sixteen? I was fifteen, and I'll tell you a little secret: when your mother started to show I thought it was plain indecent—not for her, but for him to have done what he did, a man fifty; I thought that wasn't right—for a while I even thought it wasn't possible, but I learned better than that. You're his. Isn't anybody doubts that or ever did, even then. But I mean to say, indecent."

"I asked you to not—"

"Just talking," I said, "just talking. You and I, we might never pass the time of day again in our whole lives. Anyhow he seemed older to me then when he was fifty and I was fifteen than he does to me today when he's sixty-six—because I'm a grown man now. So he must seem older than the hills to you—I've thought about that even before—and then now I say to myself: he sees his father, his own father, out—and his mother sitting there home in a wheel-chair thinking about it."

"Why don't you say that to him?"

"That would be hard, for a fact it would, but you and I—we can talk, can't we?—talk to one another like friends?"

He turned away and starting messing with his foot.

"But a person can't talk to him—not about anything but business, maybe you can, you're his son, but I can't. He'll have you down on your knees—anybody but you I mean—have you down thanking him, for nothing at all most likely."

"I think I—just want to be left alone," he said, and without even looking at me he lay down on his back, one shoe off just as he was, put a hay stem in his mouth and shut his eyes.

"That's your privilege," I said. "You want to keep to yourself, go ahead, all you had to do is say the word. Breeze feels good, hot in the sun when the truck's not moving. That's why Bill keeps in the shade. Smarter than he acts, that guy. You ought to have a hat. Sun'll burn your eyelids."

He hooked the crook of his arm over his face.

And he wouldn't move, not even going up the canal bank grade where we were tilted at an angle, or bouncing over the bridge either, he wouldn't sit up and look around him. "Quite a view from

up here," I said, just before we started down the far bank. "Don't see her car anywhere—not by the barn, not by the house. Gone. Well, it's been an hour. Think he went with her? No, there he is coming out of the barn on a horse. What's he up to now, you think? Finish one job and start another, that's the way to do it all right. What's that he's got in his hand, though, tell me that. A man had a cock that long, he'd need a woman just to carry one end of it."

Except to breathe, he didn't move a muscle.

A thousand yards off, Lou rode toward us down the lane, then turned through the open gate into the little side hill field full of bales lying turned every which way. I watched him. He rode up to the first bale he came to, stopped his horse, laid the end of his pole or whatever he had there against the end of the bale, turned the horse and rode off one step, maybe two: and the bale swung round on the ground neat as you please; he rode to the next bale and the next and turned every one to lay in line with the first. "See there?" I said. "He's wired a hay hook onto a rake handle. Simple as that. But who'd have thought of it but him? Teaching a young horse patience and manners and saving a couple of gunsels like us having to bend our backs in the hot sun. But you or I—now we couldn't dream up something like that in a thousand years, could we?"

We came off the grade down onto the flat, the truck creaking and swaying. He sat up.

"You're just like him though, people say."

He didn't answer or look at me, but he looked at Lou.

When we came by the gate to the field Lou was about a hundred yards from us, coming back up the row. He nodded. I raised my hand to him; Richard did too, then lay back down and shut his eyes—he couldn't shut his ears, though.

We swung around in front of the barn. Bill, after he pulled up twice as far as he needed to line the truck up with the doors, put it in reverse and started backing.

"Now sit up—we're going into the barn," I said to Richard.

He shook his head without opening his eyes. "I don't need to," he said.

"What way's that for a boy to talk to a man," I said. "I said things to you I wouldn't say to just anybody, and now you want to take ad-

MAX SCHOTT

vantage. Sit up. A person has to look what he's backing under when he backs under something, for his own good I mean, or he might get taught why."

That put the fear in him, I believe, but he tried not to show it and didn't at first—just lay there, till the shadow of the barn fell on his closed eyes—then he rolled over onto his belly, looking around.

"Get up on your knees and look in front of you. What if you miscounted and went a bale too high?"

"What if I didn't?" he said.

When we passed in under the high arch the truck filling the big doorway made the inside of the barn dark as night to us. Up on my knees (him on his too now beside me) I looked hard back into the barn for the midbeam, but at first all I could see was a place off to the side where a couple of dirty light beams coming through a hole in the roof struck the loft. The truck stopped and Bill called up: "Where are we? I can't see."

"You aren't anywhere, what do you need to see for?" I called down. "Back it up. You got the whole length of the barn to go. When I tell you to stop, stop."

We started backing. Ah, there it was, the flat of it coming at us, darker than a shadow up there in the shadows—thirty feet off, maybe twenty-five, dead on a level with us if you believed what you saw. "Looks low," I said. "See it?" and I felt him freeze beside me. "Ready to jump?" I said, laughing.

"When you are."

Bit by bit as we moved toward it and the angle we saw it from got steeper the beam raised itself. But he wasn't trusting his eyes or anything else. Even when we were only ten or twelve feet from it and you could tell it was going to clear us easy he still wasn't taking any chances, and when the back of the load started under the beam he dropped his chest down almost to the hay and had to twist his neck around to keep looking up. "Watch out," I said, "it'll reach down and grab you—it's only been there thirty years."

There on my hands and knees with my body turned a little at an angle I kept my eyes on the beam and on him too. I laughed out loud at him, crouching down the way he was, and when the beam came I let it pass so close over me that the underside of the wood

rubbed the crown of my cap and I felt it on my head. "See there?" I said, "Who's afraid? You don't have to lie clear down on your belly, not if you—"

My pants grabbed me in the belly. A gap jumped between him and me; his face spun round to face me and moved backwards away, his mouth round and the whites of his eyes big so that I knew something bad had happened—to him, I thought. Had the whole load split in two? What was carrying him off? But it was my own self scraping and grabbing, getting dragged over the hay, how or by what I didn't understand. A haywire I got hold of popped like a thread in my hands. Then when I saw the cab roof way down under me swaying I knew I was airborne and closed my eyes (they closed themselves) and I kicked and flailed like a baby, until when I opened them the cab was gone and way way down I saw the ground swinging so I was scared even to breathe and tried to hang still.

Scared to move—to move my chin even, I rolled my eyes down: there was Bill looking out into his side mirror, backing. "Stop," I tried to holler: "Stop." But not a word came out of my mouth. I raised my head slow and started to gyrate. Richard? There he was, where he had been, hadn't moved, up on his hands and knees staring straight at me, his mouth and eyes still as three circles, but far far away, high as I was but far away, the truck carrying him off. I put my tongue between my teeth and opened my mouth wide: "Stop," without making a sound. It took, though, and he moved, unfroze himself and started crawling. I started to hope. He stuck his head over and called down "Stop!" but too late—Bill never hit the brake, never had time to. It was the wall that stopped them and the jolt sent a tremor through the barn and popped me off that nail like a spit wad, and the next thing I knew or heard was the sound of a man groaning.

MAX SCHOTT

Old Hopes and New

In mid-December we took our VW to the shop. The brake on a rear wheel was grabbing a little. A small thing, but once Steve got it taken apart it was clear the job was going to be more complicated and expensive than anyone had expected: The brakes were shot.

We asked Steve to go ahead with it, and he called me up when he was done. "I'll be in and out of the shop, but the key's there and the car's ready. You can pick it up whenever you like."

I said I'd pick it up that day and that I'd stop by the next day to pay him. "I can only give you about a hundred dollars now, but next month I—"

He didn't let me finish. "Would it be better for you not to pay any of it 'til after Christmas?"

I told him it sure would, and tried to thank him.

"No, no," he said. "Don't even think about it."

It was typical of the man,[1] and also of the month. By which I don't mean that people are more generous in December, but that in December everything is more itself than usual. The sun is brighter, the air on the shady side of the street brisker, the gloomy person gloomier, the hysterical person more hysterical, the generous man more generous, and so on. Life runs strong in December.

But there's also, in December, an undercurrent of sadness and disappointment. It's the end of the year, and we look both directions. Ahead, we can't see very well, but things look pretty good.

Their shapes are unsettled, indefinite, but bright. When we look ahead we see by the light of hope.

Looking back, it's different. The light is not so bright, but we can see all too clearly: this is what was done this year, this is what occurred. We remember what we wanted, what we hoped for, and we use those old remembered hopes as a measure. We wanted more than we got.

Measure a life against its hopes, and it will read like a charted history of failure and loss. Mark that measurement off into years, and you will see then why the face that looks back from one December to another is sad.

But if this is so, what keeps us from learning? If bygone hopes stand out like emblems of our old perennial foolishness, then by what trick of the mind do we keep looking forward so cheerfully? If old hopes proved false, why hope again? Are we so incurably gullible?

These are probably not questions we should be in a hurry to find answers to. The Greeks, in one of their old stories, said that we, we human beings, when we were still in our original unbenighted state, could see both ways in time equally well. The future was as clear to us as the past. But this made us so miserable that Prometheus, the god who was the friend of man, took away our foreknowledge forever, and gave us as happy substitute blind hope.

It seems that hope, blind or not, is the very stuff of the mind's vitality, a form of high spirits. Probably we should not knock it, even though it makes fools of us and makes us sad.

Thomas Hardy wrote a poem about, or partly about, a frail little old bird who chose, on a darkening New Year's Eve, "to fling his soul upon the growing gloom" and to sing "of joy illimited" (or boundless joy.)

Hardy, after having listened to the bird, says:

I could think there trembled through
His happy good-night air
Some blessed hope, whereof he knew
And I was unaware.[2]

MAX SCHOTT

But was Hardy "unaware"? The hope, wherever it came from, was not just in the bird, but in the man too, who heard or imagined or felt or invented the singing bird, and turned its song into words.

NOTES
1. Steve Raffetto
2. The poem is called "The Darkling Thrush." At the end, Hardy gives a date: 31st December 1900.

Turpitude & Rectitude

Like you, probably, I'll never know. But I wonder how a person of unfailing moral rectitude might feel upon finding out that someone—friend, acquaintance, public figure—has committed a crime. My guess is that this hypothetical person (though I believe there are such people) would react simply with mild puzzlement. I mean, I doubt if perfectly honorable people really understand the rest of us.

The rest of us, who pretty much fill up the world, don't understand each other very well, either. But we do recognize, vaguely, what we have in common: We are crooks among crooks. We know this, but, as long as our neighbor's particular form of crookedness is sufficiently different from our own, we avoid taking the similarities to heart.

It may even give us pleasure to see that neighbor caught, unmasked, punished. After all, he *should* be caught, he should be punished—shouldn't he? Yes, he should. And knowing that gives us pleasure too.

But when, as sometimes happens, we hear or read about a person who has got in trouble for practicing our own brand of moral turpitude, it's harder to know quite how to react. It's not that that person shouldn't be punished. No, it's more like, maybe we should be punished too? A hard thought, for sure. And besides, to forget our own weaknesses is a temptation we've probably already succumbed to; to be reminded of them in connection with a crime, is a jolt.

This happened to me the other day when I saw, on the front page of the newspaper, an article about a young man who'd pleaded *no contest* to a charge of theft. He was the manager of an apartment building and had been accused of depositing rent checks to his personal account. He told the police that his sister had (or must have?) deposited the checks to that account by mistake. The police located the deposit slip and "found that the writing was similar" to the young man's. And he, when he was shown the same document, "said the writing looked like his and said he could see he made the deposit." As I say, he pleaded no contest. I wondered, though, after I'd finished reading: Had he ever actually intentionally lied? Maybe he really believed he hadn't made the deposit.

No way of knowing. And anyway, I realized quickly enough that I was thinking about myself. I thought about how easily I might once have been arrested for nearly the same thing. And I got reminded, too, that the same qualities are still as present in my character now as they ever were—the only difference perhaps being that I've learned to trust myself less than I used to.

What happened to me, or I should say, what I did, is this: I was living on a ranch. I had debts. They kept getting bigger. I also had some money, in stocks, but that was disappearing fast. And I had a generous and obliging father.

I used to lie awake at night, trying to look down at my little life from a star. This worked fairly well in its way: It made my debts look smaller, but did not actually reduce them.

One day I called my stockbroker and asked him to sell the last of my stock, about a thousand dollars' worth, and to send me the check. Three or four weeks later I "realized" that no check had ever arrived. I called the broker. He said he had a record of its being sent, but if I hadn't received the check he would send another.

A few days later, that check arrived. I deposited and spent it.

A few weeks after that, the broker called and told me in a very flat voice that I had deposited both checks. I said: "Oh."

The first check I must have taken—did take—to the bank. I endorsed it, deposited it, spent it. And of course it disappeared like water disappears into the air or earth, and I erased every memory of it. I admit it's unusual; such absolute forgetting is a talent few

people have. Anyhow, the broker asked for the money. I had to ask my father.

As I say, I'm no different now, though I hope I have a little bit more self-knowledge.

What would happen, by the way, to a person of apparently unfailing moral rectitude, who happened to be half out of his mind with poverty and worry, so much so that a good deal of the time he hardly knew what he was doing? Could such a person, if the opportunity came along, could he, in a state of extreme absentmindedness, pocket a small sum of money that was not intended for him, and remember nothing about it afterward? What if he were accused of it?

I ask the question only because it has been answered so beautifully in a novel—which now you will not fail to wish to read, or reread: Anthony Trollope's *The Last Chronicle of Barset*. It's one of the best stories in the world.

MAX SCHOTT

First Class

I want to describe just the beginning of my life as one of Marvin Mudrick's students. It was an experience that went on for quite a long while, though not long enough. I liked being a student, in fact I liked it better than I like being a teacher, though I like that too.

The other night, I was talking to Al Stephens—Robyn and Anne were there too, and Fran Stephens, and my wife—about how once during one of Mr. Stephens' classes, which I was taking, it came up that one of the students was the daughter, about twenty years old, of a student who'd been in a similar class that Mr. Stephens had taught more than twenty years earlier. I pointed out, in the class, that I had been in the earlier class too. Mr. Stephens smiled and said to the class, "He's a slow learner."

The first classes I took from Marvin Mudrick were in the fall of 1965, and I went on taking them, I think nearly every semester or quarter, until he stopped teaching a couple of months before he died—in the fall of 1986.

In 1965 I was thirty years old. I had come back to college to get some kind of advanced degree in English, partly because I thought I might be able to make a living by teaching, but mostly because I liked to read and write and had very little formal training: as an undergraduate, ten years earlier, I'd been an Animal Husbandry major.

I was let into the university here on a provisional basis: I was to spend a year taking nothing but the upper division courses

required for an English major. If I did well enough in those, then I could become a graduate student in English.

I didn't know anyone here, didn't know anything about any of the teachers and wasn't inclined to ask questions. I read the catalog and signed up for whatever courses met the listed requirements. Two of the classes I signed up for were taught by the same person, but that meant nothing to me at all. Those courses were Chaucer (it was a semester system then, and the Chaucer class covered both *The Canterbury Tales* and *Troilus and Criseyde*) and Nineteenth Century English Fiction. They met one after another, though not in the same room or building.

They met on Tuesdays and Thursdays, in the afternoon. So by the time I arrived at Mudrick's Chaucer class for the first session, I'd already gone to my first three classes. They'd been more or less what I remembered college classes as having been before, and in fact that's about all I remember about my first impressions of those courses. Later it began to dawn on me that the teachers were all human beings, and therefore at least worth hating, but at first even that wasn't clear.

All the English classes in those days were big—often with ninety or so people in them—and were scheduled to meet in big rooms. The Chaucer class met in the Drama building in an amphitheater. The teacher, instead of being on a level with the students or above them, was down at the bottom.

I mention this because what first struck me about Mr. Mudrick was how vulnerable he seemed. He looked nervous and rather petulant, and the first thing he said was that he couldn't teach without a table to sit at. "Sorry, have my little compulsions."

He and two male students went out after a couple of minutes and came back in, the students carrying a table and Mr. Mudrick a chair. He sat down, hunched his shoulders, and began to read the roll. Physically he seemed to want to disappear, but his voice was full and reverberant; even this casual use of it, the saying of names, I think gave him pleasure.

It was a long time ago. I don't remember the order he said things in or the words that he used, though I do remember, roughly, a lot of what he said.

One of the first things he told us, I forget how it came up, was that he'd picked up a fungus infection in the army—jungle rot, and that was the *only* reason he wore sandals (he wore sandals with socks). This was in the days of the counter-culture, the early days of the student revolution. He said he didn't want us to imagine that he conceived of himself as any kind of a rebel.

"If in the safety of the classroom I sometimes allow myself to sound like one, I want you to know in advance that it's all calculated. The risk factor, that is, is calculated and amounts to about zero. As some of you've no doubt heard, university professors after they've been around a while, are nearly impossible to fire. I mean, you almost have to be convicted of a crime first, preferably a felony involving some kind of moral turpitude. And that almost only happens to deans and chancellors, who for obvious reasons are more worth pursuing." He went on I think without pausing. "The subject of this class is Chaucer. The reading material is Chaucer, and if you don't do the reading the course will be a disaster—for you as well as me, I hope, though my primary hope is that you will read the material, which by the way most of you will find much less difficult, or at least a little less difficult, than it appears at first. Don't be frightened off by what are really only peculiarities in Middle English spelling. Anyway, I expect you to read the assignments, and to try to make out what's being said. Whether you will find the reading interesting or moving or funny or sometimes all these things together, is a different matter. You are certainly not obligated to, even though I will try very hard to persuade you not only that I, for reasons I will try hard to make clear, am crazy about this or that passage, but that you should be too.

"If this sounds like a contradiction, it is, and I don't know any way around it. I suspect that you are better off if you are not convinced too easily that Chaucer is the greatest writer in the history of creation, that you have to admire and love him, that if you don't you are unfit even to exchange literary opinions at cocktail parties, and so on.

"Nothing kills off your capacity for taking pleasure in the arts, in other things too but especially in the arts, more quickly, nothing kills that capacity *deader*, than the feeling of obligation, the notion

that you are supposed to be moved, that you ought at every moment to be saying to yourself 'this is great stuff'. I believe that. And yet you will hear me trying to persuade you that if you are not having the same responses that I claim to be having, then you are in danger of allowing the cheapest and most long-lasting pleasures to simply pass you by. Which certainly would be very foolish of you. And I believe that, too.

"Chaucer will be the hero of the class, naturally, and the whipping boy will be Shakespeare, who has had probably a greater influence, certainly a greater pernicious influence, on Western Civilization, than any other historical or literary figure; that is to say, than anyone else at all. Please stop me at any time with questions or comments or especially arguments. I like to argue and I hope that you at least are willing to argue. Because it's really the only way I know of proceeding. I will try to provoke you, and unless at least some of you react, you will all be bored and I will be unhappy."

At roughly this stage of the first session of a class, some brave offended student would usually stand up and walk out, followed then after a dignified interval, by one or two others. In later years, Mr. Mudrick as some of you will remember, set aside a special time for this leave-taking, "in order," as he put it (this is in Lance Kaplan's book, *Mudrick Transcribed*, pg. 141) "to spare your feelings as much as possible, but even more importantly my own."

I said that my first impression was that he was vulnerable. Everything afterward, during this first class, reinforced that impression, though many other impressions were added to it. He was eloquent, for example, more so than anyone I had ever heard or have heard since. And here I have to put in a disclaimer. I already mentioned that I don't remember his actual words. I should add that I don't possess the rhetorical or mental powers that I or anyone would have to possess in order to be able to reproduce Mudrick's flow of speech and flow of thought. Luckily, there is a book, and there are tapes, though not from this particular class or even from this period of his life.

He was eloquent, but in his talk, too, in his "way of proceeding," he made himself vulnerable. Chaucer was clearly on his mind, but he hadn't come in with anything mapped out to say. It was all

MAX SCHOTT

improvisation. And he put himself on the spot in other ways. He talked about himself, he made fun of himself, he boasted, he made fun of his colleagues, he said unfriendly things about Shakespeare and nasty things about Shakespeare's academic worshipers.[1] He said that he didn't like Jesus[2] and that Chaucer should have been God. He tried to provoke arguments with students—that was not just talk—he liked to argue and to be argued with. (One student, older like me, had spent years in a seminary and was a willing combatant this first day and in fact for the whole semester.)

By the end of that first session, probably sooner, I had formed an incomplete but pretty accurate impression of what we were being given. Parts of it I couldn't quite make out, other parts were clear. The gift of gab, the delight in arguing, the love of hyperbole, the propensity for intellectual provocation, the irreverence and blasphemy, the pleasure he took in kicking against the pricks, his conviction that talk and thought (even about serious things, or especially about them) could and should be entertaining: all this came across within minutes. Other qualities—his love for his subject, the scope of his reading, his timidity, his generosity, the ease with which he could be hurt—didn't make themselves apparent to me so quickly, though looking back I can see that they were apparent. One of the most attractive things about the man was that all of him was there.

What seems remarkable to me now is that by the time the first class session was over, I knew that something had happened, to me. If I'd had the words for it, I think I'd have said to myself something like: "This is an experience I've never had before and was waiting for without knowing it."

It sounds nearly like falling in love, and was as exciting as that—though it turned out to be mostly without risk or suffering: a good experience, which lasted—like other good experiences—not long enough.

NOTES
1. His position didn't soften. In 1973 he published a review of books by academics writing about Shakespeare: "Twenty-three Stone-Deaf Theologians" is the title.
2. See the title essay of *Nobody Here But Us Chickens*, 1981.

The Fashion Plate

After he heard Dr. Johnson say, "Yes, sir. No man is a hypo-crite in his pleasures,"[1] Sir Joshua Reynolds must have gone home and thought it over. Anyhow, some time later, in a note not intend-ed for publication, he wrote: "We have I suspect something of hypocrisy in our pleasures, we say we like what we think we ought to like."[2]

That's a smart, well-said thing. But Reynolds thought too well of most of us if he believed we really know what we like. When it comes to our pleasures, we're not clear-minded or self-honest enough to be hypocrites. We don't just *say* we like what we think we ought to like—we come to believe that we *do* like it.

"The word *hypocrite*," says Marvin Mudrick, "doesn't really apply—that is, people are very often influenced in the direction of imagining that they're enjoying things which in fact they don't enjoy. And all you have to do is look around any audience in an auditorium in which, for instance, music is being played or a play is being performed, and you realize that many of these people are here because they've been *persuaded* that they like this stuff."[3]

True enough. But why should it be "they"? *We've* been per-suaded, or we persuade ourselves. And when we look around, eventually we may see ourselves, and doubt our own enthusiasm. Enthusiasm is a terrible thing to doubt. If you doubt it, it can hard-ly be enthusiasm. Would we all rather be home in bed? Surely not! Surely, some of us still have a little real appetite left, even for the things we've learned to claim that we can't live without.

If we do have some little live appetite for aesthetic pleasure, then what we want to do is find it, protect it, give it the food it wants or needs—fending off all the while the heavy hands of fashion, obligation, social pressure, social anxiety, and especially our own vanity and snobbery. How do you go about it? I don't know, exactly. Stay home. Read a book.

Marvin Mudrick: "I don't know how it is with some of you, but certainly when I was very young, I would go to the library and take out books because they were long and had small type. I always thought of that as marvelous, wonderful, that all that material was contained in this little cube.... And you read because it's exciting to read, and because the *act* of reading is exciting, almost irrespective of what it is that you're reading. I mean, the idea that this much material can be contained, and that somebody's life is there, *many lives are there.*"[4]

You can't *make* yourself have this kind of experience, but if you have had it, if something like it sounds familiar, maybe it can be kept alive.

Can it? You'd think that reading at least (reading is the most private and plebeian of hobbies—who cares what you read, who even notices?) could make an easy escape from the pressures of fashion. But it isn't so. We sell out for free. We're snobs even when no one's looking, even in private. So what do we do? I mean, you and I, who still have that little ember in our bellies. Cowards though we are, it's still there isn't it?—and how do we keep it from going out?

To each his own method, or methods, or non-methods. For myself I know a good way to look for a book. What I'm after is an escape from as many forms of legislated fashion as possible and especially from those that have got incorporated into my own brain. I want to put myself in the way of a happy accident.

In the first place, I go to a library, not a bookstore (bookstores are themselves the slaves of current fashions). I wander up and down the aisles, allowing myself to be attracted by titles, bindings, subjects half-unknown to me, authors I've never heard of. I pick up a volume, read a sentence or two and either put the book back or not, as the spirit moves me. I gather up eventually, ten or twelve books, pile them on a table, sit down, open one up, read a few

more sentences. If I feel I might want to go on, I put it aside to take home, knowing that, after all, I still don't have to read it. No obligation! If I'm lucky, I find as many books as I can easily carry, and take them all home.

What do I get from this? A book to love sometimes, which is no small thing, and also, simple soul that I am, the illusion of being free.

No doubt some robust spirits, healthy iconoclasts, can maintain that illusion in a theater, a museum, a concert hall—or even at a poetry reading. I hope so, anyhow.

NOTES
1. Boswell's *Life of Johnson*, Oxford University Press, p. 1309.
2. *The Literary Career of Sir Joshua Reynolds*, F.W. Hilles, p. 104.
3. *Mudrick Transcribed*, Lance Kaplan, p. 250.
4. *ibid.*, pp 276–277.

Chekhov's Colleague

Dr. Praskovya Tarnovskaya, a Russian doctor, "author of works on psychiatry, anthropology, and social welfare," was, according to her great-nephew Vladimir Nabokov, "a very learned, very kind, very elegant lady. She had an enchanting way of greeting us, as she swept into the nursery with a sonorous *'Bonjour, les enfants!'* She died in 1910. My mother was at her bedside, and Aunt Pasha's last words were: 'That's interesting. Now I understand. Everything is water, *vyso-voda.'*"

This brief portrait, affectionate and calm, is from Nabokov's autobiography.[1] There's certainly no reason to doubt its veracity. Nabokov also says, "One evening at Ayvazovski's villa near Feodosia, Aunt Praskovya met at dinner the twenty-eight-year-old Dr. Anton Chekhov whom she somehow offended in the course of a medical conversation...and it is hard to imagine how exactly she could have provoked the incredibly coarse outburst Chekhov permits himself in a published letter of August 3, 1888, to his sister."

Here is Chekhov's description of Dr. Tarnovskaya: "She's an obese, bloated chunk of flesh. If she were stripped naked and painted green, she'd be a swamp frog. After a chat with her, I mentally crossed her off my list of physicians."[2]

Nabokov's description, compared to Chekhov's, is rather forgettable. Chekhov's is a delight. And oddly enough, some of the delight, for me at least, rubs off on the character. I *like* Chekhov's Praskovya better, though I would rather have dinner with Nabokov's.

We are, lucky us, just readers. For Nabokov, his great-aunt is a person; her memory deserves protection. For Chekhov's sister, the frog-like doctor is *probably* only literature—a character—the chances of having to put up with her are slim. For us, she's stuck safe in a book. We can relax and be entertained.

But isn't there a *moral* problem?

Is it really so, that bad and disagreeable people delight us in books, that we like to see them appear, want them to come back, and even in some weird way are well-disposed toward them? And if it is so, should we indulge it? Shouldn't books present a sort of moral simulacrum of day-to-day living? Shouldn't a good writer show us how to like and emulate the good and teach us to shun and distrust the bad? Yes, I think so. And I think Chekhov, for example, does do that. I think our affection, or mine if you like, for his Dr. Tarnovskaya is possible only because at the moment that we're reading about her, Chekhov had made our moral vision more sharp and clear than it usually is.

He has infected us with an absolute aversion to his colleague. In life we're rarely so fortunate. We want to have enemies and have elected people for the job. But we know from experience how untrustworthy our judgments are and how scattered and flimsy is the evidence we use to support them. A glimpse of my personal villain at home working in his garden or speaking affectionately to a child, or a fantasy in which he suffers too large a misfortune: even such puny oscillations in my consciousness will shake the weak foundation of my judgment and make me stop and wonder. "What if I'm wrong?" I ask myself. "What if I've been saying all these things (not that they're not true, of course, but they're so *small*) saying all these nasty things about a man more or less like myself? If only he would *do* something terrible! Even if he only just *looked* terrible." Stripped naked and painted green? No, he would simply be pathetic. But he's the best I have. Soon enough, I'm able to work myself up again to a reasonable degree of moral outrage. But I can never quite forget how little it rests on.

But the people in books are different. I mean, we see them differently. We know how good they are, or how bad, and in what ways. If they change, we see them change. In fact, what we see is

what they are. The clear light of the author's understanding is lent to us. Our usual burden of moral doubt is lifted from us while we read. And with that moral certainty comes new delights. The villain is a villain. We all know it, and he will suffer for it—suffer at the very least the punishment of being known for what he is. He can't escape; we won't be tempted to forgive him. That being taken care of, it's amazing how much there is in him to appreciate: so villainous in his villainy, so lively and energetic, so persistent and ugly, so certain to get himself in a fix eventually—so dependable!

Dr. Tarnovskaya will never give me an unpleasant surprise, or disappoint me. I don't have to be afraid that she will ever cease to be my enemy. No chat with her will ever win my sympathy. And though she'll never actually be stripped naked and painted green, we can always be sure that if she were she'd be a swamp frog.

NOTES
1. *Speak, Memory*, Vladimir Nabokov. G.P. Putnam's Sons, pp. 67–68.
2. *Letters of Anton Chekhov*, ed. Simon Karlinsky. Harper and Row, p. 311.

Liberated Dogs

According to the university regulations at King's College, Cambridge, in the fifteenth century, if you were a student you weren't allowed to grow your hair long, or to wear red or green shoes, or to "carry openly or secretly swords, or long knives or arms for assault or defense." And furthermore, "none of the scholars, fellows, chaplains, clerks, or servants...shall have dogs, or nets for hunting or fishing, or ferrets, falcons, or hawks, nor...shall possess in any way an ape, bear, fox, stag, hind, doe, badger, or any other wild animals or strange birds, whether they are useful or harmful." Moreover, "The fellows or scholars aforesaid are expressly forbidden to...throw stones, balls, pieces of wood or dirt, spears or anything else."

Whether the students wore their hair long and wore red and green shoes I can't say for sure, but they did keep pets, throw things, riot, and even kill each other in the streets of both Cambridge and Oxford. As one of the Oxford student leaders himself put it: "In short, we could not be quieted before many of our number had been indicted for felonious riot; and amongst them I, who am now writing, was indicted...and perhaps not unrighteously..." and was "tried by jury before the King's judge. From that day forth I feared the King, hitherto unknown to me in his power, and his laws, and I put hooks into my jaws."

That was a while back, but reading about it (in Edith Rickert's *Chaucer's World*) makes me remember the bad old days, when springtime at UCSB brought rallies, protests, boycotts, riots, tear

gas, a killing or two—and when you could hardly turn around, on campus or in Isla Vista, without stumbling over a dog.

As everybody knows, the students were edgy in those days. And when they did tear things up, there were reactions, of course, and revelations—often surprising. The faculty revealed themselves as being cowardly for the most part, and self-aggrandizing. The chancellor, though, turned out to be untyrannical, levelheaded, decent, and sensible. The governor of the state was another story. Brutal and vindictive, he called in the most unrestrained police force this side of Chicago and turned it loose on a largely innocent population.

Words surprised us, too. There seemed to be fewer of them and they took on bigger and bigger meanings. For instance, one morning, after a riot or two, the University Center was "liberated." That meant the authorities were too busy or cowed to intervene if you chose to "undermine the system" by taking food without paying for it. All reading and schoolwork was nothing if it were not shown to be "relevant" to the "current crisis." If it *was* shown to be "relevant," then it would "raise your consciousness," and you would be able to understand how it was that "the system" promoted the war, and once you were enlightened, you could—in fact you were obliged to—go around and "raise the consciousness" of others.

For the many students who found they couldn't easily swallow slogans whole or didn't want to, those were hard times.

But not every moment was so politically charged. People were sociable, talked to each other, shared things. And this affected the dogs. They became The People's dogs. It was not that nobody claimed them, but that everybody did. It was the new world. The dogs' doggy natures seemed to change. Certainly their manners improved. Everybody fed them, but they didn't beg (I suppose because they were too stuffed). They became quite nonviolent, apparently preferring people to each other. They wandered affably around, treating everyone equally. The authorities, leery now of the students, didn't interfere.

This lasted until the students, thoughtless creatures, went wherever they go in the summer, and left the dogs—who had to make yet another adjustment. They began to run in packs, depend-

ing on each other now. When several of them raised their hackles at you at once, you forgot all about peace and love for the time being.

Anyhow, finally the dog-police, now that the students were gone, took back their old prerogatives. The usual arrests were made, and soon there were no loose dogs on campus and not many in Isla Vista. And maybe somebody regrets it. Not me.

Yet it's true, also true, that when I or, I imagine, most anybody, reads those old medieval regulations, it's a pleasure to suspect, and an even greater pleasure to be sure, that they were often broken.

To the Blivits!

(*New Dictionary of American Slang:*
Blivit—"Ten pounds of shit in a five-pound bag.")

In moments of moral uncertainty she'll still come and take advantage of me: perch on my forearm, wrap her tail around my old, thin wrist, and let me stroke her shiny red fur. Then we'll talk, and it does us both good.

She's the only she-devil or devil of any kind I've ever seen or known. And what harm is there in it? From the start, she was never really very wild. But by now we've been in association for so many years that she's become—under my influence, I suppose, and the influence of my teachers (for we attended many classes together)—almost mellow. Almost. But take one look at her tawny eyes, and you could guess that she might still flare up on occasion. And when she does, to tell the truth I rather like it. Either she'll burst out into invective of some kind, or—and this is wonderful to watch—she'll twist around, slip a quick paw under the flap of her little knapsack, pull out the white plastic fork she picked up off of someone's salad plate in the Student Union thirty years ago—and brandish it.

But this essay was not intended to be about her. Who would believe in her anyway? I'd meant to write about good teachers—a short but surely a laudable subject. Then I was going to go on from the good teachers to two who were better than good, Marvin Mudrick and Alan Stephens. I was going to say why I haunted the classes of these two teachers for twenty years, why I still would if it were possible....

I was going to write this and I would have—if she hadn't led me

astray. It began with a pinch, a sharp little pinch on my arm, and then she said, "Why, in the half-century you've been in school, have there been only half a dozen good teachers? And why are the thousands who aren't good, so bad, so terribly, terribly bad?"

"Don't exaggerate," I said. "They just seem so bad because the chairs are so hard, and you have to sit in them so often for so long."

"So terribly, terribly bad," she said. "And so many. Why are there so many? Thousands upon thousands upon—"

"Come on, now," I said. "Even you and I have not personally had *thousands*. Besides, there are plenty of bad painters, for example, and bad writers, bad plumbers, bad doctors. Teachers are just harder to escape from is all, so you remember them longer. And also, think how they must suffer! Maybe if you taught sometime yourself you'd see how easy it is to do it badly, and pity them."

But she was not having any pity today. I could see her getting angrier. Luckily she has a sort of fetish for numbers, which I try to encourage. So finally, in the spirit of cooperation, we agreed to break the whole unwieldy mob of bad teachers down into categories and analyze them. "All right, let's stick to the humanities," I said, "since they're what we know best. In the first place there are the Frank Failures who, however much they made us suffer—"

"—Bored us literally to tears," she said. "Do you remember?"

"—whom we can only feel sorry for, and not punish."

She shook her head, but said nothing—which I thought was a good sign.

"And then there are the Fake Scientists," I said.

She grinned. "Yes, lots of them in the arts nowadays, not to speak of the thousands of fake scientists in the social so-called sciences."

"All right, then, that's two categories, and a third is the old familiar Fake Enthusiasts."

"We seem to have a common denominator here," she said.

"*Fake*, you mean?"

"Yes, and frankly, the word is too mild for what I feel. Do you remember...."

Her eyes lit up, she started giving instances, which could have gone on for decades; so I said, "All right, then *Frauds*."

MAX SCHOTT

But she was excited now and just shrugged her little furry shoulders in contempt. Her tail began to twitch, and she said:

"—The pretense of knowledge!"

"—Yes," I said, because what could I do but join in? "Answering questions they didn't know the answers to!"

"—Or evading answering them. Never saying 'I don't know.'"

"—Pretending to have esthetic responses!"

"—Yes! Even their feelings are stolen or borrowed."

"—Pretending to talk their students' own language!"

"—Yes, what condescension!"

"—Or else, puffing ordinary things up with their own wretched jargon."

"Oh, yes, jargon—and the jokes!" she said, "and the imposing looks! And the profession of interest in what we had to say—until we said it!" She'd been talking fast when suddenly she stopped and said, "Blivits! Marvin Mudrick called them blivits! Do you remember? Blivits!" She laughed aloud, and with nearly her old original quickness grabbed her little fork and jabbed the air. "A toast!" she said.

"To all bad teachers everywhere," I said mildly. "They do their job."

"To the blivits!" she said. "Here's to the blivits! If there is eternal punishment, as I still feverently hope, then may they be forced to attend their own classes—and have alert minds and front-row seats, forever!"

Looking at her, it was enough to make you fall in love.

The Act of Reading and the Prospect of Loss

So to begin with, you love to read, and there's no end to reading. You love to read—you read everything. I mean, at break-fast you read the advertising material on the Wheaties box, and you read everything, you just read everything!"

You don't read for understanding, you read for excitement—the act of reading is exciting.

You read with a furious appetite…, simply gobbling it up.

In fact you could not notice my father for days at a time. He would be sitting in a corner reading every word of the Yiddish paper. And I mean he read every word—advertisements, [inaudible]. And it was very interesting to watch him reading, because he read with the kind of appetite with which some people eat…the use of the eye in reading is special…The effort that the eye has to make in conjunction with the mind while looking at words brings into action functions which are brought into action by no other human activity.

<div align="right">

—Marvin Mudrick
From Mudrick Transcribed, *edited by Lance Kaplan*

</div>

I remember everything about it...I was puzzling at a line when all of a sudden the meaning of one word I understood hopped across—to join the meaning of the next word I understood, until there were enough words that meant something to make sense of the sentence. I was overcome with delight. I was still small—not yet four. But I ran across the field and up the road, speeding along through the summer dust—to the shop, a long distance away. "I can read!" I shouted up at the woman who ran the shop. She bent down. "Well, aren't you the great little girl!"

—Nuala O'Faolain
From Are You Somebody

1

This sounds like two subjects, one too many for a single essay. But since the two came into my mind together, I'm going to try to sort them out together.

Eleven years ago, when I was still middle-aged, I wrote an essay called "Readers." A few weeks ago, I had occasion to reread it. It started off all right, I thought. A reader, a real reader, has, or at least needs, no practical reason to read. Reading is a primary activity, an obsession, a passion, an appetite—not a means to an end.

That was the essay's argument, and when I reread the essay, the argument, the idea of the thing, still seemed sound enough. But after the first few paragraphs I began to hate the way the argument was presented. The examples were negative—I kept describing people who didn't really like to read, and the tone was cute, or facetious. Every time I picked the essay up and looked at it, I got annoyed all over again, till finally I was annoyed not just with my past self for having written it in the first place, but with my present self for making such a fuss over it.

It was my own fuss, though, and if I wanted to treat the essay as a sort of inkblot test there was no one to stop me. After a while I said to myself: "All right, then, why *do* you react to the essay so strongly?"

"Because the tone of it seems alien to me now."

"But why does the tone seem alien?"

"I hope because I've changed."

"Changed how?"

This simple question stumped me. I wanted to say that the ground of my mind had somehow shifted, that I saw the world now from a different point of view. But how can you say that, unless you can say what the new point of view is?

For a few days I walked around trying to find some useful way of comparing the present to the past. I told myself, truly I think, that holding something as trivial as an essay in contempt was just a sneaky way of holding my whole past self in contempt. And to do that, to feel superior to yourself without a reason—is unreasonable to say the least. Granted. But I still wanted an answer to the question—*changed how?*

I decided to read the essay yet again.

<div align="center">2</div>

It begins in a coffee shop.

"It's hard to tell at a glance who are the real readers, or maybe I should say the ideal readers, the ones who read just to be reading.... That boy over there is reading. In fact, he has three books, all open, and is writing too. But I'd guess that he has ulterior motives—an exam to pass, an essay to write.

"But that girl at the table over by the window, she has a book in her hand, just a book...and look how she leans into it! When she was little, I'll bet her relatives would say, 'She's a reader. Always has a book in her hand.' It starts early. And later on, at twelve, fourteen, sixteen, she remained just as book-hungry—if she really is a reader. She not only out-read her teachers (which might not be saying much). But she out-read her fellow students too. Omnivorous, she read anything and everything, read like the wind blows—in every direction. As a result, maybe she didn't always do too well in school.

"And then, to continue the story, maybe people began to tell her that she read too much, and that reading like that, for no purpose, would never get her anywhere. And she, looking sulky, would say nothing, but just go on reading. I like to think of her as being intractable. But on the other hand, it's true, they were right, it won't get you anywhere; it may even make you wonder if there's

MAX SCHOTT

anywhere to get. Anyhow, how intent she is! All these speculations are absurd, but the expression on her face is not."

Those are the first few paragraphs, the part of the essay I'd liked before. I still liked it. Only, the girl seemed a little hypothetical, as if I hadn't quite believed in her. At the beginning of the next paragraph the essay veers off in another direction and never comes back. I read it to the end. The parts that had irritated me before, now were just hard to take in, and the questions I'd hoped to answer seemed to have lost their interest, or at least their sting. Instead of trying to think, I just kept seeing the girl's face as she read—her face and then other faces.

3

My daughter Sharon, when she was thirteen or fourteen, came along one night to a class I was teaching. It was a junior college class with forty or fifty students in it. On the way there, in the car, she was reading a book, *Jaws*, and by the time the class started, if not sooner, she was completely involved in the story. But she put it aside when I began to talk and tried to look politely attentive. At some point, though, she must have been tempted to take just one more peek. Anyway, by the time I noticed, she was already in a different world. She was holding the book up in front of herself—I could just see her face above it—and she had a tense two-handed grip on it. Except for a quick repeated mechanical flick of the eyeballs, her face was perfectly still.

Another face I remembered was from Saint Augustine's *Confessions*. I couldn't remember the passage very well so I looked it up. Augustine and some fellow students are astonished to find their mentor, Ambrose, reading to himself alone, without moving his lips or making a sound. As Augustine puts it, "His eyes glanced over the pages, and his heart searched out the sense, but his voice and tongue were silent...." The young men didn't intrude ("for who would dare interrupt one so intent?"), but also couldn't bring themselves to leave. Instead they "sat long in silence," watching.

The last of these mind-pictures was this: A teacher of mine, Al Stephens, used to sit in his office reading. The door was open, and sometimes I'd walk by, half on purpose. To begin with I only knew

that it was something I liked to see. Gradually I realized that what I was seeing had a value. But if someone had asked me, I couldn't have said what it was. To me the way he read—the expression on his face—came to represent a kind of ideal. But what kind of ideal was it? It was something new.

In the past I'd seen people carried away by books, and that had seemed to me ideal—but this man didn't look carried away. His attention was fierce and absolute—but it was attention, not rapture. I couldn't quite work it out. But seeing his face again in my mind, I think I can put into words now what I felt...thirty-five years ago. The fierce attention that he pays—that's the outward sign of appetite. His alertness, his position *outside* the book—that's the outward sign of judgment. Appetite and judgment working together, neither hindering the other. That was what it was like for a grown-up human being to read, to read completely.

4

I liked having these pictures in my mind. It seemed good in itself; they were good, important memories. And to remember them was as effortless and pleasant as daydreaming. But after a while the need to think comes back, makes itself felt again—which in this case meant making another attempt to see my own mind from the outside—which in turn meant that I began again to ask myself questions.

The first question to occur to me was: Why faces? If what you're supposedly thinking about is reading, why does your mind fill up almost exclusively with faces?

I suspect this was one of those planted questions, the kind that teachers ask. And since in the province of my mind I'm quick to pick up on my own hints, I knew the answer: "The face of a person reading, even and especially the face of a person reading silently, the tension and the concentration, the stillness that hints at motion—all this reminds me that reading is a physical activity. When I read to myself I'm unconscious of the work being done (with such astonishing quickness) by the eye, the brain, the image-making part of the mind. I would like to be less unconscious of it. When Augustine and his friends see Ambrose reading—"His eyes

glanced over the pages, and his heart searched out the sense, but his voice and tongue were silent"—they are filled with wonder. I'd like to borrow a little of it. This—the act of reading—does seem wonderful to me. But for most of my life I've taken it for granted. And these days I dislike taking things for granted."

—These days?

"Yes, I think so. These days in particular."

—And why is that? Why these days in particular?

These conversations in my mind go on, melt into momentary confusion, repeat themselves, get interrupted, start up again, get sidetracked. Sometimes when I seem to be stuck, a third voice will come in and comment on or correct the other two. Sometimes I lose track of which voice is arguing for what—who is the "I" and which side is he on? This time, the question "Why is that? Why these days in particular?" was what broke up the conversation. Wasn't this the question "changed how?" all over again? Was it true that in the past I didn't mind taking things for granted, and in these days I did mind?

I spent, I believe—though really it's just a guess—yet another couple of days with these questions going in and out of my mind. Unable to think of anything sensible, somewhere along the way I said to myself: "One way I'm different: I'm happier now." After I said it, it seemed stupid. Ten or eleven years ago, I was happy enough. On what basis could I say I'm happier now? The circumstances of my life haven't really changed. How do you measure such things? There is no happiness gauge. Then what could I possibly mean—"I'm happier now"?

And yet, there seemed to be something in it. It occurred to me that one thing I might mean—one true thing—is that these days there's an intense pleasure that I feel...a particular kind of pleasure. It's not new, I've felt it before, but I feel it more often these days than I ever did in the past.

I was almost afraid to think about this pleasure, to describe it to myself in words, or even to acknowledge it—for fear of losing it. But then I thought, "If I lose it—or when I lose it, for I'm going to lose everything—when I lose it, it will not be from thinking about it. It is not as flimsy as that." So I did think about it, explicitly, in a

way I hadn't done before. It's the kind of pleasure you feel when you have an experience that makes you happy, and you see that happiness receding into the past at the very moment that you feel it. Poignant is what people call it, because of the little sword thrust of pain.

What's amazing these days is how often the feeling comes to me. When I walk down our front steps to get the morning paper, I usually feel it. Moving around the kitchen with my wife, I often feel it. The clarity of a fall morning can make me feel it. Reading a familiar passage in a book, sometimes I feel it. If there were words that accompanied the feeling they would be something like, "this may be the last time." But when I thought about it now, I saw for the first time how absurd that was. I'll probably walk down the front steps to get the paper many more times. I'll probably move around in the kitchen with Elaine many more times. In the old days the feeling came rarely, and when it came it was usually attached to some rare or unrepeatable experience. Now it came so often and attached itself to so many things…. This must be the way then that the ground of my mind had shifted. The prospect of loss is everywhere now. I carry it around with me. It intensifies pleasure and adds to happiness. It also makes me want to be aware of what I have, while it's still there. There's enough real loss, certain loss, coming. If you believe this, as I do, then taking what you love for granted, even in an essay, becomes a kind of sacrilege.

MAX SCHOTT

The Outsider

8/19/94

Idea, monk-like, of throwing out every day what I've written that day. Followed immediately by fantasy of someone saving these abandoned sheets, collecting them day by day, for posterity— posterity praises them to the skies.

8/20/94

—This diary: Don't rewrite, elaborate or explain. Date, throw into box, type up occasionally, throw into other box.

Write sparingly (mistake to say this. Don't trap yourself into commitments, which you will then resist. Don't say "I will write this diary for the rest of life," etc.) Don't write sparingly. Write whatever comes out of your pen. But, when you write, as you often do, as a way of trying to climb out of some pit of confusion…consider it not to be part of this diary.

There is very little I'm willing to be frank with myself about. I'd like to find that little and stick to it.

It would be lovely, lovelier nearly than anything, to be able to talk (on paper I mean) engagingly about yourself. Not surprising that I can't. Hardly anyone can. Herzen does. He gives the illusion that he is talking to you in his own voice, the same voice he uses to talk to himself, which necessarily includes the illusion that he can talk about anything, exaggerating nothing, leaving nothing out.

And all in language chaste, limpid, unrehearsed and relaxed.

Boswell, in his journals, comes close to making this kind of

connection with the reader. He's candid enough, and wonderfully expressive. But his innocence (attractive as it is) sometimes leaves a gap between you and him. You laugh at him sometimes when he is serious, and see him differently from the way he sees himself. Boswell! Herzen!—one of the consequences—about the only dubious consequence—of surrounding yourself with people (dead or alive, in or out of books, it doesn't matter) who are superior to you is that you are going to be eternally conscious of your own smallness—which is not absolutely a good thing to go around feeling, or pleasant either.

9/10

A boy sitting in the middle of Islay Street, outside my window. Not the boy that usually plays there; a visitor. About nine years old. He looks disconsolate, head down, his baseball bat is lying between his legs on the pavement. He raises his head and shouts at the top of his lungs, "Hey! Ronny!"

From somewhere out of sight—probably his own porch—Ronny calls back "What?"

The boy on the street, nearly as loud as before: "Do you hate me?"

The other boy, impatiently: "No!"

The boy on the street, not so loud, evidently relieved: "Okay. Then I don't hate you."

A few minutes later they are playing again, though their voices continue to sound strained or crabby.

9/10

Imagine saying to a class, in response to a question about my own writing: "I've been doing a different kind of writing from what I've done in the past—looser, more journal-like, more immediately responsive to what's going on around me. The change came partly from dissatisfaction with what I was writing before, but also partly because I'd been influenced by the work of a couple of people whose writing I'd been reading for years—Bob and Kate.* I'd

* Bob Blaisdell and Kate Johnston

MAX SCHOTT

found their writing fresher, more fun to read, more fun I think to write, than mine.

"So I've been writing more like they write—in so far as I can—in form, subject matter. In other words, I've made a decision to proceed in more artless and unpremeditated ways. I don't do it as well as they do. Almost no one does. But I wasn't doing what I was doing before very well in any case—so I have nothing to lose."

All this is true, but I'm not sure it's good to say such things unless you know the people you are talking to pretty well, or unless they know you.

9/11

Was reading this over, and watching the Women's Doubles of the U.S. Open. One of the T.V. announcers (a man) asked the other (a woman*): "Where do you buy reflexes like that?"

She answered: "Years and years of work, and also genetics. You can quicken up a little bit, but you've got to have a lot of it when you're born."

Good answer; applies to writing too.

9/23

Distant thunder and lightning nearly all night last night. Elaine was up, listening and watching.

This afternoon she said that nearly everyone she saw today was talking about it, and yawning. She said she'd felt very alone when she'd been outside in the night, and realizes now that all over town people were up and were outside watching, all feeling alone.

9/26 At Café Bianco

A woman I hadn't seen for a few months walked up to where I was sitting. "How come you're not writing? You're always writing."

"Well, I just sat down."

She went inside to order something, then sat down at a table. I'd been about to start looking at the newspaper, but now it seemed I'd better write. So I wrote down our conversation.

* Tracy Austin

10/21 On a television documentary

An old man (in Bolivia), when asked if he ever smuggled drugs (he worked on a train that crossed back and forth across the borders, so had obvious opportunities) says he was approached once but refused. "It's not in my character. I wasn't born to be a crook." He says it good-humoredly, and laughs afterwards.

10/30

Walking down State Street, I passed a book fair. The street was blocked off—foot traffic only, tables had been set up, and even groups of chairs, so that authors could address groups of people.

As I walked past one group, I heard the author—a seedy-looking white-haired man—saying "And now I'm wrapping up, putting the finishing touches on a manuscript to be delivered to a New York publisher." Then, inexplicably, he stopped lying for a moment. "Or, not a publisher. An agent." Then he started again: "These people called agents sit in New York and we all genuflect."

It isn't true. Agents don't "sit in New York" and they don't require or have any interest in genuflection. They work, and go about their business in a businesslike way, and are interested in material they can sell or that they may even like.... I kept walking. God knows, who wouldn't? Yet all the chairs set up in front of him were taken up.

10/31

Simenon's diary (1961?):

"What a fine book one could make out of the day of a man, an ordinary day! How much life! But how much more difficult than a novel full of turmoil and passion!!"

Simenon, preparing to start a novel: "During all this time (while doing errands, going to the dentist, etc.) I will think without thinking, trying to put myself into a state of grace."

11/2/94, revised 2/25/95

Reading Simenon's diary, which he published under the title *When I Was Old*. He began it, he says, when he found himself feeling old, at fifty-seven, and gave it up a couple of years later, when the feeling went away.

MAX SCHOTT

Reading his diary, which I like and which is entirely different from mine, somehow makes me like mine too.

June 30, 1961. He's disgusted by the word "author." He abominates the precious, the labored over, the profound; he hates the well-turned or the telling phrase; and when he sees that he has succumbed to a desire to interfere, intervene, throw his weight around, in whatever story he is telling, then he is disgusted with himself as well.

2/22/95 Revising a November entry

I had occasion to reread the interview[*] that Robyn did with Al and was struck again by how fertile it is. Robyn conducted it by submitting written questions, which Al also answered in writing, so that the interview is deliberate, intentional, free probably of anything he'd be tempted to take back or alter, and every passage is concentrated, and expressive of the man's character. Words set down on paper are a sacred thing for him, different from talk, though his talk is hardly careless. (In fact, words, all words, never have just a random or casual value to his mind or ear. This is no small or accidental thing: I'm reminded of what Tolstoy says somewhere: "the morality of a man is most clearly revealed in his attitude towards words.")

Anyway, I'm writing this particular entry partly with hindsight, in order to make something that is coming up more comprehensible. In her interview Robyn asks Al what he thinks of the title of a review-article about him and some other poets. The title was "Outsiders."[**]

"I was delighted by it. Whenever I have gone inside I have soon become uncomfortable, with myself and others. So I became a Cat That Walks by Himself. I wasn't robust enough to face down the moral dangers of participating in the literary life."

11/16 6:30 p.m.

Went to David Leavitt's movie (rather the movie of the same title, made from his book, *The Lost Language of Cranes*), and at eight

[*] "An interview with Alan Stephens," Robyn Bell, *Spectrum*, 1992
[**] Mary Kinzie, "American Poetry Review."

I'm going to his reading. All this not because I'm interested in him or his work but because he's coming to my writing class tomorrow, which also came about without interest or enthusiasm on anyone's part. There's money in the university budget for the stipulated purpose of bringing such and such kind of writer to campus to spend a couple of days, and one of his (very few) obligations is to visit one class. The university librarian decided the class should be in the College of Creative Studies, the only place where many creative writing classes are taught. The College was notified, the various writing teachers were informed and asked if they were interested. I recognized Leavitt's name only as the person who'd recently been accused of literary theft by Stephen Spender.* I and a couple of other teachers said we'd like to have him visit our classes. My class turned out to be the only one to fit into his schedule. This is how the world of the arts mostly operates—though at its higher levels it's worse, because there people pretend to all sorts of rapturous enthusiasms. But this is bad enough. No wonder Al hasn't the stomach for it.

Leavitt, though he's a serious writer with serious intentions, is packaged and, in a minor but unrelenting way, promoted as being gay and writing "gay fiction," as being or having been young (he's thirty-one and has been the youngest writer ever to win various recognitions which I can't remember, and the youngest writer ever to have had a story published in the New Yorker—he was twenty-one), and now also as a person involved in a legal controversy with a more famous person, Sir Stephen Spender. All this packaging he no doubt resents and protests against, which after all is also part of what he is supposed to do and is allowed to do, being an artist. And so, in this case fairly innocently, a writer gains a reputation, a career, maybe even a living.

I've dutifully read some of his fiction. Also Spender's complaints and Leavitt's cry-babyish defense of himself, "my lawyer made me do it," which seemed to me more offensive than the crime itself, if it was a crime. The movie is good. I'd seen it before

*Spender's book is *World Within World*; Leavitt's, *While England Sleeps*

MAX SCHOTT

and liked it then too. It's more stark and concentrated than the book. After the movie he answered questions. Has a comfortable public manner, is likeable enough, so far. I introduced myself to him, to make sure he was actually planning to come to the class.

11/16, 11/18
Went to the reading. The novel he's working on is like his other work; intelligent, earnest, strongly felt, derivative, a little glib, effortful. It's like most decent seriously intended novels, and my reactions to it are like the reactions I'd have if in some minor circle of hell I was condemned to read my own work. Work is the word: it shouldn't look or read or sound like work, art shouldn't.

Afterwards, in the answers he gave to questions from the tiny audience (the reading took place in a large theatre. The audience was made up of a dozen or so pairs of gay men, mostly in their thirties, two pairs of women, two or three sponsor-type persons from the library and the bookstore and maybe three or four strays like myself. No two-sex pairs, no undergraduate students), he was forthcoming, likeable, friendly, kind, interested, interesting, animated, modest, sometimes even excited. When he talked about the "beautiful, beautiful, beautiful men of Florence," who must have gone to school to study leaning,* he got across what he had intended to get across in what he'd written and had just read to us aloud. In other words, like nearly all less-than-great writers (not to speak of everyone else in the world) his presence is much more complete in person than on paper.

Anyway, by the time I left the theatre I liked the man and felt less like a dolt for having invited him to come to the class—notwithstanding the fact that it still was a foolish thing to have done.

11/17, 11/19
I introduced him to the class clumsily (clumsiness is not much of a sin, I think). Figuring it would be wrong for me to praise his work, instead I said that here was a serious writer, who makes a living by writing what he wants to write. "In other words, he does exactly

*"and the leaning! They must teach leaning in Florence."

what many of you would like to be doing or would like to be able to do." ("Desperately," Kia° said.)

To get us started I read aloud a letter from Bob Blaisdell, where he talks about what it's like for him, a newcomer in New York without anything like Leavitt's early success, to piece together a livelihood as so many writers do and have done—editing, abridging, compiling, writing short pieces, teaching classes here and there—an honorable and largely happy adventure, but time-consuming to say the least, and exhausting.

And from the campus newspaper I read a passionate, sensible essay by a student, Olaina Gupta, about the scariness and the value of giving up prospects of comfort and security for a life spent making art.

Worried by then that I was taking up too much time (about five minutes but we only had sixty), but still wanting to point out—and hoping Leavitt might take up the subject—that there are not just financial risks in the life of an artist who makes his living from his art but moral ones, I said, "Okay, just one sentence from this interview with Alan Stephens." And without giving the context or any other introduction I read the words "I wasn't robust enough to face down the moral dangers of participating in the literary life..." then turned to Leavitt, who to my surprise touched himself on the chest and said "That sentence got me right in the heart." And then, mostly in response to questions, he talked with perfect good humor and easygoing candor about his career as a writer: how he was discovered and lionized too young; what it was like to have a weak first book over-praised, then a better second one savaged by the same reviewers (The books were first *Family Dancing* then *The Lost Language of Cranes*—which went on to have quite a vital existence); how it felt to be judged a flash-in-the-pan or literary has-been at twenty-five; how the New York literary scene affected him and how so many first-book writers of his generation were done in by it; his decision to move to Italy, where he now lives (in Florence) and other steps, too, which he took to protect or save himself.

°Kia Penso

MAX SCHOTT

11/19, 11/20

Last night at Al's to supper—Fran, Al, John Wilson and Joanne, Kia, Elaine and me. I tried to describe the effect on Leavitt of Al's sentence, with Kia as a witness. Al just laughed and said "Did I say that? I'm not even robust enough to remember it."

On Reading
William Carlos Williams' Story,
"The Knife of the Times"

"As the years passed the girls who had been such intimates as children still remained true to one another."[*]

"...who had been such intimates...still remained true to one another." To begin with, we are put a little off balance. Is this the language of romantic love? Of sentimental romance? Is the language used purposefully by the author?—or misused by the characters to describe an ordinary friendship? (and if so, why do they misuse it in this way?) We go on, eager to get our bearings.

"Ethel by now had married. Maura had married; the one having removed to Harrisburg, the other to New York City. And both began to bring up families. Ethel especially went in for children."

Up to the last sentence, the language of these four sentences is neutral (neutrality begins to take on its own kind of charge or meaning though, amidst so many charged phrases; neutrality begins to indicate somebody's uninterest, in "bringing up family"— though we are hardly conscious of it. There is no such thing, in this story, as Williams' own narrative language; the language attaches itself to the characters, but in varying ways and degrees: there is direct quotation, indirect discourse or paraphrase; and very often there is a more subtle mixture of ways in which the narrative voice is infected by the voices and the needs, concerns, ambitions, self-deceptions, evasions, passions and wishes of the characters.

[*] *The Farmers' Daughters: William Carlos Williams' Collected Stories.* New Directions, p. 3.

Williams does many things at once—which is partly why the story is so swift and so short).

But "went in for children" is no longer neutral. "Went in for" implies (the uncertainty of the implication is important—we are still to be kept off balance, made to listen carefully)—implies no very passionate involvement, as if raising a family were a diversionary or experimental activity, and we begin to understand why the husband is nameless and why the children exist as a numerical progression.

"Within a very brief period, comparatively speaking, she had three of them, then four, then five and finally six. And through it all, she kept in constant touch with her girlhood friend, dark-eyed Maura, by writing long intimate letters." "And through it all," though neutral in tone is decisive in meaning—this friendship is literally Ethel's abiding interest. "…constant touch," like many of the other phrases is conventional and could be innocuous. Almost anyone might say about any long-term correspondent, "Yes, we've kept in constant touch." But we have already been alerted ("true to one another," "such intimates," "went in for children") to the extra-literal meanings of words and phrases. So here, in one sentence: "And through it all," "constant touch," "girlhood friend," "dark-eyed Maura," "long intimate letters." We work out, as best we can, the possible relations between these phrases. "A girlhood friend" —that would be easy by itself, and girlhood friends through it all might easily enough be thought to write each other long intimate letters. But "dark-eyed"?—a girlhood friend might be thought of as dark-eyed, and be dark-eyed, but as soon as she is called so, we are struck by the fact that this is an appellation used more often in the language of love than the language of friendship. And in our minds we add all this to the weight of what has come before, with each phrase stimulated and altered and thrown into question and off balance by the others.

We've now read two paragraphs, short ones, and it should be said that there's been nothing in it of strain, no phrase that isn't commonplace, and it's easy to believe that—as all his comments about his stories indicate—Williams wrote this passage, and probably the whole story, quickly and easily, when the mood was on him.

"At first these had been newsy chit chat, ending always however in continued protestations of that love which the women had enjoyed during their childhood." Now, maybe, with those "protestations of love," added to what has come before, there's no room for doubt about what Ethel is feeling and saying, though there's still the tension of a situation that although in evidence is unacknowledged. Anyhow, just here, in the next sentence, before we can relax into knowledge, our interest is made to shift. "Maura showed them to her husband and both enjoyed their full newsy quality dealing as they did with people and scenes with which both were familiar." At the very moment that the reader, and in retrospect Ethel, are found to be in full knowledge as to what kinds of feelings Ethel's letters are expressing, we discover that to Maura the letters are unexceptional (though the "at first" lets us know that this is temporary). And the question we ask ourselves now, is, how will Maura react when she finds out what we already know?

Ethel's forthcoming declarations are in the conventional language of passion (one of the advantages of conventional language for Williams is how quickly it can make itself felt): "Forgive me if I distress you with this confession. It is the last thing in this world that I desire. But I cannot contain myself longer." We get just a sample, all we need, we don't doubt the feelings, we were aware of them before they were announced—what we want to know now is how they are received. "Thicker and faster came the letters. Full love missives they were now without the least restraint." (It might be pointed out here, using as an example this last sentence, that although Williams is well known as a master of idiomatic language and as a great respecter of it, he often does not use it. When he wants to imitate an action, especially an energetic one, or to put first things first ("Full love missives") he will take the necessary liberties. For some narrative purposes the spoken language—American in particular—is incurably laconic.)

"Ethel wrote letters now such as Maura wished she might at some time in her life have received from a man. She was told that all these years she had been dreamed of, passionately, without rival, without relief. Now, surely, Maura did not dare show the letters to her husband. He would not understand."

MAX SCHOTT

The shift to Maura's point of view seems the most natural thing in the world—because our curiosity preceded it; and because it's still Ethel's voice that we're hearing. We are hardly aware, either, of the shift from direct discourse to indirect; that shift, besides giving the effect of speed or concentration, serves to gradually distance us from Ethel even as we hear her voice—it is Maura's listening ears now, or reading eyes, with which we momentarily identify ourselves.

"He would not understand." We know she means that he would, and we laugh. And yet that isn't quite all she means, or altogether why we laugh. Partly we laugh because we're aware of the complicated work this simple formula "he wouldn't understand" does for Maura—since we've probably used the phrase ourselves for the same purpose. Maura means not only that he would, unfortunately, understand, but that he would force her into a full consciousness of her own position, and wouldn't understand how unnecessary or—for her—destructive this consciousness would be. And we laugh partly because we see or sense how in using this formula Maura is deceiving herself—it is she who would just as soon not understand too much too soon, a state of mind which she can only preserve by not knowing she's in it. And it's hard to say whether it's here or just where it is that we begin to feel Williams' peculiar kind of moral emphasis. He is bent not on punishing Maura for her self-deceptions (we laugh partly because we feel somehow that Maura is not going to suffer), but on examining what they are there for and how they work. (If self-knowledge has its uses so does self-deception—not always bad uses and sometimes necessary ones. The opposing literary fashion, or fashion in literary psychology, which makes a character blind and then punishes him for it, has prevailed a long time: Williams is refreshing in this way as in others.) Maura's self-deceptions are never seen as either a sin or a virtue—they are, for her, an advantage. The possibility that they will eventually cause her trouble is not an issue in Williams' story—it's even possible that he himself doesn't know whether they will or not—and the reader is kept too busy and interested to worry about it.

"They (the letters) affected her strangely, they frightened her,

but they caused a shrewd look to come into her dark eyes and she packed them carefully away where none should ever come upon them." The "shrewd look" is there, but how aware is Maura of it?

One question that will persist now is, how much awareness is it necessary for Maura to keep from herself? (I believe the answer to this is: as much as is necessary at any given time so that the friendship can continue.) A second and related question is, what does Maura want? (I believe what she wants is for the situation to continue to be open-ended: feelings of friendship, sympathy, curiosity, a sense of possibility, a longing (though "longing" is maybe too strong a word—Maura doesn't suffer) for adventure—these are some of Maura's motives that, shrewdly, she keeps from herself.)

"She herself was occupied otherwise but she felt tenderly toward Ethel, loved her in an old remembered manner—but that was all. She was disturbed by the turn Ethel's mind had taken and thanked providence her friend and she lived far enough apart to keep them from embarrassing encounters."

"Occupied otherwise" implies the same kind of attitude toward marriage and family that was found in Ethel earlier, while "tenderly," "loved," indicate more serious feelings, directed at Ethel—with the important qualification "in an old remembered manner—but that was all." There's no reason to believe (what in a different and more common kind of fiction we would be led to believe) that Maura doesn't mean what she's given to think in the sentence "she thanked providence," etc., nor is there any reason to believe she's deceiving herself *about what she feels*. If Ethel were not to persist, Maura would probably not be affected to any great degree, and if Ethel were to subside back into friendship, Maura would be, in part at least, relieved. The questions in the reader's mind now, though he hardly has time to formulate them, are: if, as seems likely, Ethel does persist, what will Maura do? And if, as seems likely, Maura does nothing, at what point does passivity itself become a form of action? Or when will Maura recognize it as such and what will she feel obliged to do then?

We expect Ethel to persist all right, but even so, the intensity of her persistence is bracing: "But, in spite of the lack of adequate response" (I suppose even the word "adequate" hints at some

response) "to her advances, Ethel never wavered, never altered in her passionate appeals. She begged her friend to visit her, to come to her, to live with her. She spoke of her longings, to touch the velvet flesh of her darling's breasts, her thighs. She longed to kiss her to sleep, to hold her in her arms. Franker and franker became her outspoken lusts. For which she begged indulgence.

"Once she implored Maura to wear a silk chemise which she was sending, to wear it for a week and to return it to her, to Ethel, unwashed, that she might wear it in her turn constantly upon her."

The language of these letters, and the nature of this last request, turns anything but an active rejection (for instance by a refusal to respond at all) into acquiescence of a sort. The reader knows this, but by now the reader also knows that Maura's job is to postpone as long as possible the troubles—and in fact the likely end of things—which a clear facing up to Ethel's intentions, and more especially to the encouraging nature of her own responses, will bring. No mention is made of how Maura responds to Ethel's request about the chemise. Yet we know she received it and that she did more or less as she was asked to. This little blank spot in the narrative is a simulation or imitation of Maura's own reticence—we know she did what she did without thinking about it any more than she had to, and we feel now again how much she wants to remain unaware of anything that she would have to construe as a trouble-causing action (the trouble-causing action in this case would be not the sending of the chemise but the violation of conventional morality which she would have to be aware of if she thought about it). At the same time, the sending of the chemise is an expression of Maura's own feelings for Ethel—but Maura's feelings for Ethel are not, we should realize by now, simply a suppressed version of Ethel's for Maura.

"Then, after twenty years, one day Maura received a letter from Ethel asking her to meet her—and her mother, in New York. They were expecting a sister back from Europe on the *Mauretania*" (a pun—friendly, open, unlabored, unprofound, unliterary, accessible to the characters, funny, quick) "and they wanted Maura to be there—for old times' sake.

"Maura consented. With strange feelings of curiosity and not a little fear, she stood at the gate of the Pennsylvania station waiting for her friend.... Would she be alone? Would her mother be with her really? Was it a hoax? Was the woman crazy, after all? And, finally, would she recognize her?" The questions Maura asks herself are the ones we should probably expect. They are frank and honest, Maura's no hypocrite. The question she doesn't ask is the one she has always managed to evade: what, if I am taken to the point where not-to-choose is no longer possible, will I do?

"There she was and her mother along with her. After the first stare, the greetings on all sides were quiet, courteous and friendly. The mother dominated the moment....

"There was plenty of time. Yes, let's lunch. But first Ethel had a small need to satisfy and asked Maura if she would show her the way. Maura led her friend to the Pay Toilets and there, after inserting the coin, Ethel opened the door and, before Maura could find the voice to protest, drew her in with herself and closed the door after her." We are now so accustomed to, and maybe so sympathetic to, Maura's way of going about things, that we understand just what kind of truth there is (Maura believes it) in "before Maura could find the voice to protest."

The sympathetic feelings of friendship, an interest in continuation, a longing for adventure, curiosity, a "shrewd" estimation of the troubles that conscious awareness combined with conventional limitation could bring her—have got Maura this far. And having come this far she remains what she always has been, a sympathetic friend.

"No one could remain cold to such an appeal, as pathetic to Maura as it was understandable and sincere, she tried her best to modify its fury, to abate it, to control. But, failing that, she did what she could to appease her old friend. She loved Ethel, truly, but all this show was beyond her. She did not understand it, she did not know how to return it. But she was not angry, she found herself in fact in tears, her heart touched, her lips willing." We are never to doubt that these are Maura's wholehearted responses and reservations: Maura is moved by a physical appeal even when she is not moved first of all physically. Maura, in perceiving her own

responses as an aspect of friendship, or sympathy, doesn't differ from Williams ("No one could remain cold to such an appeal....").

What shall I do? thought Maura afterward on her way home, on the train alone. Ethel had begged her to visit her, to go to her, to spend a week at least with her, to sleep with her." And the story ends with a question that, for Maura (who does not easily ask herself questions, let alone answer them), amounts finally to a choice and a declaration: "Why not?"

With thanks to Alan Stephens

The Leveler

Chaucer from time to time expressed considerable skepticism about the unknowable. "A thousand tymes have I herd men telle/That ther ys joy in hevene and peyne in helle."* But at the end of his life he prayed publicly for grace, grace to be able to "bewayle (his) giltes," and so to be one of those who "at the day of doom shulle be saved."** At that moment he believed in an afterlife and may have feared hellfire more than death itself.

Unlike Chaucer, Samuel Johnson believed persistently in eternal punishment or bliss, but unreasonably feared only death. His feelings contradicted his belief, but he didn't deceive himself about what he felt, and also chose not to deceive his friends.

These are virtuous men. To discover contradictory or incompatible feelings in yourself, to admit them frankly and see them clearly, is a virtue, part of self-honesty. And when religious faith or convictions and the fear of death are at issue, obviously the stakes are high.

But Whitman, I think, when he says at the end of *Song of Myself*

Do I contradict myself?
Very well then...I contradict myself;
I am large...I contain multitudes.

* Prologue to *The Legend of Good Women*, first lines.
** Retraction—end of *The Canterbury Tales*.

is trying vaguely to excuse only an inconsistency in his *argument* (*Song of Myself* does contain a persistent and insistent argument, asserting in particular and often, that death is benevolent) by claiming for himself an admirable and frank inconsistency in his *feelings* ("I contain multitudes").

This kind of mild, self-deceiving slipperiness is typical of Whitman—the combination, maybe, of a lazy and willful intellect with a sort of generous good nature. I don't know whether I like Whitman. Sometimes I do, I think, but I know I find it hard to admire him.

Looking back at *Song of Myself* with the subject in mind, I'm surprised to see how much time Whitman spends talking about death. (It occurs to me that those people who really aren't afraid of death probably spend very little time thinking or talking about it, cheerfully or otherwise). Some of what he says just sounds like wishful thinking, or if it isn't, at any rate comes off as ludicrous assertion:

> The smallest sprouts show there really is no death (37)

> I do not know what is untried and afterward,
> But I know it is sure and alive and sufficient.(86)

> Ineffable grace of dying days! (!) (89)

> God will be there and wait till we come. (90)

> No array of terms can say how much I am at peace
> About God and about death. (93)

> And as to you death, and you bitter hug of mortality,
> ...it is idle to try to alarm me. (94)
> (The 'bitter' helps to place and save this, though).

> And as to you corpse...(94)

Such passages aside, Whitman does often manage to make me feel, momentarily at least, that death is a rather comfortable fact of life. If we can merge with the rest of humanity while we're alive, if our most important feelings aren't personal or individual, then a personal death becomes a minor incident in the course of general

human and non-human life. Tolstoy argues this with great intellectual vigor and clarity. Whitman doesn't argue it very clearly but oddly enough is more convincing. Tolstoy convinced himself eventually that he could deny the individual in himself (finally, if I remember correctly, he wouldn't even play cards—it stimulated his egotism, he wanted to win; or ride a horse or a bicycle—the peasants couldn't, why should he?). The hugeness of his self-deception (his ego did not diminish) and the absoluteness of his self-denial is fascinating and instructive. Whitman, though, it seems, really was able to merge and loved to, and is able to make that-which-we-all-share sound like the most attractive of all available experience:

> Mine is no callous shell,
> I have instant conductors all over me whether I pass or stop,
> They seize every object and lead it harmlessly through me.
> I merely stir, press, feel with my fingers, and am happy,
> To touch my person to some one else's is about as much as
> I can stand. (62)

There are hundreds of instances of this kind of pleasure ("Who need be afraid of the merge?"). It's attractive, and equally attractive is the prospect of throwing off (among other things) a large part of the burden of consciousness:

> People I meet...the effect on me of my early life...
> of the ward and city I live in...of the nation,
> The latest news...discoveries, inventions, societies...
> authors old and new,
> My dinner, dress, associates, looks, business, compliments,
> dues,
> The real or fancied indifference of some man or woman
> I love,
> The sickness of one of my folks—or of myself...or
> ill-doing...or loss or lack of money...or
> depressions or exaltations,
> They come to me days and nights and go from me again,
> But they are not the Me myself.

> Apart from the pulling and hauling stands what I am (35)

As long as one doesn't think too much about what kind of life this would be, it sounds attractive—we wouldn't, most of us, like for long to be rid of the world, but we often feel as if we would, and Whitman offers himself as a persuasive example:

> What is commonest and nearest and easiest and cheapest
> is me. (44)
> And these one and all tend inward to me, and I tend out-
> ward to them.
> And such as it is to be of these more or less I am. (48)
>
> I resist anything better than my own diversity. (49)

From here—from this community of feeling and experience—the step is short to:

> And I know I am deathless,
> I know I shall not pass like a child's curlicue. (52)

or

> I laugh at what you call dissolution (52)

or

> I bequeath myself to the dirt to grow from the grass
> I love. (96)
>
> To be in any form, what is that? (61)

In the same way, or by the same logic of feeling, all this oneness of experience and escape from the ordinary attributes of self leads to an idealization of that other great leveler, sleep ("They are all averaged now"); and from sleep to death, too, is in Whitman's world a short step, or sometimes, as in *The Sleepers*, no step at all:

> The sleepers are very beautiful as they lie unclothed;
> They flow hand in hand over the whole earth from east
> to west as they lie unclothed. (124)

The peace and beauty of sleep is the peace and beauty of death, or so I feel, for a moment, reading these lines. And when Whitman says soon after:

> I know not how I came of you…but I know I came
> well and shall go well. (125)

it's only the fact that he says it that makes me remember that I
don't believe it.

For Al Stephens

MAX SCHOTT

Chaucer's Moral Judgments

If a reasonably literate person (like me) were asked to name the great literary moralists, I wonder if Chaucer would come very quickly to mind. He's funny and calm, unexcessive in praise or blame, less bent on punishment than on revelation, unobsessed by any particular virtue or vice at the expense of the others.

After a moment's thought, though, my literate person would probably prefer as moralists such writers as Sophocles, Chaucer, Jane Austen, Chekhov, Trollope, Hardy, or even such quirky people as Sterne, Lamb, Hazlitt or Pope, to Swift, Euripides, Shakespeare, Tolstoy, or Lawrence—none of whom one would wish to have any more of God's power than he did have.

But in most of the works of Sophocles, Chaucer, Jane Austen, et al., the moral distinctions and judgments are implicit. The writers are conscious enough, but the reader reading along hardly notices the moral premises and conclusions, which is probably why the most trustworthy and unerring literary moralists don't seem at first glance to be moralists at all.

These remarks about implicitness apply pretty well to the Chaucer of *Troilus and Criseyde*, but not very well to *The Canterbury Tales* and not at all to the General Prologue, where making moral judgments—judging human value—is a large part of the subject and is carried on continually and explicitly.

A quick way to remind oneself of this is to think back to some of the words Chaucer uses—terms of moral valuation like virtue, worthy, good—and to recall that they're used not just repeatedly but

carefully, from every possible point of view and with every conceivable degree of irony.

The Knight, first of all and straightforwardly, is a worthy man. For many reasons (the absence of any mention of the naïve pilgrim narrator, whose judgments we have to judge; the Knight's character as otherwise presented in the same passage; the fact that this is the first, and therefore maybe the normative, use of the word) worthy here means simply, from any angle, worthy.

After we've already been told a good deal about the Friar (for instance, that he likes to associate with worthy women—of the town, important people in other words), we then learn that:

> Unto swich a worthy man as he
> Accorded nat, as by his facultee,
> To have with sike lazars acqueyntance

—which is as much as to say that he sees himself as worthy and that we see him as not much of a friar. But the way he sees himself and the way we see him are not the only ways he can be seen. He is, truly enough, as seen from the outside, delivering judgment in his respectable coat which he fills out well, impressive. And when our narrator calls him finally "this worthy lymytour," we have a clear but comprehensive sense of what ways he is and isn't worthy. (Later when the Wife of Bath calls him, with all the force of her contempt, "this worthy frere,' this whole spectrum of meanings is reactivated.)

The Merchant is apparently more pompous than the Friar and in his pretenses less convincing:

> This worthy man ful well his wit bisette:
> Ther wiste no wight that he was in dette
> So estatly was he of his governance
> With his bargaynes and with his chevyssaunce.
> For sothe he was a worthy man with-alle,
> But, sooth to seyn, I noot how men hym calle.

In this context, at least, the repetition of the word seems to increase its derisive and hollow connotations; and the same narrator who found the Friar and Monk to be persuasive knows that the

Merchant, in spite of what he says, is in debt, and is suspicious of the reputation of the man who didn't give his name. The Friar impresses both himself and a large part of the world; the Merchant is apparently worthy only in his own eyes—which makes a considerable difference: we hold the Merchant in contempt, but not the Friar.

The word is also used, maybe more incidentally, about the Wife of Bath:

> She was a worthy woman al hir lyve
> Housbondes at chirche door she hadde fyve...

Here the reverberations of worthy are reduced by the context of meaning that surrounds it. The sense that the Wife of Bath has been around and has been around a long time predominates—it's not how she is worthy but how long she's been worthy that our attention is mainly called to. Yet the fact that she is, or would like to be, considered worthy—i.e. respectable—which is then undercut or disqualified in the second line of the couplet, is also important.

Chaucer is evidently making a whole series of distinctions about what moral worth is: to say that he distinguishes among thinking oneself worthy, wishing to appear worthy, appearing worthy, and being worthy would be to summarize crudely and inadequately. But the point is, that these kinds of distinctions not only are made, they are made more swiftly, explicitly and in greater number in *The Canterbury Tales* than in any other work of fiction.

Something similar but different happens with the word "good." Goodness is somehow more important and fundamental than worthiness, and so the words good and virtue modulate into even more important and fundamental moral distinctions than do the variations on worthy.

First though, the more trivial uses of the word are also worth talking about. There are "good fellows," who are generally useful if you want something bad done—they have no compunctions. There are good opinions ("And I seyde his opinioun was goode") which are (or were, the past tense is important) good enough to convince a naïve listener of whatever it is that the speaker finds it convenient

to profess or to believe. There's a "good wife," and a good man of religion—who certainly is good. But here, too, (and could it be everywhere?) "good" is qualified. The Wife of Bath is good—an expert, as she'll declare and show later—at being a wife. And the good parson is a good man—of religion: and since religious feeling is good and the religious profession is good, there's no reason to doubt that a good man of religion is a good man. He is, but still, we see eventually that it's a very carefully qualified good.

The first image of the parson that comes to my mind is of him striding along, covering, it seems, the whole landscape:

> Wyd was his parish and houses fer asunder
> But he ne lefte nat for reyn ne thonder
> In siknesse nor in mischief to visite
> The ferreste in his parrish, muche and lite,
> Upon his feet, and in his hand a staf.

Both aurally (the syntactic unit runs on through the whole passage; there are a number of very heavy stresses, giving a sense of power and space; we hear the mimetic "width" between the first two stresses of the first line) and visually we're presented with an over-sized image.

But to be larger than life (or to be, as the Knight is, ideal), implies, in life, a limitation. The good man of religion lives by a set of rules not of this world. We hear them in the language used to describe him—a special language used nowhere else in the prologue—full of biblical metaphor: men are sheep, bad men are wolves, parsons are shepherds; gold, iron, rust, dung, cleanness, mire. And if gold rusts, what will iron do? There's something attractive in this kind of reduction of experience—as well as something limited and slightly comic—all of which Chaucer points out by gently parodying the metaphors that the parson lives by. (If one were uncertain of this, or thought that maybe Chaucer does it unconsciously, it would only be necessary to pay attention to the same character later, when he says to the Host, for example (with so little effect): "What eyleth the man so sinfully to swere," or later still when he turns out to be too plain spoken and serious for verse: "Ne, God woot, rym hold I but litel bettre.") It's not that this

MAX SCHOTT

kind of virtue or goodness precludes generosity, even generosity of spirit—Chaucer shows that it doesn't. But a virtue that is too unworldly is, in the world we live in, limited—which is not to say that a worldly virtue is not also limited, in other ways.

Such words—virtue, worldly ("Sownynge in moral virtu was his speche" "Ne was so worldly as to have office")—bring up that other good man (about whom the word good is never used), the Clerk. As happens surprisingly often, as soon as a character comes to mind there comes to mind with him a line or couplet that seems to define for all time a particular foible or virtue: "And gladly wol he lerne and gladly teche." But then I ask myself, if he's good, why do I laugh at him? (How quickly one has to modify or complicate—in fact modify is not the right word—any remembered single impression of a Chaucer character.)

And leene was his horse as is a rake,
And he nas nat right fat, I undertake...

There's nothing unfriendly in this laughter. The Clerk aspires to an ideal, and lives by it as far as he can, which is further than most of us could. But *we* see him in the world, we see him sleeping, for instance, under his books; he is conscious of the books, which he loves, while we see the whole image. He is probably unaware of or indifferent to what he looks like on his horse—his mind is on higher things and we admire him for that, but our eyes are on him and his horse. Again virtue, without ceasing to be what it is, is delimited, outlined, or qualified. (As might be expected, the Clerk's unworldly moral virtue will be both fully valued and its limits fully established when he comes to tell his tale.)

We can't choose, then, just to be good; we have to be good in particular ways, and those ways exclude other ways. This doesn't make Chaucer's characters less good than most of the other good characters in literature—it does make them believable and human and represents an accurate, unblinkered, and, in the most elemental sense of the word, humane moral vision.

Except it's not right to make this kind of claim without looking first at characters from the other end of the scale—from whom there are plenty to choose, virtue being limited in this sense too in

the Canterbury Tales: there's a large proportion of villains—though the inaptness of the word is striking.

The villain—Iago, say—is not a Chaucerian conception. Chaucer has the Pardoner say about himself "thogh I am a ful vicious man'" and the very moment that the Pardoner calls himself (accurately enough) vicious is the moment that we feel the full strength of the man's religious feeling. Chaucer's good people without ceasing to be good are never simply good; his bad people are bad in ways similarly qualified.

(It should be definitely said though, that Chaucer's portraits are morally complicated, not morally fuzzy. Gradation, qualification, limits, complication—there are—but not equivocation or ambiguity. The Prioress is sentimental, uninterested in people, overinterested in appearances, and rather silly; she is also capable of a limited kind of compassion, is gentle (the cruelty that accompanies her sentimentality will be discovered later), polite, handsome, would at least like to be thought of as good ("to been holden digne of reverence"), and appears to have fallen into the wrong vocation through no fault or choice of her own: this is a delicate and complicated portrait (especially in Chaucer's rendering of it), but not an ambiguous or equivocal one.)

Chaucer's moral categories are both ordinary and radical. They are ordinary in that they correspond to the way we make our own usually unthinking judgments of people, and radical in that they don't match up with the official categories which we usually think we believe in.

A man like Willoughby or Wickham is a danger partly because he is attractive. A bad or wicked man who happens also to be lively, energetic, possessed of some kind of moral force, intelligent, inventive, is likely to cause more trouble than a man who is only bad. Would it be perverse to say we're attracted to the good in him? And that these goods—liveliness, energy, ability—when they're associated with badness are still goods?

The Pardoner is not less brilliant and talented for being a bad man. Chaucer takes nothing away from him (sometimes it seems that Jane Austen ends up taking some of the attractive qualities away from her villains). He allows the reader to see and respect

and therefore to be all the more afraid of and fascinated by the Pardoner's talents. The Friar whose eyes twinkle like stars on a frosty night is terrifying partly because we are drawn to his energy (that twinkling) and at the same time see what a cold energy it is and know that it will be used to injure whoever is drawn to it.

The Pardoner, the Summoner, the Shipman, the Physician, the Man of Law, the Friar, do what they do well—are nonpareils in fact. They are not so much consummate villains as they are consummate pardoners, shipmen…, and bad men besides.

Chaucer is not morally nervous. He doesn't punish a character for one quality by denying or smudging another. It may also follow, as Jane Austen seems to think too, and Freud (though they appear more worried about it than Chaucer does), that moral virtue, its exercise, may put a damper on liveliness (for Jane Austen this sometimes means that liveliness itself is suspect).

One other thing affecting our reactions, and apparently Chaucer's own reactions, to his bad characters: Although we don't forgive them for being what they are—this is not expected—it often seems that the universe has given them very little space to make choices in. The Pardoner's physical and sexual constitution is a given—he has to orient his life to it; he is almost bound to be a renegade of some kind, and is certainly bound to be at least an outcast.

Some of the gentler hypocrites too, like the Prioress and Monk, seem to have been dropped from the sky into the wrong vocation: the Prioress with a little better luck could have been a real lady and not a lady prioress; the Monk could have followed his hounds and eaten his swan without having to try to justify himself, had he been by some other twist of fate a plain country gentleman.

Related to this is the matter of temptation. Temptation for pardoners, friars, summoners, monks, is great—and their sins are great. In a way, the wickeder the man—Pardoner, Friar, Summoner—the more qualified our condemnation of him has to become. Big sins have a stronger appeal than little ones. This doesn't make these men better, it makes them worse, but they are worse sympathetically, if such a thing can be said. Anyhow, I think this is why the pilgrims for whom Chaucer seems to feel the least sympathy (and who deserve the least) are not those who sin the hardest or

are the most wicked; Chaucer is least sympathetic to those who succumb to the most trivial, resistible or contemptible temptations—the social climbing tradesmen, for instance, who are described quickly in a lump; the pompous, self-impressed and boring ("sowynge alwey th' encrees of his wynning") merchant. (Is this really the same merchant we hear from later? I've never found the connections discovered by critics to be very convincing.)

With thanks to Marvin Mudrick and Logan Speirs

A Short Happy Marriage

"I am nat textueel," says Chaucer's good parson. "Experi-
ence, though noon auctoritee/Were in this world, is right ynogh for
me..." says the Wife of Bath. The Franklin apologizes for his lack
of literary training: "...by cause I am a burel man,/ At my bigyn-
nyng first I yow bisseche,/ Have me excused of my rude speche./ I
lerned nevere rethorik, certeyn;/ Thyng that I speke, it moot be
bare and pleyn." The Host asks the Clerk to eschew his "Heigh
style"; "Speketh so pleyn at this tyme, we you preye/That we may
understonde what ye seye." And the Knight cuts short the Monk's
bundle of recited official stories, the written texts of which (more
than a hundred) are in his room back at the monastery.

These are the jokes of a man who, though no more credulous
than the Wife of Bath, worked from books whenever he could and
sometimes was "textual" with a vengeance: Putting together the
Clerk's Tale "apparently, his method of procedure was to read a
passage in Petrarch's Latin, then to read the corresponding passage
in the French translation, and finally, under the immediate in-
fluence of this double recital, to set down his own version, stanza
by stanza." (*Sources and Analogues of Chaucer's Canterbury Tales*,
Bryan and Dempster, 289.)

But like many English writers after him, Chaucer didn't just
work from other people's texts, he worked from his own as well. A
few instances of this are still retrievable. In an earlier version (of
the prologue of the Nun's Priest's Tale—see Robinson's explana-
tory and textual notes) it is not the Knight who interrupts the
Monk, but the Host:

"Hoo!" quod the Hoost, "good sire, namoore of this!
That ye han seyd is right ynough, ywis,
And muchel moore; for litel hevynesse
Is right ynough to muche folk, I gesse.
For therinne is ther no desport ne game.
Wherefore, sire Monk, or daun Piers by youre name,
I pray you hertely telle us somewhat elles…"

The later version reads:

"Hoo!" quod the Knyght, "good sire, namoore of this!
That ye han seyd is right ynough, ywis,
And muchel moore; for litel hevynesse
Is right ynough to muche folk, I gesse.
I seye for me, it is a greet disese,
Whereas men han been in greet welthe and ese,
To heeren of hire sodeyn fal, allas!
And the contrarie is joye and greet solas,
As whan a man hath been in povre estaat,
And clymbeth up and wexeth fortunat,
And there abideth in prosperitee.
Swich thing is gladsome, as it thynketh me,
And of swich thing were goodly for to telle."
"Ye," quod oure Hooste, "by seint Poules belle!
Ye seye right sooth; this Monk he clappeth lowde.
He spak how Fortune covered with a clowde
I noot nevere what; and also of a tragedie
Right now ye herde, and, pardee, no remedie
It is for to biwaille ne compleyne
That that is doon, and als it is a peyne,
As ye han seyd, to here of hevynesse.
Sire Monk, namoore of this, so God yow blesse!
Youre tale anoyeth al this compaignye.
Swich talking is nat worth a boterflye,
For therinne is ther no desport ne game.
Wherfore, sire Monk, or daun Piers by youre name,
I pray yow hertely telle us somewhat elles:"

MAX SCHOTT

The fundamental psychology of the revision is that of a man who thinks dramatically; it makes very little difference whether he is a writer or an oral composer: Homer would have done the same, maybe. But the economy and method of the change appear to be the work of a man who has looked back at his own written text. The Host and the Knight are two very different characters; they think and speak differently; they share an action here, but not from the same motives (the Host is irritated and bored and is also acting in his position as a literary critic; the Knight finds the stories morally oppressive) or the same feelings. The shared reaction with all its concomitant dissimilarities of temperament and style makes the passage many times more lively. And yet for all that, Chaucer sees that he has only to change a single word in the first seven lines. The dramatic conceiver, and the tinkerer-with-words-on-paper are both operating in full and cooperative force here.

Chaucer was a writer, yet he composed for the ear—wrote for an audience of listeners, wrote verse, which itself is an oral form. What does this marriage mean and how did it come about? What value is in it? To begin to answer these questions it's necessary to go back, though Chaucer as an oral-written poet remains the subject.

Chaucer belonged to one of the first generations of literate English poets. To imagine what it means to be a literate poet one has to try to imagine what it means or meant to be a non-literate poet; which we can do fairly well thinking about Homer, but the mixed conditions that followed upon the Greek adaptation and adoption of the alphabet (and which continue to exist, at least in verse, even today) make the subject a hard one, though rather fun.

If an oral poet, Homer say, were to recite for a scribe, and in this way preserve his poem in writing, we wouldn't call him literate. If Aeschylus, or an even earlier dramatist, raised in an oral tradition of dramatic composition, decided to use the new system of written preservation, but used it without altering his way of inventing or of thinking, we might hardly know whether he should be called a writer or not. But once he began looking today at what he wrote yesterday or last year, and changing it, or getting ideas from it, or writing new passages which had a relation to what came before—a discovered relation which memory alone could not have

produced, then we know that whatever we call him, writing has entered his life, and the life of his culture, as more than just a system of storage.

One indication of how quickly the Greeks not only began to make use of writing, but to incorporate it, to make themselves literate, is the fact that it didn't take them long (as these things go) to begin writing prose—for a prose literature is the direct consequence of the invention of writing. (A curious incidental fact is that prose literature has a traceable history—an anthology, beginning with the first major writer of prose, Herodotus, could be assembled on a chronological and developmental basis, without a break (W.P. Ker, *Essays on Medieval Literature*); while literature itself had a long history before our history of it could begin).

A second indication of how quickly the Greeks became not simply adept at using writing, but literate, is their (I am talking about a small number of educated people) early accomplishment of that most difficult cultural feat, silent reading. When a person can or even prefers to read silently, the invention of writing has literally been incorporated. When a group of people can read silently, that part of the culture—which is likely to include its writers—then has become literate. Also, and this is pertinent, the preference for silent reading is the beginning of the end of the preference for verse as a major literary form.

But how soon is quickly, and how big is a group and what relation has this to the middle ages and Chaucer?

Before stating the case for the frequency of silent reading, it's best to remind oneself of the norm, not just in antiquity but through Chaucer's time and past the time of the invention of printing and the wide distribution of printed books: "the normal way to read a literary text was out loud, whether before an audience, in the company of friends or alone." (Bernard M.W. Knox, "Silent Reading in antiquity." *Greek, Roman and Byzantine Studies*, Winter 1968). When, as often happened, the writer's audience corresponded to this norm, or rather was part of it, while the writer himself was not, an odd sort of split was in effect, one similar to and related to the split between an author who writes and an audience that listens.

MAX SCHOTT

Knox establishes that the Athenians, as early as the fifth century (about three hundred years after the introduction of the alphabet into Greece), read silently, and that the practice wasn't thought to be rare, astonishing, or even peculiar. His evidence is fascinating in itself:

> The first is Euripides' *Hippolytus* 856ff. Theseus notices the letter which is tied to the hand of his dead wife. After some speculation about its contents (all very wide of the mark) he proceeds to open it. "Come, let me unwind the wrappings in which it is sealed and see what this letter wishes to say to me" (864–65). The chorus now proceeds to sing five lines of lyric apprehension, followed by three lines of apotropaic prayer, and then Theseus bursts out in a cry of grief and anger: "Evil upon evil, unbearable, unspeakable." Clearly he has read the letter and read it silently—the audience watched him do so.
>
> The second passage shows silent reading not of a letter but of an oracle. In the prologue of Aristophanes' *Knights*, Nicias comes out of the house of Demos at line 115, carrying the oracle which Paphlagon guarded most carefully, but which Nicias has managed to steal from him as he lay snoring. "Bring it here, let me read it," says Demosthenes and then, like Theseus, "Come now, let me see what is in it." He cries out in astonishment as he reads; indeed, he is so affected by the contents of the oracle that he demands more drink. For five more lines he continues to express amazement and demand more wine while the anxious Nicias presses him with demands for information. Finally, at line 127, he begins to explain, and it is clear from what he says that he has read right through to the end. At 128 he finally begins to tell Nicias what he has read. This is all the more striking evidence for quick and skillful silent reading because, while he is reading, Demosthenes is giving orders for more wine, making exclamations of amazement and indulging in a rhetorical address to Paphlagon.

These three passages, from Antiphanes, Euripides and

Aristophanes, clearly demonstrate for fifth and fourth century Athens that silent reading of letters and oracles (and consequently of any short document) was taken completely for granted.... The audience has watched Theseus read the letter, and he did so in silence.

Evidence from Rome is easier (for Knox) to gather. Horace and Cicero not only read silently themselves but seemed to take it for granted that this was a common enough accomplishment to be dangerous to the proper appreciation of verse—a complaint that has been repeated ever since, or rather began to be reiterated in recent centuries: After the fall of Rome there was a backsliding. According to Havelock (*The Literate Revolution in Greece and Its Cultural Consequences*), the literacy rate of Rome—meaning I suppose a rough ability to read and write—was unequalled anywhere again until the nineteenth century (and then first in England), though one might well wonder where such statistics come from and how reliable they are. But that the back-sliding was severe and long-lasting there is no doubt.

The example of St. Augustine observing St. Ambrose as Ambrose sat reading is well known:

When he read, his eyes scanned the page and his heart explored the meaning, but his voice was silent and his tongue was still.

Augustine as he goes on tries to explain the probable reason for this anomaly, ending up puzzled but still faithful: "...whatever his reason, we may be sure it was a good one." (*Confessions*, Book six, chapter three.)

Knox, a classicist, takes issue with the obvious inferences to be drawn from the passage, arguing that Augustine was at the time a provincial. But Coulton (*Medieval Panorama* and in other books as well), who probably read more and knew more about Medieval documents than any man who ever lived, takes Augustine's astonishment to be well justified.

Both Coulton and W.P. Ker talk impressively about the oral nature of literary culture in the early middle ages (the date of

Augustine's observation of Ambrose, by the way, is around 400). Even much of the prose was, in the worst sense, verse-like, or jingly.

> Prose is more difficult than verse in some stages of literature, and where a good deal of prose was made to be read or recited, where the homilist was the rival of the poet or the story-teller, there is small wonder that often the sermons fell into a chanting tone, and took over from the poets their alliteration and other ornaments. (Ker, *Essays on Medieval Literature*)

Far surpassing the Greeks in this rather backward respect, the reading population of early medieval England demanded not only that their *stories* be versified—a sensible demand—but

> Long after Alfred there still remained, as a disturbing force (disturbing to the development of good prose), the natural antipathy of the natural man to listen to any continuous story except in verse. The dismal multitude of versified encyclopedias, the rhyming text-books of science, history, and morality, are there to witness the reluctance with which prose was accepted to do the ordinary prose drudgery.... The audience expected something finer than spoken language. (Ker, *Essays on Medieval Literature*)

This oral-and-verse bias, which prevented English prose from really coming into its own before Malory, obligated a man even of Chaucer's generation to tell his stories in verse, though by that date he might choose to deliver a moral treatise (like the "Tale of Melibee"), a book of instruction ("The Astrolabe"), a book of philosophy ("Boece"), or a sermon ("The Parson's Tale"), in workmanlike prose, apparently without fear of losing his audience. An obvious effect of the oral bias is the high achievement of much Medieval verse, even excepting Chaucer. Another effect was the development, beginning around Augustine's time, of a new mnemonic (the Greeks had it but had little use for it) which took Europe by storm—rhyme.

At the beginning of this essay we saw that Chaucer, although he wrote for an audience of listeners, was a literate writer who,

however fine his own ear was, didn't compose by ear entirely, but worked from other people's texts and from his own. The split between this kind of writer and his audience was remarked on. A verifiable external symptom of this split was said to be the ability of writers to read silently, while their audience not only preferred to, but could do nothing else but, listen—even a man alone reading being a listener for his own speaking voice. I also indicated that only a population of listeners could make the preservation of verse as a major literary form possible.

Chaucer was one of the last generations of Englishmen for whom telling their stories in verse was an inevitable decision (in fact hardly a decision at all; Chaucer could choose among Latin, French and English, but the choice of verse was made for him). At the same time he was of one of the first generations of educated men to read silently, probably in Medieval Europe, certainly in England.

In "The House of Fame," Chaucer's most intimately autobiographical poem, the eagle, when he comes down to carry "Geffrey" off, describes Chaucer's everyday after-work routine—the wool shipments all having been dutifully recorded:

> For when thy labour doon al ys,
> And hast mad alle thy rekenynges,
> In stede of reste and newe thynges,
> Thou goost hom to thy hous anoon,
> And, al so domb as any stoon,
> Thou sittest at another book
> Tyl fully daswed ys thy look...(lines 653–58)

"Geffrey," like all of Chaucer's literary versions of himself, is no exceptional man, while at the same time to read a book "dumb as any stone" is still not so common a phenomenon as not to be mentioned. (Coulton points this out, though I'm not sure where.)

The marriage between complete literacy and the demands of an oral tradition (sustained by a listening audience) was a short and happy one. At one point (Book I, line 267 ff.) in Chaucer's novel-in-verse, *Troilus and Criseyde*, Troilus casts his roving eye on Criseyde, where it stops:

MAX SCHOTT

Withinne the temple he wente hym forth pleyinge,
This Troilus, of every wight aboute,
On this lady, and now on that, lokynge,
Wher so she were of town or of withoute;
And upon cas bifel that thorugh a route
His eye percede, and so depe it wente,
Til on Criseyde is smot, and ther it stente.

No structure which approaches the informality of prose can pro-
duce an effect of equal finality. A couplet would not do quite so
well, blank verse less well than that. Prose? Well, prose is not with-
out its own systems of expectation, surprise and denial, postpone-
ment, etc. "No iron can stab the heart with such force as a period
put at just the right place." (Isaac Babel) But the trouble is, there
are too many right places, and the effect will either be slighter than
the effect of verse, or degenerate into bombast and artifice.

Good prose will never be quite as moving as good verse. Good
novelists know this, and there's something wistful in their attempts
to face up to the fact. "To desire to give verse-rhythm to prose, yet
to leave it prose and very much prose, and to write about ordinary
life as histories and epics are written, yet without falsifying the sub-
ject, is perhaps an absurd idea…. But it may also be a great experi-
ment and very original." (Flaubert, quoted in *The English Novel* by
Walter Allen.)

But the experiment was not Flaubert's. Ordinary life, written
about as histories and epics are written, yet without falsifying the
subject—this is *Troilus and Criseyde*, and the effect of verse was
given, as it only can be given, by verse itself.

It was a marriage that couldn't last. A world of silent readers
demands a literature of prose. Chaucer, at the end of *Troilus and
Criseyde*, is foresightful enough to satisfy anybody.

Go, litel book, go, litel myn tragedye,
Ther God thi makere yet, er that he dye
So sende might to make in som comedye!
But litel book, no making thow n'envie,
But subgit be to alle poesye"
And kis the steppes, where as thow seest pace

Virgile, Ovide, Omer, Lucan, and Stace.
And for ther is so gret diversite
In Englissh and in writing of oure tonge,
So prey I God that non myswrite the,
Ne the mysmetre for defaute of tonge.
And red wherso thow be, or elles songe,
That thow be understonde, God I biseche!

(Book V, line 1786 ff.)

Chaucer would hardly have been surprised could he have known that beginning a generation or two after his death and continuing on for some three hundred years (until 1776) he would be mismetred for default of tongue by everyone in England who tried to read him. But even Chaucer couldn't foresee, as history would have it, that the first English novel in verse would be the last.

For Marvin Mudrick

MAX SCHOTT

The Scene in the White Hart Inn

Like most other scenes or dramatic episodes in novels, the scene at the White Hart Inn in *Persuasion* seems at once to be self-contained and to be the most probable consequence of all that comes earlier. If a scene can be said to have an emotional tone, the tone of this scene is excited and anxious joy, at first, and joy alone at last—a culmination toward which the whole book has been moving.

The earlier mood of *Persuasion* is one of restrained intensity. Anne is passionate, so possessed by strong feeling that more than once voices hum and the room swims. At the same time, she's the soul of propriety: her strong will and perfect sense of what's right make it certain that she'll never act on her feelings till conscience and good sense allow or demand it. From her own point of view, which we largely share (except that we know she's a character in a romantic novel—she doesn't), any such alignment seems unlikely. She hardly dares to hope. And as both the intensity of her feelings and the power of her restraint are great, the first two-thirds or so of the book is highly charged, in a painful sort of way (for the reader the pain is adulterated with hope and expectation, for Anne even hope is painful). Because we are reading a novel, we long for and expect a time to come when Anne will have the opportunity and the right to act.

From the time the attractive stranger (who only later will become the disagreeable Mr. Elliot) gives Anne a look and provokes Captain Wentworth and the reader to do the same, the spirits of the novel rise. No longer are the reader and Jane Austen the only

ones who know the full value of this isolated person. From now on the world (Mr. Elliot, the Crofts, Captain Benwick, the Harvilles, finally even some gossipy women who compare her favorably with her self-promoting sister Elizabeth)—not to speak of Captain Wentworth himself—will take increasing notice of Anne. But all this is incremental and has the appearance at least of being incidental. The fundamental restraint on Anne's passionate intensity must be in effect as long as she has to assume that Wentworth's affection for her is dead.

The change comes with a jolt:

> No, it was not regret which made Anne's heart beat in spite of herself, and brought the colour into her cheeks when she thought of Captain Wentworth unshackled and free. She had some feelings which she was ashamed to investigate. They were too much like joy, senseless joy! (160) (Signet Classic edition)

The lid is off, and from now on the mood of the book soars. Anne has never doubted her own feelings, and her appreciation of him now moves quickly from a more-than-reasonable hope to reasoning certainty: "—He must love her." (177)

That the union has already been accomplished in their hearts, separately, Anne is *almost* sure. The only impediment is, that Wentworth doesn't know what Anne feels or wants. But Jane Austen refuses to allow delays or superficial suspense or cleverly wrought misunderstanding—those staples of novels—to dull the spirit of this ending. Captain Wentworth is jealous (a clear and amusing sign in itself of his attachment) and things are for the moment not going well:

> She tried to be calm, and leave things to take their course; and tried to dwell much on this argument of rational dependence—"Surely, if there be constant attachment on each side, our hearts must understand each other ere long. We are not boy and girl, to be captiously irritable, misled by every moment's inadvertence, and wantonly playing with our own happiness." (211)

MAX SCHOTT

Anne is a creature of reason, and unlike most rationalizations this one is more comforting to the reader than it is to the character who makes it. But within two pages Anne is able to make it clear enough whose company she prefers to Mr. Elliot's, speaking ostensibly to Mrs. Musgrove and for Captain Wentworth to hear:

"If it depended only on my inclination, ma'am, the party at home (excepting on Mary's account) would not be the smallest impediment, I have no pleasure in the sort of meeting, and should be too happy to change it for a play, and with you. But it had better not be attempted, perhaps."

She had spoken it; but she trembled when it was done, conscious that her words were listened to, and daring not even to try to observe their effect. (213)

Excited joy, joy in motion: events conspire to happen quickly: "Do not you think, Miss Elliot, we had better try to get him to Bath?" (165); "and the very next time Anne walked out, she saw him." (166); "Two minutes after her entering the room, Captain Wentworth said," (218).

But it's a joy laced with anxiety. Anne has allowed herself to hope and to believe, and she feels she owes it to herself and especially to him to act as well: "She felt that she owed him attention." (171); "…and making yet a little advance, she instantly spoke. He was preparing only to bow and pass on, but…" (173); "Anne felt truly obliged…for the opportunity it gave her of decidedly saying—" (213). Anne acts on the basis of what she has reason to believe; she doesn't wait for confirmation, but takes the risk of providing confirmation to him instead. Anne in her always quiet way is as nervy in her willingness to act as she was brave in her willingness to suppress. The courage we admired or were touched by before we thrill to now, when everything is at stake.

Which brings us to the scene itself: "She had promised to be with the Musgroves from breakfast to dinner." But the weather is bad, and when:

she reached the White Hart, and made her way to the proper apartment, she found herself neither arriving quite

in time, nor the first to arrive. The party before her were Mrs. Musgrove, talking to Mrs. Croft, and Captain Harville to Captain Wentworth, and she immediately heard that Mary and Henrietta, too impatient to wait, had gone out the moment it had cleared, but would be back again soon, and that the strictest injunctions had been left with Mrs. Musgrove to keep her there till they returned. She had only to submit, sit down, be outwardly composed, and feel herself plunged at once in all the agitations which she had merely laid her account of tasting a little before the morning closed. There was no delay, no waste of time. She was deep in the happiness of such misery, or the misery of such happiness, instantly. Two minutes after her entering the room, Captain Wentworth said, "We will write the letter we were talking of, Harville, now, if you will give me materials."

Materials were all at hand, on a separate table; he went to it, and nearly turning his back on them all, he was engrossed by writing.

Mrs. Musgrove was giving Mrs. Croft the history of her eldest daughter's engagement, and just in that inconvenient tone of voice which was perfectly audible while it pretended to be a whisper. (218–19)

Harville is apparently lost in thought, and Anne is left standing around uncomfortably, forced to have to pretend not to listen to what she in fact would rather not hear.

With hindsight it's easy to see that this unobtrusive opening is remarkable for a sort of vectored fertility. What begins as no more than a pleasantly convincing new twist on the old convention of overheard conversation will within a few pages turn into the most psychologically complicated and finely turned echo-chamber in fiction. What will become one of the most passionate and moving double declarations of undying love begins and will end with the gentleman seated, writing, with his back "nearly" turned. What begins as a letter written for a friend will become a hard-pressed and urgent outpouring of a man's own heart. And the ordinary and

MAX SCHOTT

inevitable small talk about Henrietta's engagement will electrify the very people who have the least interest in it.

Mrs. Croft is sensible and Mrs. Musgrove isn't, but both have good reason to speak well of short engagements. Anne expects their conversation—carried on mostly by Mrs. Musgrove in her "powerful whisper"—to be overheard by Captain Wentworth; the idea is painful, and the conversation proceeds as Anne fears and expects until Mrs. Croft, agreeing that a long engagement is bad, adds:

> "Yes, dear ma'am...or an uncertain engagement; an engagement which may be long. To begin without knowing that at such a time there will be the means of marrying I hold to be very unsafe and unwise, and what, I think, all parents should prevent as far as they can."
>
> Anne found an unexpected interest here. She felt its application to herself, felt it in a nervous thrill all over her. And at the same moment that her eyes instinctively glanced towards the distant table, Captain Wentworth's pen ceased to move, his head was raised, pausing, listening, and he turned round the next instant to give a look—one quick, conscious look at her.
>
> The two ladies continued to talk,...but Anne heard nothing distinctly; it was only a buzz of words in her ear, her mind was in confusion. (220)

We don't know what is in Captain Wentworth's mind. We do know that he is strongly moved, and that he isn't averse to letting Anne see that he is.

Anne, in the grip of feeling, looks unconsciously in the direction of Captain Harville, who kindly invites her to join him. "She roused herself and went to him. The window at which he stood was at the other end of the room from where the two ladies were sitting, and though nearer to Captain Wentworth's table, not very near."

"Though nearer...not very near." This delicate stage direction gives us to understand—or rather to guess—that Wentworth might be near enough to overhear what Anne and Captain Harville might say, and that at the same time he is not so near as to make Anne

certain or conscious that she is talking for his benefit. In this entire scene, gestures, tones or loudness of voice, position and distance, silence, and absence of motion are as important as talk. The larger instances of gesture or dumb show are used to staggering effect, but even the tiniest parenthetical comments, as when we are told that Captain Harville while speaking happens to look "towards Captain Wentworth," serve important purposes (in this case the purpose of keeping the reader constantly aware of Captain Wentworth's physical and probably listening presence). "Poor Fanny!" says Captain Harville, thinking and speaking of how quickly his sister has been forgotten by Captain Benwick, "she would not have forgotten him so soon!"

"No," replied Anne, in a low feeling voice. "That I can easily believe."

"It was not in her nature. She doted on him."

"It would not be in the nature of any woman who truly loved." (221)

Speaking, as she thinks, in general, and calmly enough at first (though even at first, for all the lovely brilliance of what she says, Anne isn't quite able to keep to the original subject, Captain Benwick, for it's Captain Wentworth, who when the subject is "men," serves as a type: "You have always a profession, pursuits, business of some sort or other, to take you back into the world immediately, and continual occupation and change soon weaken impressions." Captain Harville reminds her that this doesn't apply to Benwick. "'True,' said Anne, 'very true; I did not recollect.'"), about the superior constancy of women, and the equal but different trials of men, Anne can finally not sustain her tone. "'Neither time, nor health, nor life, to call your own. It would be too hard indeed (with a faltering voice), if woman's feelings were to be added to all this.'"

"We shall never agree upon this question," Captain Harville was beginning to say, when a slight noise called their attention to Captain Wentworth's hitherto perfectly quiet division of the room. It was nothing more than that his pen had fallen down, but Anne was startled at finding him

MAX SCHOTT

nearer than she had supposed, and half inclined to suspect that the pen had only fallen, because he had been occupied by them, striving to catch sounds, which yet she did not think he could have caught.

"Have you finished your letter?" said Captain Harville.

"Not quite, a few lines more. I shall have done in five minutes." (222)

If Anne up to now has believed that she was talking only to the Wentworth in her mind and heart, then from now on she must know, whatever she may say to herself, that she's talking to the one in the room as well. She sinks her voice, we find out later from Wentworth's letter, but only for a time.

"Oh!" cried Anne eagerly, "I hope I do justice to all that is felt by you, and by those who resemble you. God forbid that I should undervalue the warm and faithful feelings of any of my fellow-creatures. I should deserve utter contempt if I dared to suppose that true attachment and constancy were known only by woman. No, I believe you capable of everything great and good in your married lives. I believe you equal to every important exertion and to every domestic forbearance, so long as you have an object. I mean, while the woman you love lives, and lives for you. All the privilege I claim for my own sex (it is not a very enviable one, you need not covet it), is that of loving longest, when existence or when hope is gone."

She could not immediately have uttered another sentence; her heart was too full, her breath too much oppressed.

"You are a good soul," cried Captain Harville....(224)

Captain Wentworth thinks so too. And the woman he loves lives.

You sink your voice, but I can distinguish the tones of that voice, when they would be lost on others.—Too good, too excellent creature! You do us justice indeed. You do believe that there is true attachment and constancy among men. Believe it to be most fervent, most undeviating in F.W.

I must go, uncertain of my fate; but I shall return hither, or follow your party, as soon as possible. A word, a look will be enough to decide whether I enter your father's house this evening, or never. (226)

Anne reads it. But I was wrong to think of her culminating joy as pure pleasure: maybe excited joy is always mixed with a bit of anxiety or something like it, at least in a nature as passionate as Anne's. (Did someone say *Persuasion* is "dull"? And someone else "autumnal"?)

Such a letter was not to be soon recovered from. Half an hour's solitude and reflection might have tranquilized her; but the ten minutes only, which now passed before she was interrupted, with all the restraints of her situation, could do nothing towards tranquility. Every moment rather brought fresh agitation. It was an overpowering happiness. (226)

For Logan Speirs

MAX SCHOTT

From a Diary

January 6, 1997

For the past three years I've kept a diary about my father. When I began it, he was eighty-nine.

In its natural state this so-called diary is just a huge mass— many hundreds of pages—of barely decipherable and sometimes hardly comprehensible notes: a messy affair which I sort out and type up a bit at a time. It gives me pleasure to do this, and I don't altogether look forward to finishing the job.

April 30, 1994

I was writing and watching a basketball game on TV at the same time—or watching the game and writing at the same time.

Game over, I turned off the television set.

From the kitchen Elaine said, "Are you through watching it?"

"Watching what?"

"Watching television."

"That depends what you mean. The essence of any question of that kind is time. I'm probably not through watching it forever."

"Is the game over?"

"Yes."

She came into the room. "You must be writing about your father again."

"I am, yeah."

"Whenever you begin talking like that, I can tell."

September 9, 1994

Talked to my brother on the phone. He asked how I thought Dad liked it now at Vista Del Monte. He, I think, feels responsible for Dad's being there, and it cost him something to ask the question. And it cost me something, too, to answer, "I think he likes it. He's happy, or, happier, there." I was surprised to find the words coming out of my mouth.

October 1, 1994

When I visited Dad yesterday he said something he said last time I was there, too: "It's getting dark surprisingly early today." Both times it was a cloudy afternoon, but early, and plenty bright out, and quite light inside where we were sitting. Is this a sign that his vision is suddenly failing, or just part of normal deterioration?

In many ways, though, he seems to feel better, and looks better, than two or three or even five years ago.

He showed me a small red leather-bound book: "A Line A Day" it says on it, in gold letters. Mom's diary, which she kept for a little more than a year, beginning in 1925, "the year we met." I ask if I can look at it sometime. "Of course. Take it with you."

I ask questions, and he tells me how they met. Most of the details are new to me.

He was a senior at Cal Tech, and her family lived in Pasadena. His best friend at college, Bob Bogen, knew Mom's family somehow, and after running into them somewhere one night, he told Dad he was "surprised by how the Kavinoky girls had grown up" (Mom was about seventeen, Elsa a couple of years younger), and "he decided he was going to fix me up with one of them. He'd done this two or three times before—arranged blind dates for me, including one with his older sister, who was too old for me, too mature. I don't know whether he was getting tired of it, or giving up hope, or whether he somehow just guessed that we'd be a good match—anyway, I remember he said, sort of jokingly, 'this time I want it to be permanent.'

"He introduced us on the phone: 'Vita, I want you to talk to a friend of mine, Otto B. Schott'—one of the nicknames they'd given me in college. But it confused Vita about what my name actually

was. And something like that happened at the theater, too. There were, I don't know, seven or eight of us, and she was meeting all of us except Bob for the first time—just outside or maybe even inside the theater, I don't remember. I remember it was the anti-war play, *What Price Glory?* Anyway, she was introduced to several of us, and then she was seated between me and Sherman Hale. Herman Schott and Sherman Hale! So although I think she knew which one of us she was with, she didn't quite know who I was, or at least what my name was."

He laughed, then added: "Years later, she told someone that she had only gradually discovered that she liked me. Probably there was a little mistrust at first, just the way you mistrust somebody you don't know…. When it comes to marriage, we have very few choices really. Very likely there are any number of people who might do just as well, but who we don't happen to meet, and even many who we'd have more in common with or be more compatible with. And yet it seems to work out pretty well, in a surprisingly large number of cases."

October 5, 1994

Mom's line-a-day diary provided her with all the room she wanted. The first impression she makes is of someone who has very little interest in keeping a diary. It begins on January 1, 1925, when she is sixteen. It's hard to tell whether she's intelligent. But she is attractively straightforward. The first entry reads: "I don't like Ch.'s choice of friends, as shown in last night's affair." She is desultory, sometimes bored, often cheerful and happy, never vapid. She wants romance, has a romantic heart, and is winningly incapable of very much self-deception.

There is plenty of male interest, and it seems she would like to be awakened by it, but, on past her seventeenth birthday, just isn't:

August 22—Weenie roast in honor of Mark. Good time. Went with D.G. and Mama to Duarte. Good time again.

August 23—Went out to Gold Rush with Donovan. Hope he never gets mushy. Mark over in evening. Talked about petting. (And in the margin, I can't tell which young man it refers to): I won his respect and admiration.

By September 2nd Mark has gone east to college, which makes it easier to conceive of romance, briefly: "Got lovely letter from Mark. Day dreamt on verandah in moonlight. Sentimental gives way to common sense, soon."

September 11th, it's Donovan again: "Don and I went to a movie. I wish he'd find someone—he's a nuisance and a bore." October 2: Don and I...decided that comradeship was as far as it's wise to go."

October 11—If I could stoop to petting, I would probably enjoy it, but I can't and won't stoop.

On November 6: Went out with Bob Bogen and Cal Tech Boys to *What Price Glory*. (In the margin with a different pen she's written, with the last name misspelled: "Hermann Schot.")

November 11: Hermann Schot called me up about Saturday nite—Nice fellow—ok—Lots nicer than Don

November 14: Hermann Schot.

November 21: Hermann and I...(a list of places they went—football game, dance) Home 2 A.M.

Under "Memoranda" at the end of the month:

Right now Hermann Schott is the B.F. Sure is keen. The whole bunch from Cal Tech are fun.

December 12: He sure is keen

December 13—H probably out with someone else

December 19—Cal Tech dance. Hermann and Boris and I sat around from 2 A.M. to 3:45 A.M. Hermann is lovely.*

December 20—The morning after the night before has nothing on me. (Except for the October 11 and December 31, these are complete entries)

December 21—Papa bawled me out for Dec. 19 and 20th—Which just made me think of H.S. more than I should.

December 31—It's worth everything to hear him say that it was the most wonderful evening he ever spent. I often wonder if he got enough adoration and loving, because his mother died when he was five or six, and he has such a wistfully sweet smile. I'm afraid

* Anna pointed out to me that "lovely" is an afterthought. Vita first had written, in tiny letters, "kissable."

MAX SCHOTT

that I've actually fallen in love…Nov. 6, 1925 was the beginning—
What, the end?

That peroration ends the year, and she begins 1926 in her more usual and less elevated tone:

January 8: H.—I wish I knew whether he's just playing. I hope not, cause I'm gone.

January 9: H. was here. I often wonder how much further I can fall.

January 12: It's just our secret. He gave me one, and I gave him one. It kept me awake the rest of the night.

January 15: We're going to study together…since we can't study apart.

January 22: Saw Love Call with Hermann. Hadn't seen him since Tuesday night. Had a glorious time—(to which she adds "on the sofa," then crosses it out.)

January 26: The last Tuesday before the new term. Thank goodness! My grades are going to be awful.

January 27: Studying together is lovely—especially the aftermath.

October 7, 1994

Because my mother's brain operations both took place before I was six months old, I've lived my whole life without knowing what she would have been like, and wondering what she had been like.

Anyone could see that her sweetness of nature must always have been there, but beyond that, what? My father and my aunt Elsa, if I asked (which I rarely did), would try to tell me about her; but my mother herself, an invalid with various degrees and kinds of dementia, was always there to overwhelm all other possible impressions—until her death. And even after that, no other image formed. What could it form from?

And so, this girl from the diary is the only brain-whole mother I've ever had, and the only model I've ever found for what she might have become. Whether it's because it's all I have, or for more objective reasons, I can't quite tell, but my inclination is to find her very attractive—but so young!

October 14, 1995

A couple of nights ago Elaine's students played at Vista Del Monte, to an audience of the children's parents and old people—many of them retired teachers.

Dad got a big charge, not so much out of the performance itself as from other people's reactions to it. His pleasure and excitement was evident that night, and since then has even increased, as his fellow residents continue to talk to him about it and ask him "how Elaine does it."

That night, as we were walking from the big room where the concert was held back towards his apartment, he told us that he'd discovered that his balance was better and that he could walk more easily and faster if he sang while he walked—and he began to sing a loud tuneless, more or less wordless, song, swinging his cane and walking fast.

When a little later we left his room, he walked out with us. We expected him to stop at the top of the stairs. And I think he expected to—he said good night to us there, but then he went down the stairs with us, and said good night again at the edge of the parking lot—but he didn't stop there, either. He walked with us all the way to the car.

Last night he left a message for Elaine on the answering machine: "Hi…it's Hermann. (Laughs self-consciously) I wanted to tell you how much appreciated you were. Everybody's been telling me how uh wonderful you and your pupils are (click)."

October 14, 1995

He called back today to deliver the message in person and expand on it, as since yesterday "even more people" have come up to him and told him "what a marvel" the children were.

Although ordinarily when he asks questions he doesn't listen to the answers, this time Elaine says he asked her some questions about her teaching and did listen. I guess he'll convey the answers to the people who've been asking him questions.

Anyway, it's wonderful to see him so lively in spirit even when his body and in some ways his mind too are failing him.

I asked him (when I got on the phone) if he's still going to the

MAX SCHOTT

exercise class. He said yes, pretty regularly. "I make myself feel important by bringing in an extension cord. She—the young woman who teaches the class—likes to play music for some of the exercises, and the outlet is in a rather inconvenient place. So, sometime back I began bringing a short extension cord I happen to have. People told me I shouldn't leave it there: someone would take it or move it or lose it. So I bring it each time. It also gives me incentive to go to class even when I'm not sure I feel like it. They need me— or at any rate the cord."

October 14, 1995
Elaine read this and said, "He didn't ask me questions, you got that totally wrong. He repeated the questions that other people asked *him*."

She also said that he didn't say that he'd discovered his balance was better and that he could walk more easily and faster if he sang, but that his balance was better and he could walk more easily *"if he walked faster and sang."*

This discovery of his, I should mention, is partly a reaction to reading Oliver Sacks (*An Anthropologist from Mars*, *The Man Who Mistook His Wife for a Hat*, and *Awakenings*).

November 26, 1995
Dad was over. Anna, in town for a few days from NY, invited him, cooked supper for us.

He is wobblier. Even with his cane he had a hard time negotiating the steps of our front walk (there are no handrails—he kept putting his free hand out hopefully). At the end of the evening, leaving, he was even worse. "Some days I seem to have more trouble with my balance than others," he said after staggering a bit. "But that's why I carry a cane."

At first, he also seemed deafer. When we were first together in the car—I picked him up just after dark—I said, "It was a beautiful day."

"Oh, really?" he said. "Where did you hear that?"

"No—I said it was a beautiful day," I said, or shouted.

He laughed. "Oh, I thought you said it was going to rain. Yester-

day was very nice, too… *Did* you say something about rain?"

At supper he said that a person, "an imaginary person, I think it's a woman," appears in his room sometimes, and tries to speak to him, but that "her presence irritates me, and I tell her (he makes a gesture with his hand to go along with the words) 'Go, go away,'— which she generally does."

Evidently one part of his mind creates her, another wishes her gone.

I reminded him that these visitations have been going on for more than a year now, and that in the past sometimes it's been a man.

"Oh, is that so? I'd forgotten."

A little later, in some context I've forgotten, he recited a four-line poem I'd never heard before. His voice was steady, slow, the effect rather haunting:

> The other day I saw a man upon the stair.
> Yesterday he wasn't there.
> He wasn't there again today.
> I wish that man would go away.

He smiled afterward and said, "I suppose it has to do with the unconscious, if there is such a thing. Something that isn't there is felt to be there after all. It makes you uncomfortable."

Anna wanted to get it by heart and asked him to say it over.

He asked Anna about her life in New York (the postcard she'd sent him had been packed with information, he'd showed it to everyone. She'd mentioned her job as a nanny, he asked her now to describe her routine).

She said she and Wogart meet the two children at their school, in Greenwich Village within walking distance of her own apartment which is on the Lower East Side. She walks with them to their apartment, stopping on the way at Tompkins Square Park "if the weather's good, which it isn't lately. I hate the cold."

"You do? I thought I'd never hear you say there's anything you don't like about New York."

Anna is the grandchild of his old age. When she was growing

MAX SCHOTT

up, they were not quite real to each other. She was skittish and he was vague. But lately—at the last possible moment—they've become fond of each other. It's pleasant to see. They're bashful with each other, sometimes, but even when they are, they still seem to be on the same wave length.

For example, when she was going to go up to his apartment with us on Thanksgiving Day, I was afraid that instead of just being surprised he would be confused (like us he thought she was in New York). I said something about it as we were going up the stairs to his apartment, and she nodded and said that she'd thought of that too.

When he opened the door, she stepped in and said, "Hermann, do you know who I am?"

He hesitated for a moment, and she said, "I'm Anna."

He put his hands on her shoulders, looked closely into her face and said, "You can't be Anna. Anna's in New York. You do look awfully like Anna though. It's good to see you, dear."

December 15, 1995
Elaine and I invited ourselves to dinner at Dad's dining hall.

He's taken a turn for the worse. Twice in the last week or so he fell. The first time was at the bottom of a flight of stairs ("for some reason I thought there was one more step"), the second time he tripped over a curb.

"Did you have your cane?" "Yes, I had it." "Do you think your balance has got worse?" "Possibly. Mainly I think it was inattention. But why I should be so inattentive, I don't know."

Both times he was able to scramble to his feet again fairly quickly (he told me this and so did my nephew Craig, who was with him the first time). His legs got scraped up in several places. The nurse has him come to her office every day. One of the scrapes she says became infected.

While we were eating, one of his favorite croquet players, a pleasant round-faced healthy looking woman, came up and chided him for not being there to play that afternoon.

"I'm afraid I wasn't feeling very well," he said.

December is an unhappy month for him. His sister Clara was killed this month about seventy-five years ago, when he was seven-

teen. And there are other unpleasant associations which he's told me about but that I can't remember. And a few days ago his sister Katy died. At dinner he was carrying copies he'd made of the obituary articles and giving them to people who had asked him for them or seemed interested.

But I'm not at all sure that he's oppressed in spirit by anything except feeling rotten. Rotten and rotting is how he feels, I think. But that isn't how he looks. I sat across from him at dinner. His face was paler than usual, and smoother and more handsome. As if some of the life had gone out of it and a new repose come in. But since that doesn't correspond to how he feels, it seems to be, like the repose of death, just an accident of the flesh.

After dinner we went up with him to his apartment. We'd brought over some Christmas presents that I'd bought (with his money). They were to be from him to Alora, Nathan, Ben and Torre, four of his five great-grandchildren, and we wanted to show them to him before they were wrapped. We'd brought with us wrapping paper, scissors, ribbon and tape.

He wanted to help. We hadn't brought any tags, he noticed, and he began to look for some "pretty ones" that he was sure he had. It wasn't that he couldn't find them that seemed different, but that he wasn't able even to methodically look. When he tried to understand what was for whom, he couldn't keep the information in his mind for even as long as a minute or two. Worse yet, or more painful, he was conscious of his own failings, apologetic, grateful, and as he put it finally, "just very tired."

You can't make wishes for other people with any confidence, but my inclination is to wish for him that if all the tomorrows were to be like today, it would be better if there were not too many of them.

January 21, 1996
Last night's dream: Walking somewhere with my father: old, as he is now, but somehow more touchingly so, hunched over, cane.

A man, young, not friendly, stops us, hands my father a white envelope. He opens it, unfolds a letter. His cheeks squeeze up like a baby's and he begins to sob.

MAX SCHOTT

"What is it? What happened?"

"U.C.—they don't want me back."

He hands me the letter. It's written in pencil, a few scribbled lines giving reasons, a, b, c…I don't read it through. His body heaves and shakes, he can't stop crying.

When I woke up my first thought was, I haven't been to see him for weeks—that's why he's inconsolable in my dream. My second thought: the letter in the dream is really for me.

But even after I realized that the dream was chiefly a translation of my own guilt and self-concern, I still couldn't get the image of my father convulsed by sobs out of my head.

January 6, 1996

Talking about his cane, I said: "It must be pretty old. I barely re-member Uncle Morris. Didn't you say he made it?"

"Yes, when I was about seventeen. He made oh, I think three or four of them, possibly more, out of what he called "freak bamboo" that he found growing in my parents' garden. The rings of the bamboo stems—here, you can see it on the cane—were unusually close together, which Morris thought would make the canes stronger than bamboo canes usually are.

"I broke one of them though. I liked it very much. It was lighter than this one, which is why I liked it. And perhaps also why it broke. Anyhow, one day I was having an argument with my father, and I got so angry that I struck the floor with the cane and broke it. I remember my father saying, 'You see what you've done now?!' "

This conversation was at dinner at Vista Del Monte, with other people at the table. He hadn't said what the argument was about. I was on the verge of asking, but it crossed my mind that he had maybe purposely not said.

A little later, when Elaine and I were walking with him back to his apartment and no one else was around, I said: "Do you remem-ber what you were arguing with your father about when you broke the cane?"

"I do," he said. "I had found a book, an informative book about sex, and especially about masturbation. I was in my early twenties by this time and wasn't living at home. My brother Walter was

sixteen or seventeen, and I wanted him to be given this book to read, and my father didn't want him to see it. He said that he was too young. You see, the books that we had, one in particular that I had read when I was Walter's age, had disturbed me very much and done me a great deal of harm, I felt, and I felt that it was wrong to allow the same thing to happen to Walter. But I lost the argument of course—and my cane."

May 18, 1996
Took Dad down to Seminar Day at Cal Tech. A long day, picked him up early, at six-thirty, got back about eight.

It was mostly a sad excursion. Almost as soon as we got there, after we'd walked the few hundred yards from the parking lot to the building where they pass out the name tags and stuff, he stopped on the lawn, looked around blinking—disturbed I thought by feeling disoriented on his old campus and said: "Now that I'm here I remember why I decided not to come last year. The year before, I had difficulty hearing the speakers. And walking around was…tiring. This is the last time I'm going to come."

After that, he didn't complain, but it was easy to see that he was troubled and disappointed. We sat up close to the front in the auditorium, and he could hear most of what was said, but still he was unable really to take it in. "I think I do better by reading," he said. "I find it easier to concentrate."

After lunch we walked over to the shaded walkway where other years we'd found the posted lists of the alumni who had come. Usually it had been the first thing he wanted to look at, but this time I had to suggest it. So far, he hadn't seen anybody he knew— though in truth he was hardly capable of recognizing anyone or even of looking.

The lists were there. Each graduating class—class of 1936, class of 1992, etc.—had been given a separate sheet of paper, with the exception of classes from the 1920s—because there were altogether only five people attending from that decade. For the class of 1926 Dad was the only one listed.

"Do you recognize any of the names from the other years?"

"Not at the moment."

MAX SCHOTT

Another thing too that bothered him: Two of his grandsons had signed up to come, then decided not to. Dad had paid thirty-five dollars a piece for them, and there was no way to get it back.

So many losses!

The sun was in our eyes driving home; in our eyes about equally but since I was driving he kept offering me his cap.

He was not uncheerful. When we were coming down the Conejo grade, the name (rabbit or jack-rabbit in Spanish) made him think of something. He said to me, "I think I told you about the time I looked up hare and rabbit?"

"No, not that I—"

"I wanted to know what the difference was, so I looked up 'hare' in the encyclopedia. It said a hare is different from a rabbit: the hare has longer legs. I thought, good. But then it went on to say: 'A Belgian Hare is actually a rabbit, and a Jack-rabbit is a hare. And in fact in general most people call hares rabbits and rabbits hares.' I closed the book, then."

October 3, 1996

When I visited him last Thursday, looking at him I thought: "This time he's not going to recover even partially."

A conviction like that is hardly worth much—I'm not a doctor. But I suppose I still believe it: there'll be moments of clarity, good humor, wit, affection—and a steady physical decline.

October 8, 1996

I called him from school and said I'd like to stop and see him on my way home. His voice on the phone was almost as hoarse and whispery as last time, though putting it that way implies no improvement—and I do think it's better.

When I got there I found him about the same: weak, shaky, tentative, cheerful.

"How was it, going to *Singin' in the Rain*? Did you enjoy it?"

"Eh?"

"*Singin' in the Rain*," I shouted.

"Oh, yes. I didn't do very well. I was, oh, just very wobbly. I noticed two or three times that people were putting out their hands

to help me—or to catch me, I suppose. Which was partly how I realized that I was having trouble."

He asked me how I was and what I'd been doing. I told him, and he asked me about my classes, whether my students believed what I told them, or something like that. I told him there'd been a pretty good argument in my class that morning.

"Oh? What about?"

"I was trying to convince some of the students that stories, good stories, virtually never come from bright ideas or theories about society or the world."

"Why not?"

"Because the theories are always second hand," I said.

"That's true," he said. "You have to be a specialist, and know nearly everything that's been done in your field, in order to have an idea that someone hasn't had before—and even then of course, you probably won't. And if you present an idea that someone has had already, even if it's a sound one, people will say, 'so what?'"

It's odd to have conversations with him these days. I have to shout, for one thing. And then there's sort of a misplaced feeling of accomplishment, along with the sense that this time, any time, might be the last. Also, we rarely really argue, or even disagree, as we always used to do. And neither of us is irritated by the other. I think that on his side this is because he's grown kinder generally in his feelings, and on mine it's because I'm aware of how helplessly weak he is.

Later when I stopped by, I asked him again about his visit to the doctor (earlier, on the phone, he'd talked about it), and he told me again what he'd told me earlier. "Dr. Fisher says he is not at all sure that this pain-in-the-neck that I have is cancer, which is what I thought it was and what Dr. Lynch suspects it is. But he says, Dr. Fisher I mean, that it doesn't really matter, so far as treatment goes. If it is cancer, it's in a place where we can't do anything about it, and so it's best at this point simply to treat the pain or whatever other symptoms develop. What the treatment might be, I don't quite understand. I'm going to see him again on Friday. I suppose in a way I was somewhat relieved."

It was clear to me that he was not relieved, or mostly not

relieved. He had hoped that the thing could be treated or removed.

I myself did feel relieved, though, that the doctor didn't want to do anything. The difference in our feelings made me aware again of the limits of sympathy, mine at least. If I were in sympathy with him I'd want for him what he wants for himself, which is, at any reasonable price, to live. Instead I find myself wanting (supposedly for him) an easy death.

We looked around on his desk for the letter he got from Anna, which I wanted to borrow. But we couldn't find it.

Before this last illness he'd usually walk down to the car, or at least down the stairs, with me or whoever was leaving. Last Thursday he walked along the balcony of his apartment building, to the top of the stairs. Today he just came to the door. I said, "Goodbye, it was good to see you."

He said, "I'm sorry. My thoughts so much of the time are confused.... I get frustrated about something because I'm not able to think clearly about it—and then I can't remember what it is!"

"You don't sound confused when you're talking."

"I don't? Well, that's good."

October 29, 1996

When I came back to my office from class, there was a note on my desk from Kia. "Max—please call Elaine at home." The foolish thought darted through my mind, "Something terrible must've happened," and then, almost like a prayer, "Since it has to be, please let it be him."

I called Elaine. "Your father wants you to pick up a prescription for him at Long's Five Points. He thought you'd probably be able to do it on your way home."

So I'd caught myself, as happens fairly often, wishing my father dead. Oh, well. To catch yourself is no doubt better than not to catch yourself. To have such wishes is harmless in itself, but you have to be careful you don't act on them. And how can you be sure you're being careful enough? For the next couple of hours it made me nervous.

For example, there were little decisions to be made about taking him the medicine. Any other time they would've seemed

simple and easy to make. Now they seemed fateful. What if, out of this unconscious desire to see my father dead, I did the wrong thing?

I really didn't want to take the medicine over to him today if he didn't need it till tomorrow. But if I asked him if he needed it today, wouldn't it be like him to say no, just because he didn't want to put me to any more trouble than necessary? And if, knowingly, I put him in that position, then wouldn't I have to look back and see (if he dropped dead tomorrow) that I was no better at heart—and not just at heart—than an Ivan or a Smerdyakov?

Still, it was raining and I was tired, and it would be foolish to run scared from a harmless fantasy or two. I called him. "Dad, it's Max."

"Hi, Max, are you at the university?"

"Yes. I'm going to pick up your prescription on the way home. Um, is it something you're supposed to start using tonight?"

"Well, I don't know that it actually matters very much. But Dr. Fisher said he hoped I could begin taking it tonight rather than waiting till morning."

"Oh, I see, okay, good, I'll be there within an hour."

"Thanks a lot, son."

But that wasn't the end of my apprehensions.

I picked up the medicine at the pharmacy. It was apparently a powerful antibiotic (I forget the name of it). There were only six tablets, two to be taken initially, then one every twenty-four hours for the next four days. The pharmacist told me (and the directions on the container said the same thing) that the first two pills should be taken on an empty stomach "at least an hour before or three hours after eating."

Outside the pharmacy when I got back into the car I looked at the clock: a quarter to four. Dad usually—or rather always—went down to eat at five. It would take me about eight minutes to drive over to Vista Del Monte and five minutes to get up to his apartment—if all went well.

Clearly the doctor wanted him to begin taking the medicine as soon as possible. And if he didn't take the first two pills by four, then he would have to wait until nearly nine. And at nine he might

not remember. Therefore, it was my duty, my bounden duty, to see that he took the first two pills as soon as I got there. The thing was, it was not just *his* behavior that I had to keep a careful watch over, but also my own, especially my own.

It's difficult for me to describe what my feelings were when I actually got there and saw him. He was so clear headed and kind, and very ill. He thanked me again for bringing the medicine over so quickly. He smiled at me, but while he was talking he leaned back against the wall. He did it in a way that looked casual, but it was something I had never seen him do before.

"How are you feeling?" I asked him.

"Oh, fairly lousy."

I asked him some questions.

"When I cough," he said, "it's often quite painful, especially at night. And I seem to have more and more difficulty breathing. I saw Dr. Fisher. He didn't seem very optimistic. I keep asking him whether the cancer may have spread to my larynx or brain, and he says, 'Well, if it has, we can't do anything about it. So let's hope that it hasn't.'"

What moved me nearly to tears, though, when I thought about it later, was his reply to my attempt to persuade him to take the first two pills right now. "It's after four o'clock," I said. "And you're supposed to take them an hour or more before you eat. Don't you go to dinner at five?"

He resisted, politely and mildly at first, saying that he'd take them "in a few minutes." And I, thinking that maybe his mind was not as clear as it seemed, and with my own mind full of my own plan, became more and more insistent.

"No," he said at last. "I'm supposed to take all the medicines over to Health Care. That's the way it's set up now. And it's better for everyone if I stick to what's been agreed to. Otherwise, if I make a mistake one of the nurses might be blamed for it."

This was unanswerable, but I pressed him anyway. Was he going to go down there soon? "It's a quarter after four."

"Yes, right now, of course," he said. "As soon as you leave."

November 16, 1996
Sunday. 1:00 P.M. Called him.

His voice tiny, hoarse and strained. A whisper, but effortful, as if he is having to shout. He sounded bad in other ways: the difficulty breathing, for example. But there was something else, too, which I couldn't identify at first.

"I'm just going down to lunch," he said.

"Oh. I thought you'd be back from lunch. Don't you usually go earlier?"

"Yes, I'm late."

I'll let you go, then."

4:00 P.M. I forget whether he called or I did. Anyway, he started talking about his glasses. Apparently he'd mislaid them. For the first time many of the words that he said, I couldn't make out. It was partly because of the troubles with his voice and breathing, but it was also because there were repetitions, and jumps in logic. His talk was a kind of jumble. And yet he sounded unusually cheerful, almost giddy. While I was listening to him I wrote on a little pad by the phone, "It breaks your heart," and then, probably a while later, added, "But *it* is what? The loss of mind? He no longer has a clear view of himself."

4:30 P.M. I began to have more practical worries.

Craig, my brother's youngest son, has been staying in Dad's apartment at night for the past several weeks, but now he's gone back to Portland. If Dad isn't lucid, is it all right for him to be there alone so much of the time?

I convinced myself that it probably was all right. Then I remembered something my brother had suggested as a possibility. He said that he'd talked to one of the head nurses, who'd said that if Dad remained well enough to stay in his apartment but at the same time became not entirely self-sufficient—if he needed help with some things, taking a shower, for example, or organizing what he was going to wear or finding things he'd misplaced, or even if he just needed a bit of company—then it might be possible to send an aide over for a couple of hours each day or evening. We had talked about it as something that might someday be necessary.

I found a number I'd written down on some other occasion.

MAX SCHOTT

It turned out to be the wrong facility and the nurse I reached, in trying to find out from me who I was, what I wanted, and why I had dialed her number in the first place, became more and more impatient. But when I happened at last to mention my father's name her voice brightened and she said, "Oh, I know him. What a lovely man! I think you should talk to Eileen in Health Care. Let me find the number."

I called. Eileen said she'd arrange it, certainly for from tomorrow night on, and probably for tonight, but if not, she would look in on him tonight herself.

5:00 P.M. I told Elaine how Dad seemed, and told her what I'd arranged. Instead of being impressed by how thoughtful and responsible I was, she said to me, very gently: "I was wondering, now that Craig isn't there…have you thought of going to stay with your father?"

"Me? No, I don't want to."

"Have you thought of doing it, though, anyway? Just so he wouldn't be there alone."

"I'm not going to."

It was one of those conversations that astonishes you when it replays itself in your mind.

Diary About My Father

"The affection of a father and a son are different: the father loves the person of the son, and the son loves the memory of his father."
 —Anonymous, early eighteenth century

November 16, 1998
Even towards the end, when I'd begun to catch up with him in age—I mean, when for the first time we were both in the same stage of life—and when for a change I was making a fairly conscious effort to see what the world might look like to him—even then, and even now that he's comfortably dead, I still have trouble seeing him as anything but my father.

Come to think of it, it must be that way for my own children too.

Anyway, to us, when we were children, Dad almost literally meant the world—while for him, by the time we were born, there was a world already in existence.

The point is, I think the point is, it isn't too late even now, to see him a bit more clearly than I do.

November 22, 1998
There are moments when I imagine that if—by some small trick of the mind I could just read the diary I kept about him, really read it, take it in from the outside as if he were not my own father and the observations in the diary were not my own either—*then*, when that happened, I would understand everything, not just about myself and him, but about blame, conscience, suffering, death, justice.

This kind of daydream is foolish, but not necessarily useless.

Late November, 1998

I see by the light or lights of my own mind and am troubled or limited in seeing by my own particular darkness. This is a general way of speaking—no good, except to remind me that if I could see myself from the outside I might see where some of those dark places are and avoid some of the mistakes of judgment that I've made in the past.

I never will see all the way around myself, will never see my mind working. There is no camera or mirror for that, no way to get outside in order to look in. And yet, I do at least get glimpses now and then. And from these glimpses, like anyone, I try to put together a theory or picture of my mind. There's pleasure in doing this, but it seems to me that there's also an obligation to do it. I mean, if I am setting out to examine or judge my father, I should try to know in advance, as well as I can, the quirks and limits of my judgment.

I love my own mind. There are many things about it that I love, and I want to make a list sometime of what they are, but I'm disturbed by the way it reasons—it reasons badly—and by the tricks that it plays on itself—many of which I'm afraid are never discovered.

December 2, 1998

He died two years ago today. At about two in the morning, so that to us it seemed like the night of the day before—which was five years to the day after Mom died.

After being ill for how long, fifty years? Sixty? She slipped away so easily.

A few years ago, if someone had said to me, "He behaved towards her like a saint," I would've said, or wanted to say, "Yes, but I don't like saints." But now it seems to me that the truth is much simpler. No saint, but a man in a situation not of his own making, he did as well as he could. And though his faults were not large or many, he was more aware of them and more troubled by them than anyone who knew him was.

Early January, 1999

You say you can't see yourself from the outside, and yet, you say, you have glimpses. What are these glimpses?

Well, they are insights, almost always into trivial matters. In important things I deceive myself thoroughly. But these insights allow or force me to draw conclusions about myself that also apply to important things.

You've changed the word without answering the question.

As I say, they are glimpses into awfully small matters.

"There is nothing too little..."

Well, for example, New Year's morning I was shaving. I have—or had—a little plastic-framed mirror that I'd lean up against the windowsill in the bathroom, above the sink. I had the razor in my right hand and was thinking or daydreaming about this diary, in other words about my father and myself, when for some reason—I'd like to know the exact thought I was thinking—my left hand hit the mirror and sent it flying. It struck the side of the sink, bounced and ended up on the floor behind the toilet, where everything that falls seems to end up.

I got down on my hands and knees and was picking up the pieces—to my surprise the glass hadn't broken, just the plastic—when Elaine, who'd heard the noise, came in.

"It was just the mirror," I said.

She laughed and said, "Seven years bad luck!"

"No, the glass didn't break—just the frame."

She kidded me a little, and dropped the subject. But I kept thinking about it. To my way of thinking, far from being bad luck, the fact that the glass part hadn't broken meant that it was a lucky break. What it showed was, that good luck followed me around and was with me even at unlikely times and against the odds. At that moment, this very superstitious way of seeing things seemed perfectly reasonable to me.

But then, maybe because I had so little at stake, I allowed myself to live through the whole thing again in my imagination. Only, this time I pictured the glass breaking and all of a sudden I realized—this is the "glimpse," or the "seeing myself from the

MAX SCHOTT

outside"—I realized that if the glass had broken I would've just said to myself, "It's a good thing I'm not superstitious." I would have said it to myself with absolute conviction. And in that case that way of seeing things would also have seemed perfectly reasonable to me.

I had to conclude that reason, the whole process of reasoning, is for me just a way of keeping myself comfortable. The worst thing, though, was realizing that if the event had not been such an unimportant one, I would never have seen through myself at all. That frightened me. It made me see that the mental ground I normally walk on is much less solid than it seems. Of course this kind of fear doesn't last long. The old complacency covers it over in a moment. But that's frightening too, if you think about it.

Mid-January 1999
The old complacency, the feeling, "I am right, I am right, I was right before and I am right now," is in itself a respectable feeling. Why should I not be right? It's a sort of optimism of the flesh, transferred to the mind. I am alive in my own skin. I may allow that other people have the same feelings, but I am I and the world outside myself is something rather less—it depends on me, in fact, for its very existence. The rightness that other people feel, I don't feel.

To deny this, to *feel* that my own inclinations are wrong, would be a kind of disaster, a vital collapse, a lie to the soul, a sort of perversion. It's this vital prejudice Lawrence is defending when he begins a poem

> You tell me I am wrong.
> Who are you, who is anybody to tell me I am wrong?
> I am not wrong.

It's not the primacy of feeling that I object to in myself, but the misuse of reason. I see myself as a creature of reason (and a creature of reason, once it has reasoned things out, is even more right than a creature merely of feeling). But to see yourself as a reasonable person and to be a person who reasons well are not the same thing. And

when I catch myself using the prestige of reason, a semblance of reason, in order to persuade myself that whatever I feel, whatever I'm inclined to believe, is true—that troubles and frightens me—though I suspect it doesn't trouble or frighten me enough.

Still later in January, 1999

Am I as absent-minded as my father was?

I like to think that my case is different. It's just that my mind is likely, at any given time, to be occupied by some word, image, idea, memory, set of thoughts, which isn't easily budged. As a result, when somebody says something to me I may not hear it, or may only reply to it minutes after it was said, or may twist it around to fit whatever's already in my mind. (In this last way at least, I am more irritating than my father was.)

For example, a couple of mornings ago Elaine said to me, "Do you want to go to Follow Your Heart for breakfast?"

"Follow Your Heart?—Why?"

"Oh—I meant Judge For Yourself...Follow your heart; Judge for yourself: What's the difference!"

We both laughed.

But then a few minutes later, out of the blue it must have seemed, I said, "That's the trouble."

"The trouble with what?"

"Between feeling and judgment, I mean, that's the trouble. There ought be a difference."

She gave me a look.

February 12, 1999

Turned sixty-four today.

I could give a fair number of instances like the ones I gave earlier—times when I've seen that I was wrong, in some small matter, and have gone through a change of mind or heart.

But when the matter hasn't been so small, when things I care about have been at stake—beliefs, for example, grudges, notions of what or who I am or of what my abilities and defects are, or theories I've worked out regarding what I've been deprived of and who

MAX SCHOTT

is to blame—when such important matters as these have been at issue, I can count nearly on my thumbs the times I've looked at myself and said "You are wrong," or "The truth may be not what you think."

It's not in my nature to condemn myself for this complacency of mine. I wouldn't willingly be less comfortable. As it is, if my conscience makes me suffer, I usually don't know it, and am secretly glad not to know it.

Even so, I remember those two or three changes of heart with a feeling something like gratitude ("something like" because after all there is no one to be grateful to). It's as if, those two or three times, the divine inventor, Chance, opened my eyes, and allowed me to be better than I was. It may be just the scarcity of these occasions that makes them seem so strange and valuable.

February 13, 1999
Questions:

Your belief that you underwent a "change of heart"—couldn't this belief be just another kind of self-deception?

It could.

Couldn't such an illusion be the result of the same combination of factors you've already described: your inclination to always think well of yourself, combined with your facility with what passes in your mind for reason?

It could.

And in this way, couldn't you be tempted to remember revelations that never took place, changes of heart that were not real changes, and so on?

Very likely. Anyhow, I do believe that my attitude towards my father changed for the better, and it does seem to me that it happened suddenly. And in my memory at least, I know almost exactly when.

If there was such a change, *why* did it take place?

I don't know. A general answer, which I may have already given, is "He was eighty-nine and I was fifty-nine."

And how did it happen?

I don't know how, either. I found myself feeling more curious, less presumptuous.

Feeling, again! Were there any practical, measurable results from this change?

Practical, yes, but not measurable. In my opinion, I went on to behave better towards my father, during the last years of his life, than I might otherwise have done.

And *when* exactly did this change occur?

When?—while it was still not too late, that's the main thing. Imagine how I would've felt, how I would feel now, if it hadn't happened till after he was dead?

But when *did* it happen?

One night, five years ago.

Under what circumstances?

He was guest of honor at a banquet. I was there. He'd been told in advance that at the end of the evening he would be asked to come up and receive a plaque and that after the usual sorts of things were said about him he would be invited to say a few words himself, if he felt up to it. When the time came, he did speak, for three or four minutes at the most. He was frail, and very tired. Before he spoke, while we were waiting, I remember being afraid (I sometimes confuse fears and hopes)—afraid that his mind wouldn't be clear, even that he might collapse, might die.

And your change of heart took place while he was speaking? Was it a reaction to what he said?

I don't know. I remember the circumstances, but I don't know.

Beyond what you've already said, what are the circumstances that you remember?

It's late.

February 14, 1999

What circumstances do you remember? Or do you have a diary from that time?

I do and I don't. I began this diary the day after the banquet. But I was trying so hard to sort out my thoughts that the first entries were mostly unintelligible. I learned something though from

writing them, or rather from reading them over afterwards. Wherever I'd happened to write down something my father actually said or did (usually for the purpose of analyzing my reactions to it), the diary seemed less murky. I kept noticing this, whether I liked it or not, and gradually I realized that instead of trying to think, I should try to pay attention. He was more interesting than my ideas about him, old age was more interesting than my ideas about it, I was more interesting than my ideas about myself, and so on. No doubt there was nothing new in this, but I realized it in a way that was somehow new for me. And at the same time it began to seem to me that whatever went unrecorded, also in a way went unnoticed, unobserved, slipped away out of consciousness and out of the world. Talk especially, a few words uttered here and there that written down might indicate a living presence, became lost in the air so quickly.

But I'm getting ahead of myself. Those ruminations came later, beginning, at the earliest, the day after the banquet.

Of the earlier part of the day itself, nearly all I remember is a feeling of resentment: I *had* to go.

As it happened, Dad had been staying with my brother for a few days, so it was arranged that we—my brother, his wife, Dad and I—would ride down to Los Angeles together in my brother's car. (Elaine, lucky her, had a rehearsal.)

It was late in the afternoon, almost dark—it got dark while we were driving. Dave and Connie were in the front seat, Dad and I in the back. Dave, at one point, according to a preconceived plan, brought up for the first time in Dad's presence the "possibility" that Dad might be better off selling his house and moving into a retirement home, near us.

Dave gave what seemed like dozens of reasons why this would be a good idea and why not to do it would be a bad idea. Dad grunted amiably from time to time, to show that he was listening, but when Dave finished Dad was silent. Finally he was silent so long that it was no longer even awkward—as if his thoughts had just strayed away to some more interesting subject and he could see no immediate reason for trying to bring them back.

Finally Dave turned his head towards the back seat. "Well, how does the idea sound to you? Do you have any preliminary feelings about it, one way or the other?"

"About moving to Santa Barbara?"

"Yes, near us."

"But what would Lucy do?"

This irritated Connie, if she wasn't already irritated. "Lucy has a home of her own, Hermann."

"Yes, of course. But she has no other job."

"Lucy will find another job."

"Jobs are not so easy to find."

Connie was on the verge of saying something more, but my brother stopped her. "Lucy is something we should be concerned about," he said carefully, "but first I think we should be concerned about what would be best for you."

"I suppose you're right that I shouldn't make it a primary consideration."

"Lucy certainly wouldn't want you to," I put in.

"That's true," Dad said. "On the other hand we've just agreed that we aren't necessarily obliged to consider what Lucy does or doesn't want."

He chuckled at his own wit, then was content to ride along in silence again.

Till finally Connie said, "Hermann, do you have any other thoughts about it?"

"Thoughts? Oh, sure. It's hard not to have thoughts about almost anything, I've found—though it's sometimes difficult to know what they are." Another pause. Then he said, slowly: 'There are three possibilities: I'll decide to move to Santa Barbara. I'll decide to stay where I am. Or I won't decide anything."

He laughed, my brother and I laughed politely, and for the present the subject was allowed to drop.

MAX SCHOTT

February 18, 1999

November 1, 1993

Lawrence says about one of his characters that "even her memories were the work of her imagination." That's the way it is with me, I'm afraid—at least when it comes to this particular evening.

We stopped at Dad's house. Lucy'd gone home, but she'd laid out the clothes she thought he should wear. Dave said to Dad that he should lie down for a few minutes first, then dress. Dad looked at his watch. "But is there enough time?" We both told him, yes, there is plenty of time. He looked at his watch again and said that although there was probably not as much time as we seemed to believe, at any rate there was enough.

He took his shoes off, lay down on his bed and dozed, I think, for a few minutes, while Dave and Connie and I wandered around the house, trying, as the spirit moved us, to avoid or recreate the past.

We picked up Elsa, my mother's sister, on the way, and got to the restaurant just at eight. Someone pointed the way to the banquet room, a big square space with long tables (already set), a bar, a small raised platform, a lectern, even a microphone. There were maybe fifteen people already there, standing around. They all knew my father and most of them seemed to know my aunt. Other people were coming in behind us, and by eight-thirty there were seventy or eighty of us in the room.

We were all middle-aged or older. Yet it was hard not to notice that Dad was in a class by himself. I stood around, talking mostly to my aunt, but all the while feeling that my main occupation was to watch my father, to watch him and to watch over him. One after another, or sometimes two at a time, people kept coming up to him, to say hello and to offer congratulations of some kind.

Why was he the guest of honor? Apparently someone on the board of directors had suggested it, for no very definite reason, and no one had objected, and so it had been printed on the flyers that had been sent out. The first Dad had known of it was when one came in the mail.

It was a homemade-looking flyer, with strange orthography and my father's name misspelled.

MISSION ACCOMPLISHED!!

A Celebration of the Crestwood Hills Credit Union's
46 Years of Service to Our Community
AND to Especially Honor Herman Schott's
Long and Dedicated Service

You are invited to join in an evening of festivity
At the VELVET TURTLE Restaurant
[and so on] "Your check is your reservation."

Dad had read it, and it had made him angry. He called Mary Jane, the credit union's only paid employee, and she protested that she had just done what she'd been told to do by the board. He called someone on the board, and told whoever it was that it was wrong to single one person out in this way, that others who had worked harder would be make to feel the injustice of it, that he couldn't in good conscience allow it, as he would have said beforehand if he had only been asked. After that, various emissaries had been sent to his house to try to persuade him. The argument he finally gave in to was the simplest one: Although you're no doubt right, isn't it too late?

Anyway, he was the guest of honor, and people kept coming up to him.

"Hermann, it's good to see you." He'd look at the person speaking, blink, and say, after a pause, something like, "Thank you. I..." Most people had the wit to break in quickly then with a name, and he would say, "Oh, yes. It's good to see you too."

But sometimes, before he could place or remember someone, that person was gone.

He didn't see or hear well; his hands shook. Behind his glasses, his eyes blinked constantly, which gave or added to the impression that he was not quite sure where he was. He stayed on his feet, and people kept coming, coming up to him, greeting him, leaving him. To me, there was sort of a sweet pathos in it: he was there alone, occupying his own space which, because of the slowness of his senses, no one else could penetrate. And it seemed to me that I, watching him closely, aware in almost a physical way of his condition—that I was his protector, that I would see him through

MAX SCHOTT

the evening, and that with luck he would not live very much longer, but would die peacefully and easily (maybe even tonight, celebrated, among friends), with little pain either for himself or others.

I didn't see anything cruel or self-regarding in these thoughts, and in fact congratulated myself for having them.

Afraid he'd soon be completely worn out, I found the emcee, Jim Burt (he was a friend of my father's—younger, about seventy) and asked him what the schedule was. Soon we'd sit down and eat, he said. After dinner there'd be informal speeches, anecdotes, really whatever anyone wanted to stand up and say. And then at the very end, Dad.

"But if he seems to be getting too tired?"

"Of course. We can switch the order. Anything you'd like."

"I'm afraid his mind might become a little cloudy."

"I know the feeling!" Jim Burt said, laughing. "But I've talked to your father quite a bit recently. I don't think we need to worry about his mind."

"I don't think we need to worry about his mind." The remark rankled. It was as if he were saying he knew my father—my own father!—better than I did.

Just a few minutes after this, though, Jim went up to the microphone, tapped it a time or two and said that in order to speed things up a bit, he thought, if nobody minded, he would make some of his after-dinner remarks while we were waiting for dinner to be served, and that maybe other people would want to do the same. "We have no formal agenda," he said.

"That's fitting, since as most of you know, as an organization, or corporation, we no longer have a formal or legal existence. We're celebrating our own dissolution, which is now complete. The last dividends have been sent out. And, as some of you may not know, all our bills are paid. The few loans that remained outstanding have been transferred to other lending institutions with no change in terms and we hope with no inconvenience to anyone. All this was done with the approval of the membership—that is, we voted to disband—how long ago? A year now? And we did this for the simple reason that, as our membership has aged, fewer and fewer of us have required loans...I see that our salads are arriving...I don't

promise that this is my last word. You all know me better than that—but I do want to say, now, just this: our only purpose this evening is, to say to ourselves and to each other, including my friend Hermann here, if he will allow it, 'A job well done!' Thank you."

We all looked at my father, who just at that moment was being shown to a chair reserved for him at the table nearest the podium. Mary Jane had a hand at his elbow. After an interval, as the words sank in, he raised his hand and waved.

Soon we were all seated. My father was a couple of tables away, but I was facing him, and all my sympathetic concern melted away the moment he picked up his knife and fork. "Don't be foolish," I told myself. "If you don't like to see him eat, don't look."

I did look away. When I looked back, his salad was gone and his dinner plate was in front of him. I watched him cut his meat— efficiently, for someone so old (after all, he had been a chemist). He cut it into small pieces and then, immediately, his chin rather low, began shoving it rapidly piece by piece into his mouth and chewing-chewing, like a machine. "He's not even greedy," I said to myself. "Greedy people are aware of what they eat, are aware of eating." I shook my head to rid myself of my irritation, but went on in the same vein: "Unconsciousness has always been his abiding sin, the one that led to all the others. His sins all have been sins of omission: unaware of what was around him, not hearing what was said to him." There was, had been, cruelty in it. And now, in old age, when everything, people said, was to be forgiven—he was still at it, allowing himself to become more and more unconscious.

"Don't be foolish," I told myself. "He's old, and you're not a child. Where will your childish grudges get you now?"

But it was irritating just to look at him.

Before anyone else at his table, he had finished eating. He sat there now, staring blankly forward, with his mouth open. Did being old excuse that, too? Even a door with a broken spring can be shut.... I shook my head again to clear it. By an effort of will I looked away. When I looked back, he had raised his arms in the air and was stretching, making, I was sure, the little groaning sound that he always made when he stretched. Then he lowered his chin to his chest (which had the effect at least of closing his mouth), and closed

his eyes. "He is tired, and it's wise of him to rest," I told myself. "I wish him well. Even if he falls into a deep sleep, no one will mind."

Whether he actually slept I don't know. His chin on his chest, his forearms placed squarely on the table, he sat without moving while the evening's events went on around him. One after another, people went up to the microphone. One person related anecdotes about the difficulties of the credit union's early days. Someone else thanked various people. Someone else passed along the regrets and good wishes of a friend who couldn't come. Two or three people read passages from letters.

One man, slightly more lively than the others, delivered a kind of testimonial: "I was a young man, a boy, trying to buy, wanting to buy—my first car. To get a loan, what security could I offer? I was just out of high school, no job, owned nothing. But my argument was, this is the argument I presented to the credit union—once I had the car, I could get a job, and pay for the car. [Laughter]. Well, the credit union lent me the money. I bought the car, I got a job, I paid off the loan."

He sat down, people applauded, someone else stood up.

Time passed, not slowly exactly, but a lot of it. After his rest my father raised his chin and sat almost without moving, his mouth closed now and his eyes open.

When there was every reason to believe we were at last nearing the end (who was there left to speak?), Jim Burt went back to the microphone and began praising a whole series of people—members of the board, former members of the board, founding members, members who over the years had volunteered or been elected to fill this position or that..."And finally," he said, "our secretaries—who have been more than secretaries—who have done the day-to-day and week-to-week work of our organization, and who have done—have very often done—a great deal more than they were paid to do—"

This provoked a couple of wisecracks.

"More work than they were paid to do.... So, a hand please, for all our past secretaries."

A bit of tepid applause got cut off when someone broke in, "All of them? Have you forgotten the one who ran off with the money?"

It became a sort of chorus: "*I* haven't."

"How much did she take?"

"Thirty-seven hundred dollars."

Laughter.

"I won't clap for *her*."

"A hand then, for *nearly* all our past secretaries—those of good character."

"Good behavior's good enough."

People laughed. My father looked around as if he were puzzled, and when the rest of us began to clap he just sat there.

But a minute or two later, when Mary Jane was asked to stand up, he lifted his hands and clapped along with the rest of us. It seemed to me that he was taking in very little of what was going on, and the sight of him joining in, joining in like a little child, made me soften towards him again. And as Jim Burt began at last to introduce him, the feeling of anxious concern came back to me, this time so strongly that I took in only snatches of what was being said: "...our guest of honor who of course is not really a guest but has been with us from the beginning..." "The only founding member present..." "Our volunteer treasurer for the past fourteen years..." "—To express our friendship, respect and gratitude..."

My father put the palms of his hands against the table edge, pushed his chair back, then rocked his upper body forward. Up on his feet, he made his way past the tables, stepped up onto the platform, skirted a nest of electrical cords and approached the lectern. Jim Burt intercepted him, grasped his shoulder, shook his hand, uttered yet a few more words, and stepped aside.

Dad gripped the sides of the lectern and looked out at us. A shiver went through me. Just before in reality he opened his mouth to speak—in a mad vivid daydream, the work of an instant, I saw him open his mouth and heard the staticky breath that came out of it, mixed with gibberish: a few broken indecipherable words, and that was all.

For the third or fourth time I shook my head to clear it.

He opened his mouth, hesitated, blinked, cleared his throat and began to speak—talk is a better word. "Thank you. It's been, oh, several years since I've done much more than sign the documents Mary Jane brings over to the house. As work, that comes out to, I

MAX SCHOTT

don't know, a few minutes a month. I mention it because I think people may see my signature on all these things and imagine that I've…been productive.

"Two things occur to me—if I haven't forgotten what they are. One is connected to what I just said. People who work as volunteers are very often given credit for a great deal more than they actually do—very often they do very little—while at the same time, people who are paid a salary often work many more hours than they're paid for. We don't really have an easy way of taking this into account. They aren't volunteers, they are paid employees. So we are likely just to say to ourselves, 'Oh, well, it's her job,' and let it go at that. It's a small thing, of course.

"The second thing is, if an invisible person—an invisible judge, were to follow any one of us through the day, and were to keep an accounting of the good that we do, and the harm, it would be seen I think that any one of us does, on nearly any day, more good than harm. We might be surprised to see this, it might clash with the way we usually think about ourselves and about other people—especially people who have done some things that are bad and whom we call, correctly, criminals, thieves, and so on. But I think it is true that even the people we call bad are good most of the time.

"You see, probably, what I'm getting at. The woman who worked for us, who did what she certainly should not have done, in running off with our money. She too spent, I would guess, minutes, hours, even days, doing the work she was hired to do—resisting temptation at some moments, possibly not even feeling it at others…. Since tonight, as seems to be agreed, we're here to celebrate the good that we have done, I suggest that no one, no one who's here, and even, for the sake of our consciences, no one who isn't here, be disincluded. Thank you very much."

Riding home that night, by myself in the back seat of my brother's car, an image of Dad standing up in front of us, and bits of what he said, kept coming into my mind. I found myself smiling, was surprised, and then was more surprised by feelings of release, excitement, confused happiness.

It was hard to sort out. Why should recollecting his speech give

me so much pleasure? I felt as if it had been a kind of triumph. But that was puzzling too: a triumph over what?

He had said the sorts of things that anyone who knew him should have expected. And in his own mind he surely would have made nothing special of it. So, if it was a triumph, it was a triumph only over my own expectations. And why should I take pleasure in that? What's more, if I'd be honest with myself for a moment, it was a triumph not just over my expectations but over my desires.

My most vivid wish had been, not just to see him peacefully dead, but defeated, ruined, broken in body and in mind. And if that was my wish, and if my wish was that intense, then why did it give me pleasure to remember how my wish was contravened?

When I got home I began to write down these thoughts and questions, and went on writing them down the next day, and the next, mostly saying the same things over and over again, and not finding any quick answers.

At the same time, too, along with the feelings of confusion and the need to sort them out, I kept feeling that same sense of release and excitement, as if I had got around some obstruction and was seeing the world, especially the part of the world that had my father in it, from some new point of view or angle. It was as if I had somehow for years neglected to be curious about him, or had subdued whatever curiosity I might naturally have felt.

But I couldn't see at first what to do about it.

When I looked back over the notes that I'd written, all my self-analysis seemed flat and dull. That wasn't unusual in itself. What surprised me was that here and there, where I'd included, almost by the way, a few words of my father's conversation, a gesture, a look on his face—these seemed alive on the page to me.

It was impossible not to see at last that I wanted to keep a diary about my father—not about my ideas about him but about *him*— and I couldn't help seeing that in a clumsy way I'd already begun.

The idea was a pleasant one—I looked forward to carrying it out. But also, I was afraid *not* to carry it out: afraid of how I'd feel in some not too distant future, if I let this impulse just slip away.

MAX SCHOTT

Santa Barbara News-Press Obituary

December 15, 1996

Hermann Schott, 92, died December 2nd at Vista Del Monte, where he'd lived for the past three years. Hermann was alert and active until a couple of weeks before his death. Those who knew him will not be surprised to hear that even in the last months of his life he continued to spend part of nearly every day working in Vista Del Monte's health center as a volunteer.

Hermann's parents, Max Schott and Clara Schott (born Saloman), were orphans who first met as children in a Jewish orphanage in Germany. They emigrated separately, met again in New York, fell in love and married. Hermann, born July 18, 1904, was their first child. When he was five, Hermann's mother died in childbirth. Three years later his father married Alice Tuohy (Alice F. Schott), whom all his life afterward Hermann called "Mother."

Hermann's father's business took him from New York to Saint Louis, Saint Louis to Denver, and finally the family settled in Santa Barbara, where Hermann attended Santa Barbara High School.

Without much effort, he did exceptionally well in school. His bent of mind, even as a boy, was skeptical, logical, and inquiring. In spite of the gentle bashfulness of his manner and character, his mind was rigorous, and it became clear fairly early that he was likely to become a scientist or mathematician.

From Santa Barbara High (he graduated in 1921 or 1922) Hermann went on to Cal Tech, where, as he used to say, "I was shocked to find that some of the other students were smarter than I was."

Before long, life at Cal Tech came to include more than just science and math. On a blind date, arranged by friends who knew them both, Hermann met a girl, Vita Kavinoky. They met in November and by the end of December she was able to write in her diary: "December 31. It's worth everything to hear him say that it was the most wonderful evening he ever spent. I often wonder if he got enough adoration and loving, because his mother died when he was five or six, and he has such a wistfully sweet smile. I'm afraid that I've actually fallen in love." She was seventeen. A month later she wrote "January 27. Studying together is lovely—especially the after-math." A few months later they were married.

After earning a Ph.D. in biochemistry Hermann began his vocation as a scientist, seeking, along with his colleagues, a better understanding of cancer. From 1931 on, the results of his research were published in a series of papers in scientific journals.

In addition to his work in biochemistry, Hermann wrote and published in the field of symbolic logic, which he studied during the 1940s under Hans Reichenbach and also with Bertrand Russell, who took Hermann and a few other advanced students through the entire *Principia Mathematica*.

Hermann's attitudes toward himself were an important part of his character. So it should be said that finally he did not consider himself to be a success as either a chemist or a logician. He began to see himself, while still in his forties, as a person who had not lived up to his potential, who procrastinated too much, involved himself too much in distracting side issues, and allowed himself to be too much directed by others. Oddly enough, it was partly this pervading sense of his own fallibility, his cheerful acceptance of the "fact" that he was no great shakes, that made him such an attractive personality to so many different people. He was very often loved, and certainly respected, but people were rarely in awe of him. Children in particular seemed to divine quickly that here was a man who could be interrupted, asked questions, climbed on, rolled on the floor with or asked a favor of.

Partly because he'd inherited money from his enterprising and industrious father, Hermann (along with Vita, before she became incapacitated by illness) was able to do a great deal for a great

many people. (It would irritate him to hear it said, but the truth is, nearly everything he did was for the benefit of others). He gave students a place to live and sometimes helped them through college. He and Vita sponsored at least two musical careers. He gave land to the city (of Los Angeles) for a park. He was instrumental in founding, organizing, operating: a cooperative housing project, a co-op grocery store, a community credit union, a day care center, a riding stables, a swimming pool and a summer day camp. In all these activities, and many others, he never impressed anyone as being just a philanthropist. Somehow his whole diffident, good-humored self always got involved.

For example, at the last possible moment Hermann helped to bring over three families from Hitler's Germany. It might seem that these people would be in the difficult position of feeling uncomfortably grateful for the rest of their lives. Instead, to their credit as well as his, he became, somehow, a lifelong friend.

For him charity (if that's even what it should be called) was rarely abstract. Sometimes, without his intending it, people were a little taken aback. New frequenters of Cottonwood Park, for instance, reported later how surprised they were to find out that the laborer they'd seen on weekends, grimy, with a spray tank on his back and a shovel in his hands (he was out clearing brush from the trails and spraying the poison oak), was the man who used to own the place, and that he was working now for nobody, not even himself, but just doing what he thought needed doing. Why? Well, because he enjoyed it. If you asked him, that's what he'd say, and if you pressed him further, he might say also that he liked the feeling of doing something useful—it gave him pleasure. In any case, he would persuade you eventually that he was being perfectly selfish.

Vita died five years ago. She lived to be 82, but was an invalid for many years. For the last ten years of her life she needed every sort of assistance. Hermann provided it, at night and on weekends alone, and the rest of the time with the loving assistance of Lucy Apodoca.

His greatest fear, Hermann acknowledged once, was that he would die before Vita did—for who could care for her as he had?

Hermann's political and social convictions were liberal and

democratic. His ideals, which he put into practice, but rarely talked about included tolerance, freedom of conscience, and the absence of every form of bullying or violence. Perhaps his most abiding conviction was that the world does not owe us anything, that we humans are very small creatures in a big universe.

Boswell, Johnson, Hume—
Their Attitudes Towards Death

From a diary (revised and rewritten, May, 2001)

June 22, 1995

For a couple of days (beginning a few weeks ago) I thought about, made notes, looked up passages about, Johnson's attitude towards death, and was gradually drawn into making the old comparison between Johnson's attitude and Hume's.

My source for all this, naturally, was Boswell.

Then it dawned on me, I can't recall just how, that I'd been making the usual academic mistake of treating Boswell as if he were only an inspired busybody, an invaluable source of information about people more interesting and important than himself.

Why do we make that mistake? Boswell, bless him, had no aura of greatness. And we, being ordinary, align ourselves with him, then hold him in contempt for being just like us. This is doubly wrong. We aren't contemptible, just ordinary. And Boswell isn't ordinary. If it seems so, if he seems to be just like you or me, it's because he's like you *and* me—"Boswell, how many qualities good and bad does that name bundle up together!" is how his neighbor, Lord Kames, put it, when Boswell was still little more than a boy. (Peter Martin's biography of Boswell, p. 98.)

Boswell didn't like being such a hodgepodge of qualities. All his life it troubled him. He longed for balance, steadiness, self-certainty. "I should be happy if I did not have an imagination that runs about the fields without asking my permission." (Letter, December 1760). "Spirit crushed...afraid of ghosts...my imagination continually in a state of terror..., the most timid and contemptible

235

of beings." (Boswell's description of himself, written for Rousseau. From Peter Martin.) "My misery is…I am convinced by the last book which I have read. I have a horror at myself for doubting thus. I think of death, and I shudder…. Shall I ever be a solid, uniform, and happy man?" (Letter, 22 May 1764).

As a matter of fact, he would often be happy. "Mr. Johnson and Dr. Goldsmith and nobody else were the company. I felt a completion of happiness. I just sat and hugged myself in my own mind…. Words cannot describe our feelings. The finer parts are lost, as the down upon a plum; the radiance of light cannot be painted." As Peter Martin points out, it would be hard to be happier than that, or to express it better. (Martin, p. 279).

But to have the kind of happiness Boswell sought—the easy contentment of being "solid and uniform," would be to be a different man. More often than not, he knew this: "I am a being very much consisting of feelings. I have some fixed principles. But my existence is chiefly conducted by the powers of fancy and sensation." But even when he knows it, he's tempted to draw the wrong conclusion: "It is my business to navigate my soul amidst the gales as steadily and smoothly as I can." (Martin, p. 350).

He would always be hopelessly bad at "navigating his soul." Happiness was a momentary thing, and precarious. "There are hours, my dear Sir, when a man…finds himself in perfect health, finds his mind gay and at peace with itself, finds his soul strong and virtuous; hours when he is not perplexed by the question why God has created him…. As I write I have the good fortune to enjoy one of these delicious hours…. Oh, why cannot I remain in these sentiments? I do not know." (Letter, 3 April 1765.)

The *ground* of Boswell's mind was gloomy and fearful. It was Boswell's word. The ground is what you come back to, the underpinning, the thing that can't be changed. And yet, he wanted to change it. (Marvin's essay "The Entertainer" in *Books Are Not Life But Then What Is?*) A forlorn hope. As Marvin puts it, throughout his life at any moment Boswell could be "knocked flat." He was to remain at the mercy of his own fears. But if he longed not to believe this, if he kept hoping to find the way to steadiness and

MAX SCHOTT

peace, it's hard to blame him. From our point of view, looking back, his *real* business lay not in learning how to conquer or control feeling, but in catching it on the wing. It was his particular genius to "picture the varieties of mind minutely." He opened himself up, over and over again, to those same "powers of fancy and sensation" by which, he said, his existence was "chiefly conducted." And he found ways to dramatize those fluctuating powers and to describe them. In so far as the radiance of light can be captured in words, or the down upon the plum not scraped away by an awkward thumb, he was our man. But if he didn't quite see it that way himself, if he didn't like being at the mercy of his own emotions, if he kept imagining that he could—by finding the right set of habits, the right church, mentor, place of residence, wife, occupation—turn himself into a steady man, we can only wish him well in the attempt and be glad he failed.

Why did he fail, though? Other people subdue their doubts, at least to a degree, and conquer their fears. Why not Boswell? He certainly made intelligent stabs at it. He wasn't weak, he wasn't fickle. He was a passionate, ebullient man, who formed strong attachments to places, people. He was faithful to his talent, persistent in his ambitions, successful in the world, loyal and affectionate in his friendships, a good father, lucky in marriage. He found (except in one respect) the best of all possible mentors. He became (although always a great sinner) a steady churchgoing Christian. Yet his mind and feelings remained ever disobedient to his will. He could never quite call himself to order, or settle into a single mode of being. And he could never settle his religious doubts or escape for long his fears of death. I don't know why. He himself would say that the cause was a disease, melancholy, a bout of which could come on at any time, paralyzing his will, knocking faith on the head. At those times he saw before him "death so staringly waiting for all the human race, and…such a cloudy and dark prospect beyond it…." (Marvin's essay). "When I am attacked by melancholy, I seldom enjoy the comforts of religion. A future state seems so clouded." (Letter, 9 April 1964).

When he was young, before he met Johnson, Boswell believed

that there was a connection between spiritual comfort in this life and the prospect of eternal comfort in the next. He thought that, if he could persuade himself that Christianity was true, then his fears would be assuaged. If the prospect of a future state was secure, then death would hold no terrors, and life itself would take on a meaningful and permanent shape.

It was Johnson, the great exemplar and good Christian, who taught Boswell that this connection was not to be made. The promise of salvation is a true promise, Johnson believed, yet the fear of death is the most constant and awful of fears.

It was a painful lesson. Although Johnson did what he could, both by precept and example, to shore up Boswell's faith, he also told him, and showed him, that fear—terror even—in the face of death (and we are always facing death), is what a rational person feels and should feel—should feel not just intermittently like Boswell did, but at every moment.

Since Johnson himself was in every other way fearless, this terror of his was hard not to take to heart. A good example he was, in nearly every way, but not a comforting example. "Fear was indeed a sensation to which Mr. Johnson was an utter stranger," wrote Johnson's friend and confidante, Mrs. Thrale—"excepting when some sudden apprehension seized him that he was going to die.... Nothing was more terrifying to him than the idea of retiring to bed. 'I lie down (said he) that my acquaintance may sleep....'"

During the twenty-odd years that Boswell knew him, Johnson's fear never wavered, and Boswell, like a recording angel, seems never to have failed to mark it.

BOSWELL: "Is not the fear of death natural to man?"

JOHNSON: "So much, Sir, that the whole of life is but keeping away the thoughts of it." He then, in a low and earnest tone, talked of his meditating upon the awful hour of his own dissolution.

BOSWELL: "But may we not fortify our minds for the approach of death?"

JOHNSON (in a passion) "No, Sir, let it alone. It matters not how a man dies, but how he lives. The act of dying is not

MAX SCHOTT

of importance, it lasts so short a time." He added (with an earnest look), "A man knows it must be so, and submits. It will do him no good to whine."

I attempted to continue the conversation. He was so provoked, that he said, "Give us no more of this"; and was thrown into such a state of agitation, that he expressed himself in a way that alarmed and distressed me; shewed an impatience that I should leave him, and when I was going away, called after me sternly, "Don't let us meet tomorrow."

I went home exceedingly uneasy.... I seemed to myself like the man who had put his head into the lion's mouth a great many times with perfect safety, but at last had it bit off. (*Life of Johnson*, October 1769).

They did meet again, congenially, the next day. And Boswell would go on putting his head into the lion's mouth for another fifteen years.

BOSWELL: "But may not a man attain to such a degree of hope as not to be uneasy from the fear of death?"

JOHNSON: "A man may have such a degree of hope as to keep him quiet. You see I am not quiet, from the vehemence with which I talk; but I do not despair." (*Life of Johnson*, June 1784).

Such remarks weren't reserved just for Boswell. Upon being told by Mrs. Seward that annihilation is "only a pleasing sleep without a dream," Johnson replied, "It is neither pleasing, nor sleep; it is nothing. Now mere existence is so much better than nothing, that one would rather exist even in pain, than not exist." (*Life of Johnson*, April 1778).

Johnson, when he came to die, died bravely and gracefully, but unlike many people who are old and suffering, he didn't kid himself about what he wanted and what he felt. "O! my friend [he wrote in a letter], the approach of death is very dreadful. I am afraid to think on that which I know I cannot avoid." (*Life of Johnson*, December 1784).

At first Boswell was comforted to find that Johnson's most troubling ailment was the same as his own: "It gave me great relief to talk of my disorder (melancholy) with Mr. Johnson; and when I discovered that he himself was subject to it, I felt that strange satisfaction which human nature feels at the idea of participating distress with others; and the greater person our fellow sufferer is, so much the more good does it do us." (Boswell's Journal, 27 July 1763). But in the long run it was disturbing—especially since Johnson wouldn't admit that the fear of death was part of an illness. The fear of death is a rational fear, Johnson believed, and for a rational fear there's no cure but dullness, or self-deceit.

Boswell struggled for years with the question: Didn't at least some good people overcome their fears? "I told Dr. Johnson that my friend Dempster, who used formerly to be gloomy from low spirits, was now uniformly placid and willing to die. Dr. Johnson said that this was only a disordered imagination taking a different turn."

Boswell wouldn't let it go. He himself, after all, had moments when he wasn't afraid of death. "Therefore, [I] ventured to tell Dr. Johnson, I could suppose another man in that state of mind for a considerable space of time." Johnson replied simply that he "had never had a moment in which death was not terrible to him"—so terrible that "the whole of life was but keeping away the thoughts of it."

But hadn't historians recorded any number of exemplary deaths?

Yes—but only because public figures know they are being watched: "He [Johnson] said it had been observed that scarce any man dies in public, but with apparent resolution; from that desire for praise which never quits us."

"I said, Dr. Dodd seemed to be willing to die...."—Dr. Dodd was a minister, on the whole a good man, who had forged a check, been caught, tried, convicted and hanged—"Dr. Dodd seemed to be willing to die, and was full of hopes of happiness."

"'Sir,' said Johnson, 'Dr. Dodd would have given both his hands and both his legs to have lived. The better a man is, the more afraid he is of death, having a clearer view of infinite purity.'" (*Life of Johnson*).

MAX SCHOTT

Johnson's arguments were powerful, and he was the dominant force in Boswell's life almost from the day he entered it. But his example was heartbreakingly difficult: A rational, truthful, steadfast and courageous man who fears death so constantly that the whole of life was but keeping away the thoughts of it? Was there no countervailing force of the same size?

Hume came close. Boswell's old neighbor in Scotland, nearly the same age as Johnson, nearly as imposing, and even more famous. Hume was amiable, congenial, cheerful, apparently comfortable in his own skin, and a notorious unbeliever. Boswell knew that it was hopeless to try to bring Hume up seriously to Johnson, but of course he did it anyway.

"When we were alone, I introduced the subject of death, and endeavoured to maintain that the fear of it might be got over. I told him that David Hume said to me, he was no more uneasy to think he should not be after this life, than that he had not been before he began to exist."

"'Sir,'" [said Johnson] if he really does think so, his perceptions are disturbed; he is mad: if he does not think so, he lies. He may tell you, he holds his finger in the flame of a candle, without feeling pain; would you believe him? When he dies, he at least gives up all he has.'"

And yet Boswell knew Hume well enough to know that he was not lying, that he was not mad, that he did not believe in any sort of afterlife or punishment or salvation, and that he, to all appearances, was not disturbed by the prospect of death and was not afraid of it.

This troubled Boswell, sometimes made him indignant with Hume, sometimes made him hopeful, and very often made him curious. An image of the fat and happy atheist (The Great Infidel, as people called him, St. David) was never far from his mind.

June 24, 1995
I'm in the Coffee Cat, Saturday noon; it's almost deserted because of the parade. A group of people comes in. I don't recognize them individually, but as a group—three or four clean-cut-looking young Asian men and two or three young non-Asian women—they look

vaguely familiar. The men are speaking something, Japanese I think. Gradually I remember: I've seen them here other Saturdays. They're carrying pamphlets and books and have probably come from some kind of religious service.

One of the men comes over and sits down at a big table near my small one. The others are still ordering. He looks at me, nods and smiles. I nod back, but try to look unassailable. The others come over with their orders and sit down.

I scribble away on what I was working on: Boswell this, Johnson that....

The girl nearest to me tilts her head. "What's that? What are you writing?"

I don't want to say I'm writing about the fear of death, for fear it will lead to questions about religion. "Uh, I don't know exactly."

She smiles. "You don't know? Are you finding out?" Suddenly I like her.

"Yeh, I hope so."

"What is it for?"

"I don't know. Nothing. It's just about people I'm interested in. It's about two friends, a friendship, between two men, Boswell and Johnson, in the eighteenth century."

Her eyes glaze over a bit. She runs her fingers over a slim green book she's holding. "Have you read these writings?...the New Testament?"

"Some of them."

"Do you like them?"

"Yes, mostly."

"Do you believe that they're inspired by God?"

"No, not really."

"You just think they're good writing?"

"Oh, no; more than that."

"What do you believe in?"

"Oh, lots of different things. Friendship, pleasure, justice, I don't know."

"Have you thought about whether God exists?"

"Not much, but I guess so, at some time I must have—when I was a child."

MAX SCHOTT

"But you don't think He does?"

"I don't think about it much. I've never seen any evidence for it."

"Did you know that the Bible has a description of the earth as a sphere, written while everybody still believed it was flat?"

"Some of the Greeks thought so, too."

"The Greeks? But they also believed it rested on the back of a tortoise. They believed a lot of untrue things, but the Bible only says it's a sphere, hung in emptiness."

"That was a good guess."

"A good guess?" She laughs. "Don't you wonder whether God is good, or why He's there if He is, or why you're here, or what your life is for, or what will happen after it's over?"

"I don't really. Not exactly, anyway. I mean, the people I'm writing about here, they ask themselves those kinds of questions, and I'm interested in them."

"Are they people you've made up?"

"No, they're real."

"Do you know them? Are they friends of yours?"

"No, they lived in the eighteenth century."

She hits herself on the forehead. "You told me that! I'm sorry, I'm dense today."

"That's all right. I am too."

Her companions are getting up to go. She stands up, puts out her hand. "I'm Lisa. I forgot to introduce myself."

"Max."

"Max!"

We shake hands.

"There's a proof for the existence of God," she says. "By calculus. I can't do it myself because I'm not good at math."

I can't think of what to say to this, and just nod and smile.

"Well,"—holding up her book—"read these writings again. Don't put it off too long. I hope you don't get writer's block."

June 26, 1995

After church one Sunday, Boswell, at the age of thirty-five, long a confirmed Johnsonian, content with the sermon, satisfied (as he

puts it) with his spiritual condition, goes home and writes in his diary: "[During the service] a strange thought struck me that I would apply to David Hume, telling him that at present I was happy in having pious faith. But in case of its failing me by some unexpected revolution in my mind, it would be humane in him to furnish me with some reflections by which a man of sense and feeling could support his spirit as an infidel. I was really serious in this thought. I wonder what David can suggest." (Boswell's Journal, 13 November 1775).

Boswell didn't carry out his plan, but a month later his mind was still or again in the same groove. He visited Hume and wrote afterward with apparent equanimity: "It was curious to see David such a civil, sensible, comfortable looking man, and to recollect, 'This is the Great Infidel.'" (Journal, 17 December 1775).

But two months after that, when a Mrs. Stuart wrote to him, "Lord help me, I have been reading Hume's essay on natural religion, and it almost made me an infidel," Boswell writes back that he is "shocked." "You shall not be an infidel as long as I live. Why do you read such books?" And he promises to send her some suitable literature.

He could not, apparently, bring Hume to rest or find an attitude to take towards him.

During the summer of 1776 Hume lay dying. It was a well-publicized affair. As Burke—an anti-Humean—put it, "great rout" was made over the occasion, both by the public at large and by Hume's own circle ("Hume's Church," Burke called it). Would he die well? Would he lose his equanimity? Would he abandon at the last moment his unbelief? So much was made of these questions that Hume's friends kept a sort of informal watch over him, afraid that some unknown minister might come in, spend a few minutes alone with Hume, then claim afterwards that Hume had recanted.

Hume himself, put in the position of having to meet his last end as a sort of poster boy for agnosticism, responded in typical active, quiet, good-natured fashion, receiving one curious visitor after another, and even writing up a document to be read after his death, advertising his own condition.

"In spring, 1775, I was struck with a disorder in my bowels,

which at first gave me no alarm, but has since, as I apprehend it, become mortal and incurable. I now reckon upon a speedy dissolution. I have suffered very little pain from my disorder; and what is more strange, have notwithstanding the great decline of my person, never suffered a moment's abatement of my spirits; insomuch, that were I to name a period of my life which I should most choose to pass over again, I might be tempted to point to this later period. I possess the same ardor as ever in study, and the same gayety in company. I consider, besides, that a man of sixty-five, by dying, cuts off only a few years of infirmities."

He goes on to give, in the past tense ("for that is the style I must now use in speaking of myself") a favorable (and accurate) description of his character, and ends by saying, "I cannot say there is no vanity in making this funeral oration of myself, but I hope it is not a misplaced one; and this a matter of fact which is easily cleared and ascertained."

Published nine months after Hume's death, it was an odd, interesting and useful document, bound to stir sympathy in his friends and suspicion and irritation in his enemies. In Boswell it no doubt evoked all these feelings together.

Before that, though, when Hume was still resting comfortably on his deathbed, Boswell went to see him and to "interview" him. He did not go to Hume out of personal sympathy alone; nor did he go—as the biographers, even Boswell's own, like to imply—out of some kind of pertinacious nosiness or from a desire to get "the scoop of the eighteenth century."

He went to see how Hume would die. He knew that Hume's own love of truth was strong, like Johnson's. Yet every man is capable of deceiving himself. And if you have deceived yourself, and have a conscience, there is always the possibility that, in the face of death, you will not be able to sustain the deception. Was Hume afraid? Would he admit his fear? Boswell wanted to see for himself.

AN ACCOUNT OF MY
LAST INTERVIEW
WITH DAVID HUME, ESQ.

Partly recorded in my Journal,
partly enlarged from my memory
3 March 1777. *

On Sunday forenoon the 7 of July 1776, being too late for church, I went to see Mr. David Hume, who was returned [to Edinburgh] from London and Bath, just a-dying. I found him alone, in a reclining posture in his drawing room. He was lean, ghastly, and quite of an earthy appearance. He was dressed in a suit of gray cloth with white metal buttons, and a kind of scratch wig. He was quite different from the plump figure which he used to present. He had before him Dr. Campbell's *Philosophy of Rhetoric*. He seemed to be placid and even cheerful. He said he was just approaching to his end. I think these were his words. I know not how I contrived to get the subject of immortality introduced. He said he never had entertained any belief in religion since he began to read Locke and Clarke. I asked him if he was not religious when he was young. He said he was.... I had a strong curiosity to be satisfied if he persisted in disbelieving a future state even when he had death before his eyes. I was persuaded from what he now said, and from his manner of saying it, that he did persist. I asked him if it was not possible that there might be a future state. He answered that it was possible that a piece of coal put upon the fire would not burn; and he added that it was a most unreasonable fancy that we should exist for ever....

I asked him if the thought of annihilation never gave him any uneasiness. He said not the least; no more than the thought that he had not been... "Well," said I, "Mr. Hume, I hope to triumph over you when I meet you in a

* A few months after Hume's death

MAX SCHOTT

future state, and remember, you are not to pretend that you was joking with all this infidelity." "No, no," said he. "But I shall have been so long there before you come that it will be nothing new." In this style of good humour and levity did I conduct the conversation, [says Boswell, though clearly the more impressive good humour is Hume's]. Perhaps it was wrong on so awful a subject. But as nobody was present I thought it could have no bad effect. I however felt a degree of horror, mixed with a sort of wild, strange, hurrying recollection of my excellent mother's pious instructions, of Dr. Johnson's noble lessons, and of my religious sentiments and affections during the course of my life. I was like a man in sudden danger eagerly seeking his defensive arms; and I could not but be assailed by momentary doubts while I had actually before me a man of such strong abilities and extensive inquiry dying in the persuasion of being annihilated. But I maintained my faith. I told him that I believed the Christian religion as I believed history. Said he: "You do not believe it as you believe the Revolution...."

They talked on. Hume at one point casually refers to futurity as an absurd or foolish notion. Boswell: "I believe he said, such a foolish, or such an absurd, notion; for he was indecently and impolitely positive in incredulity." But finally Hume's manner and demeanour were irresistible:

> ...for the truth is that Mr. Hume's pleasantry was such that there was no solemnity in the scene; and death for the time did not seem dismal. It surprised me to find him talking of different matters with a tranquility of mind and a clearness of head which few men possess at any time....
>
> Mr. Lauder, his surgeon, came in for a little, and Mr. Mare, the Baron's son, for another small interval. He was, as far as I could judge, quite easy with both. He said he had no pain, but was wasting away. I left him with impressions which disturbed me for some time.

A good year and a half after the interview, Boswell added a few more notes, which include a remarkable evocation of Hume's speaking presence: "He said this with his usual grunting pleasantry, with that thick breath which fatness had rendered habitual to him, and that smile of simplicity which his good humour contently produced."

It's no wonder that Boswell was left with impressions that "disturbed him for some time." The Great Infidel was dying like a saint, his flesh wasting away, his spirit whole.

But the interview doesn't give the whole picture. The only way to get an accurate sense of Boswell's emotional and moral distress and confusion during the weeks immediately following his interview with Hume, is to look at his journal.

> *August 22, 1776 (but written on the 24th):* Called at Mr. David Hume's, wishing to converse with him while I was elevated with liquor, but was told he was very ill. I then ranged awhile in the Old Town after strumpets, but luckily met with none that took my fancy. Came home.... I was noisy and had a voracious appetite. I was shocked by the consciousness of my own situation.

> *Monday, 26 August:* Balburton informed us that David Hume died yesterday. This struck me a good deal. I went and called at his door, and was told by his servant that he died very easily.

> *Tuesday, 27 August:* Was indolent and listless and gloomy.

> *Wednesday, 28 August.* (Writing at Auchinleck, 20 September.) I drank too much. We had whist after dinner. When I returned to town, I was a good deal intoxicated, ranged the streets, and having met with a comely, fresh-looking girl, madly ventured to lie with her on the north brae of the Castle Hill. I told my wife immediately.

(Boswell's reactions to Johnson's death, some seven years later, were strangely similar, though even more intense. Upon first hearing that Johnson had died: "I did not shed tears. I was not tenderly

MAX SCHOTT

affected. My feeling was just one large expanse of stupor." A couple of months later, when he visited their old haunts in London, his attempts to deal with his grief became more frantic than ever before: "On 28 April he attended the execution of nineteen prisoners. 'Not shocked,' he wrote, although bodies were still hanging as he walked to Betsy Smith's dwelling nearby. 'I have got a shocking sight in my head,' he said to her; 'take it out'. 'Her pleasing vivacity *did* remove it,' he wrote." (1783, Peter Martin's biography, p. 475).)

> *Thursday, 29 August:* Was vexed at my rashness last night, but was somehow in a very composed, steady frame. It was a very wet day. After breakfast Grange and I went and saw David Hume's burial. [We] looked at Hume's grave, watched the funeral procession, then went to the law library and read some parts of his Essays: of his "Epicurean," his "Stoic," his "Sceptic"; and "On Natural Religion." I was somewhat dejected in mind. The day was passed to little purpose.

> *Friday, 30 August:* My mind was not right.... I set myself resolutely to write letters to Dr. Johnson and Mr. and Mrs. Thrale, which did me good.

In his letters Boswell tried hard to put Hume behind him. He told Mrs. Thrale that he was shocked to think of Hume's "persisting in his infidelity." Hume must have "by long study in one view, brought a stupor upon his mind as to futurity.... What a blessing it is to have a constant faith in the Christian revelation!... I am of Dr. Johnson's opinion that those who write against religion ought not to be treated with gentleness."

In the following June he wrote again to Johnson: "Without doubt you have read what is called *The Life of David Hume*, written by himself, with letter from Dr. Adam Smith subjoined to it. Is this not an age of daring effrontery? Would it not be worth your while to crush such noxious weeds in the moral garden?"

When he next saw Johnson in person, Hume had been dead for a year, and Boswell was still trying to settle his ghost. "[I] told Dr. Johnson that David Hume's persisting in his infidelity when he was

dying shocked me much. 'Why should it?' said he." Johnson mentioned Hume's ignorance of the New Testament (which in fact Hume had probably read in Greek), and went on: "'Here then was a man who had been at no pains to inqure into the truth of religion, and had continually turned his mind the other way. It was not to be expected that the prospect of death would alter his way of thinking, unless God should send an angel to set him right.'"

But Boswell, as he would, persisted: "I said Hume told me he was quite easy at the thought of annihilation. 'He lied,' said Dr. Johnson. 'He had a vanity in being thought easy. It is more probable that he lied than that so very improbable a thing should be as a man not afraid of death; of going into an unknown state and not being uneasy at leaving all that he knew. And you are to consider that upon his own principle of annihilation he had no motive not to lie.'" Later that evening, Boswell recorded this conversation in his journal and added, "The horror for death which I have observed in Dr. Johnson appeared strong tonight."

Years later, when Boswell, working from his journal, was putting together *The Life of Johnson*, he made a change in this entry. The "He lied" of the journal becomes, in *The Life*, "It was not so…" ("I said, I had reason to believe that the thought of annihilation gave Hume no pain. JOHNSON: 'It was not so, Sir. He had a vanity of being thought easy.'")

To make that change was a sin against the truth and against good copy. It was also an act of kindness and generosity towards the memory of both men.

One night in a dream, eight years after Hume's death and a year after Johnson's, Boswell managed at last to solve the problem of Hume. In his dream Boswell "'found a Diary kept by David Hume, from which it appeared that though his vanity made him publish treatises of skepticism and infidelity, Hume was in reality a Christian and a very pious Man.… I [dreamt] I read some beautiful passages in this Diary.… After I awaked, [this dream] dwelt so upon my mind that I could not for some time perceive that it was only a fiction.'" (The dream took place in January, 1784. *The Life of David Hume*, Ernest Campbell Mossner, 2nd edition, p. 606.)

MAX SCHOTT

May 20, 2001

Not long after Dr. Dodd was executed, what was supposedly his last written utterance—an address to his fellow convicts—was published. After reading it a friend of Johnson's—Mr. Seward—said in Johnson's presence that this piece of writing sounded more intelligent, contained more "force of mind," than anything he had ever seen by Dodd before—and he ventured to suggest that Dodd had not actually written it.

Johnson replied with his usual force: "Why should you think so? Depend upon it, Sir, when a man knows he is to be hanged in a fortnight, it concentrates his mind wonderfully." Johnson said this even though he knew very well that in fact Dodd had not written his own last words. (Johnson, as part of an attempt to save Dodd's life, had written them himself).

Even so, I've always wanted to believe that Johnson meant what he said and that what he said is true. In other words, I like to imagine that that's how it would be with me. In my daydreams, when I'm told I only have so many days or weeks to live, I become as concentrated and profound as anyone could wish.

Recently I was given a chance to try this notion out in real life.

For a couple of months, back in January and February and early March, I was feeling some mild pressure high in my chest when I'd go for a walk; also I found myself getting out of breath more easily than usual. I thought this was the result of a cold at first, and kept waiting for it to stop happening. Finally I called our family doctor to get it checked out. He was out of town, but another doctor saw me within a day or two. I remember it was a Wednesday morning. Mary Proenza's literature symposium was going to be that afternoon. I told the doctor I didn't think it was my heart, and she said obligingly that it probably wasn't but that that was the first thing to get checked. She arranged for me to see a cardiologist the next day, for a treadmill test.

The cardiologist, Dr. Van Hoek, was less sanguine. She said my symptoms were typical of heart trouble. She said the treadmill test would almost certainly lead to an echo-stress test and that the echo-stress test would almost certainly lead to an angiogram. She suggested we go straight to the angiogram; within about three

minutes she got hold of the angiogram doctor, Dr. Weldon, and scheduled one for early that afternoon. Meanwhile, a nurse would take me across the street to the hospital, where they should already be getting a room and a bed ready for me.

The next couple of hours passed pretty quickly. I signed various things, was told various things, called Elaine, then was taken on a gurney down to the angiogram lab, wheeled under a huge machine, comforted and reassured by various people and given a tranquilizer, which I was glad to have. If I understand it correctly, a catheter was put into the femoral artery, down around the groin, some dye was shot up toward my heart—and on a video screen, which I could see, the whole works was visible, the heart pumping, blood vessels of all sizes twitching. Mostly it was a jumble to me, but Dr. Weldon pointed out a large vessel—a coronary artery that was almost totally constricted. It looked like it had been squeezed together with a clothespin. He said that three more smaller ones were also clogged up. If there'd been fewer blockages, he said, it would be worth putting in balloons and stents, which was actually his specialty, but since the chance of any given balloon or stent failing to hold is pretty high, twenty or twenty-five percent, he thought it was clear that I should have a bypass operation instead.

I knew roughly what that consisted of. I was around for my father's open heart surgery years ago and had terrible dreams about it afterward, more on my own account than his. And in the last decade or two I've read a couple of essays by men whose lives were saved and more or less ruined by the same operation. These memoirs and my memories and dreams had made such a strong impression on me that a few years ago I told Elaine that if it ever came to that—in other words, if I were ever in exactly the situation that I was in now—I'd prefer just to drop dead like a gentleman. I thought I was serious. But at this moment, looking at the shut-down artery, watching the dye squirt around, and wanting to live, I agreed without hesitation.

It was still only early afternoon. I was shifted back onto a gurney and pushed along the halls to the elevator and taken back up to my room again. I don't want to go through everything that happened. I called Elaine. Dr. Van Hoek called the surgeon, Dr. West. There

was some talk about doing the surgery that same evening, Thursday. Dr. West said he could do it then. The disadvantage, Dr. Van Hoek said, was that he'd have been working all day beforehand. But he couldn't do it Friday, and apparently they thought it was a bit dangerous to wait. Finally they decided to do it Saturday morning, and to let me spend Thursday night and Friday and Friday night at home, with a bottle of nitroglycerin tablets at hand.

Meanwhile, before I was allowed to leave the hospital, a number of people came by to talk to me and to have me sign a few forms and documents. The two things I remember best are these: a young woman came in and explained to me in detail what the operation and recovery were going to be like. She explained it all in two ways: objectively—what was going to be done to me; and then from my point of view—what I was going to experience. She told me I was going to wake up with a number of tubes in me, and she began to describe them one by one, why they were there, when they'd come out, and so on. Towards the end, she smiled and said, "You look a bit overwhelmed."

The other thing I remember is my reaction to the word "death" on a form I was asked to sign. One part of the form was a permission slip: If, when I was unconscious, I needed a transfusion, I hereby granted the doctors permission to give me one. By the same token, if my heart stopped and I needed to be put on a heart-lung machine, I gave permission for that to be done. Another part of the form was a declaration that I understood roughly what the operation consisted of and also that I understood that there were risks involved and that there might be certain undesired side effects. Not surprisingly, death was one of them. But I was taken aback to see the word there—and to be asked to put my signature below it. "Huh!" I thought, and imagined myself greatly insulted—but came to my senses after a moment and signed the form.

In the evening Elaine took me home, where I spent two fairly uneventful nights and a long, strangely elegiac day. During that day my mind was concentrated, I think, at least if concentrated means something like what they do to orange juice. My thoughts were less diffuse than usual. Only a few things seemed important, and those few seemed more important than they usually did. I don't believe

that this kind of narrowing down is all to the good. Diminishment, removal from the world—in general these are bad things. But that is how it was. My world suddenly had fewer things in it. In moral emergencies the mind protects itself, senses what can be accomplished, makes adjustments, limits its desires.

For example, I remember looking at my desk, the piles of scribbled-on paper: If all went well, if I was lucky, if my mind recovered, it was going to be at least ten weeks before I'd be able to make any kind of sense out of the stuff again. The reasonable thing to do was to sort through some of it now, so that it would be easier for me—or someone else—to figure out what to do with it later. But it would be impossible, in the few hours that I had, to sort through very much of it—and there were other things I wanted to think about. Therefore, I at least ought to fret, to feel bad about what was left undone. I would *usually* feel bad about it. I stood there, looking at the stacks of papers, wondering why I wasn't feeling properly bad. Then, as they say in books or sermons, a sort of peace came over me. It couldn't be done, I hadn't the energy or time—or desire really. And since it couldn't or wouldn't be done, it became, as I stood there, unimportant.

At the same time, all sorts of small things, the quiet routine of daily life—talking to Elaine and Anna and Tim, looking at the sports section of the *L.A. Times*, sitting in a café, walking (albeit slowly, with the bottle of nitroglycerine tablets in my pocket. The only written instructions the surgeon had added to the printed form I'd been sent home with were, in big block letters: TAKE IT EASY!), looking through the mail, reading, noting down a random thought, the sight of green things growing, the neighborhood cat, a mockingbird, the dog Wogart—these small experiences took on a kind of glow. Most of all I found myself responding to indications, spoken or not, of goodwill, kindness, sympathy, affection—coming from others and even coming from myself. I discovered in myself a new alertness to such things, as if I'd shed a skin.

I thought about the operation. Sometimes I willed myself to think about it, other times I tried to will myself not to. Images of being cut open came into my head and frightened me. I told myself I'd be unconscious and that the operation itself was other

MAX SCHOTT

people's problem—in effect I wouldn't be there. This helped some, I suppose—who knows?—but I was frightened anyway. I was even more frightened, certainly more reasonably frightened, of the operation's aftermath. Thoughts about waking up, hurting, etc., got all mixed up with thoughts about never properly recovering, losing brain cells, going into a life-long funk.

All this was unpleasant, but at the same time I was conscious of being less frightened than I'd expected to be. Also, I see now that it was a good clean sort of fear, by which I mean it was only there when it was there. It didn't turn into anxiety or seep into my bones and organs. I suppose that's why it was possible for the day, that Friday, on the whole and in so many of its moments, to seem so delicious to me.

As for the fairly remote possibility that I might die, on the operating table for example, or in the intensive care unit afterwards, I tried to think about that, too. But I had trouble getting my mind around the idea. I don't think this was solely from fear. Nothingness is…. I draw a blank. What is there to get hold of? As William Carlos Williams puts it, "Death is difficult for the senses to alight on…. There is a cold body to be put away but what is that? The life has gone out of it and death has come into it. Whither? Whence? The sense has no foot space" ("The Accident").

At night it's different. Like anyone, once in a while I'll wake up feeling a clammy existential terror—and I persuade myself then that it's death I'm afraid of, and even imagine that I'm actually apprehending it. At such times Johnson's word "dissolution" seems to fit very well.

But in the daytime, nothing. Sometimes I believe, and I'm sure people who know me believe, that the reason I can't get my mind around the notion of death is that I'm an insensitive clod, greatly repressed. Roughly speaking, this is true. But to defend myself against the charge I think of Hume—who after all was unafraid, and not a clod. But it's not an entirely successful defense. In the end, Johnson, Hume's polar opposite, is for me, with all his terrors and all his courage, the more fully human figure.